FROM POUSSIN
TO MATISSE

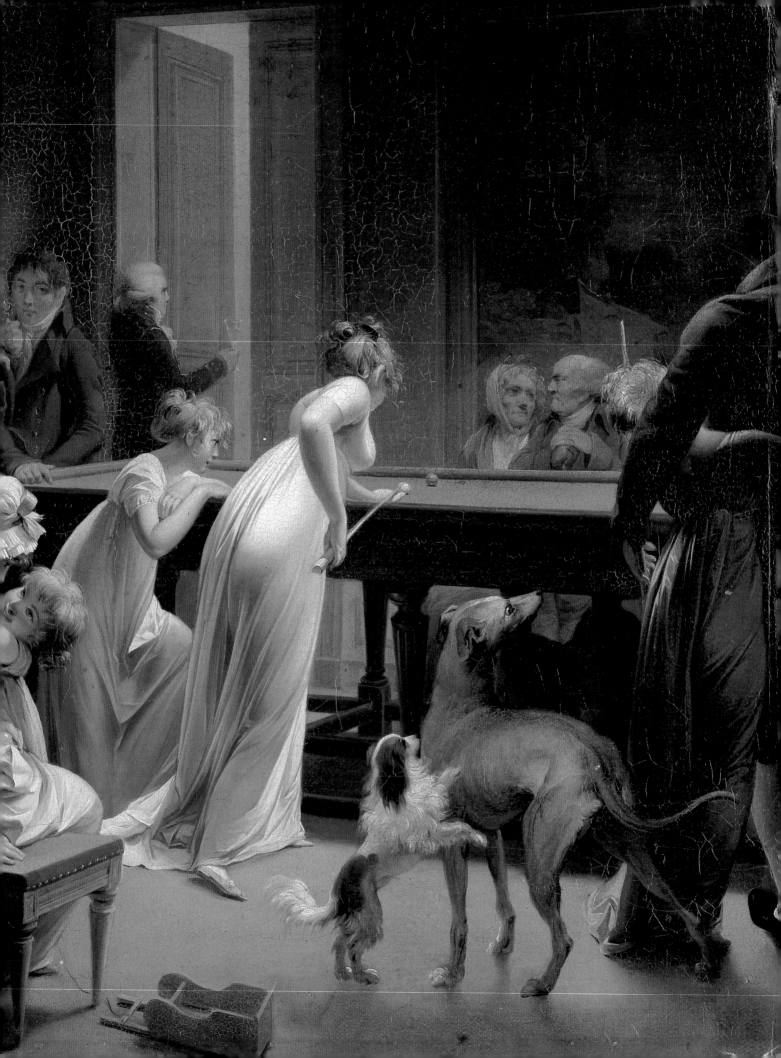

FROM POUSSIN

THE RUSSIAN TASTE FOR FRENCH PAINTING

TO MATISSE

A Loan Exhibition from the U.S.S.R.

THE ART INSTITUTE OF CHICAGO
THE METROPOLITAN MUSEUM OF ART, NEW YORK

Distributed by Harry N. Abrams, Inc., New York

This publication was issued in connection with the exhibition "From Poussin to Matisse: The Russian Taste for French Painting," held at The Metropolitan Museum of Art from May 20 to July 29, 1990, and at The Art Institute of Chicago from September 8 to November 25, 1990.

This exhibition was made possible by Sara Lee Corporation.

Transportation assistance was provided by Finnair.

Produced by The Art Institute of Chicago
Susan F. Rossen, *Executive Director of Publications*
Katherine Houck, *Production Manager*
Bruce Campbell, *Designer*

Hermitage Museum Publications Department: Vladimir Terebinin, Chief Photographer; Leonard Heifetz, Photographer

Typeset in Bembo by Paul Baker Typography, Evanston, Illinois
32,000 copies were printed on Magnohalbmatt and bound by Arnoldo Mondadori, SpA, Verona, Italy

Front cover: Detail of Henri Matisse, *Blue Tablecloth* (no. 47)
Back cover: Detail of Nicolas Poussin, *Tancred and Erminia* (no. 3)
Frontispiece: Detail of Louis Léopold Boilly, *The Billiard Party* (no. 21)
Page 6: Detail of Paul Cézanne, *Still Life with Curtain* (no. 31)
Page 35: Detail of Nicolas Poussin, *Tancred and Erminia* (no. 3)

LIBRARY OF CONGRESS CATALOGUING-IN-PUBLICATION DATA
From Poussin to Matisse: the Russian taste for French painting:
 a loan exhibition from the U.S.S.R.
 168 p.
 "Prepared for the United States by two major Soviet museums, the
 Hermitage in Leningrad and the Pushkin Museum in Moscow"—Foreword.
 Includes bibliographical references.
 ISBN 0-86559-087-7 : $35.00. — ISBN 0-86559-086-9 (pbk.) : $19.95
 1. Painting, French—Exhibitions. 2. Painting, Modern—France—
Exhibitions. 3. Gosudarstvennyĭ Ėrmitazh (Soviet Union)—
Exhibitions. 4. Gosudarstvennyĭ muzeĭ izobrazitel'nykh iskusstv
imeni A.S. Pushkina—Exhibitions. I. Art Institute of Chicago.
II. Metropolitan Museum of Art (New York, N.Y.)
III. Gosudarstvennyĭ Ėrmitazh (Soviet Union) IV. Gosudarstvennyĭ
muzeĭ izobrazitel'nykh iskusstv imeni A.S. Pushkina.
ND544.F75 1990
759.7'074'77311—dc20 89-77582
 CIP

Contents

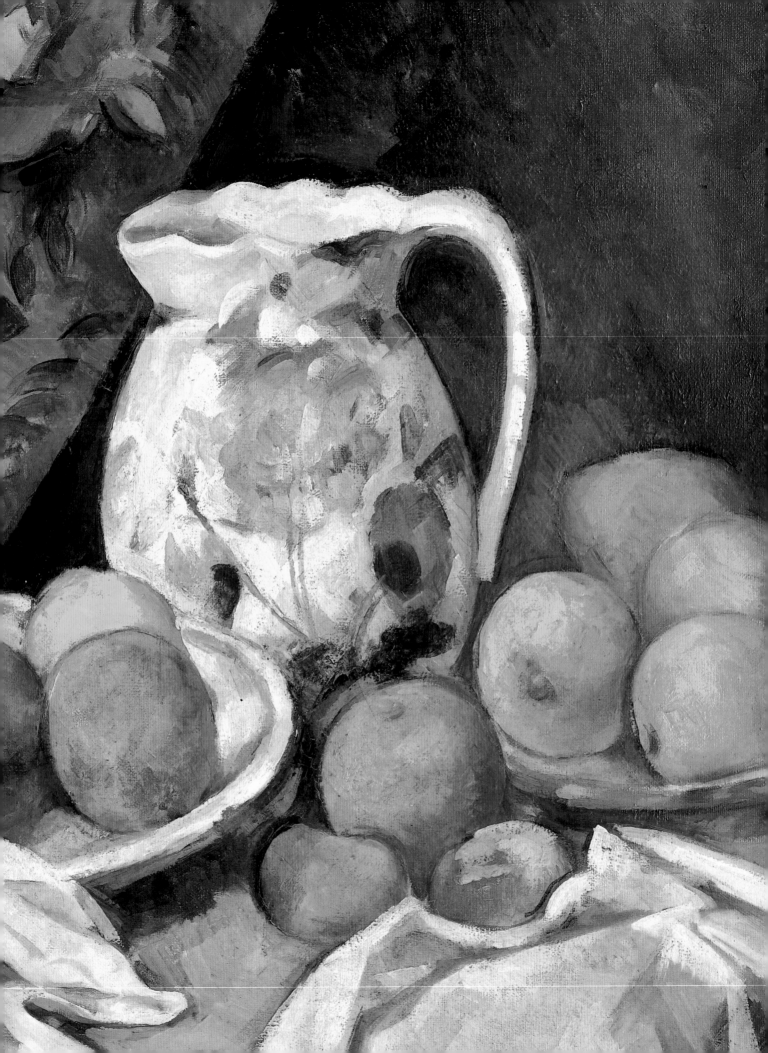

Foreword

The exhibition "From Poussin to Matisse: The Russian Taste for French Painting" has been prepared for the United States by two major Soviet institutions, the State Hermitage Museum in Leningrad and the Pushkin State Museum of Fine Arts in Moscow. These are the major repositories of Western art in the Soviet Union.

Like most famous European museums, the Hermitage began as a court gallery. It was established in the early eighteenth century and has become one of the greatest museums in the world. The Pushkin Museum is much younger. It opened as the Museum of Fine Arts in 1912 as a showplace for plaster casts of distinguished pieces of world sculpture. The museum's painting gallery was organized in 1924. Forming its core was work that had been housed in the Rumyantsev Museum in Moscow and from many large private collections which entered the State Museum holdings with the nationalization of private property after the October Revolution.

The holdings of the Pushkin increased rapidly. A number of outstanding works were transferred there from the Hermitage. The painting collection also grew through purchases and bequests. In 1937, the museum was renamed in honor of the great Russian Romantic poet Aleksandr Sergevich Pushkin, on the one-hundredth anniversary of his death.

In 1948, the brilliant collection of the State Museum of Modern Western Art in Moscow was dismantled and divided between the Hermitage and Pushkin museums, enriching their collections considerably. Since that time, many canvases from the Hermitage and Pushkin museums have been exhibited in the United States. In exchange, exhibitions from the National Gallery of Art in Washington, D.C., The Metropolitan Museum of Art, New York, and The Art Institute of Chicago, among others, have traveled to the Soviet Union.

The paintings shown in the present exhibition are some of the finest in the collections of the two museums. Russian interest in French culture and art is nearly three hundred years old. Russians have been particularly attracted to French painting, with collectors eagerly seeking to grace their sumptuous mansions with canvases from the West.

One quarter of the holdings of the Hermitage is French paintings. (It is one of the largest such collections outside France.) The Pushkin Museum boasts over seven hundred French works of merit. It is a collection diverse enough in periods and styles to demonstrate all major stages in the development of French painting from Poussin to Matisse.

The following two essays trace the history of the collecting of these artistic treasures. It is a story interesting in itself and is closely tied to the development of Russian culture.

IRINA KUZNETSOVA, DIRECTOR
Department of Western European and American Art
Pushkin State Museum of Fine Arts, Moscow

Foreword

The new cultural agreement signed by General Secretary and President Mikhail Gorbachev, and President Ronald Reagan at the Geneva summit meeting of 1985 opened an era of cooperation that has had a major impact on the cultural life of both the Soviet Union and the United States. The arts have frequently served as advance scouts exploring new territory and challenging old assumptions, and over the past five years the beneficiaries have been the Soviet and American peoples. This exhibition is the second of two ambitious exchanges that were initiated immediately following the 1985 summit. The first exchange, which occurred in 1988, brought an unrivaled selection of Dutch and Flemish paintings from the State Hermitage Museum in Leningrad to The Metropolitan Museum of Art, New York, and The Art Institute of Chicago. Simultaneously an exhibition of French nineteenth-century and early twentieth-century painting, which conveyed the full breadth of our combined collections, was welcomed by large and appreciative audiences at the Pushkin State Museum of Fine Arts in Moscow and at the Hermitage. Today, while Americans experience the extraordinary range of French painting that has become one of the central strengths of the Soviet museums, the Metropolitan Museum and the Art Institute have sent a selection of medieval art from late antiquity to late Gothic, the most ambitious exhibition of its kind to have been seen by the Soviet public.

Although the initial negotiations with our Soviet colleagues occurred only weeks after the 1985 summit, in an atmosphere of mutual enthusiasm, these exhibitions have been the fruit of years of effort. They have fostered an expanding relationship between our institutions that has resulted not only in these four exhibitions but also in a growing exchange of information between our respective staffs. Plans are already under way to lend additional works from our collections to specific Soviet exhibitions; and a unique body of work by the German Romantic painter Caspar David Friedrich, from the collections of the Hermitage, has been arranged for our two museums.

As in the case of "Dutch and Flemish Paintings from the Hermitage" in 1988, "From Poussin to Matisse: The Russian Taste for French Painting" and its catalogue, as well as the exchange exhibition of medieval art currently on view in the Soviet Union, have been made possible by the generous support of the Sara Lee Corporation. Long before our completed negotiations had assured the actual content of these exchanges, John H. Bryan, Chairman and Chief Executive Officer of Sara Lee Corporation, committed the support that has made these ambitious plans a reality and allowed the many months of research that these projects have required.

The Russian taste for French painting has expressed itself continually from the eighteenth to the twentieth century. From Catherine the Great to Sergei Shchukin, it was focused, passionate, and insatiable. In fact, if one is to understand fully the masters of French painting from Poussin to Matisse, one must visit Moscow and Leningrad. There are few countries from which such an exhibition could be drawn, not to mention from only two museums in a single country. Comparable strength could be claimed in the United States only by combining the holdings of the Metropolitan, the Art Institute, the National Gallery of Art in Washington, D.C., and The Museum of Modern Art in New York; and

in France by pooling the resources of three museums: the Musée du Louvre, the Musée d'Orsay, and the Musée national d'art moderne, Centre Georges Pompidou, all in Paris.

The current group of exchange exhibitions and the spirit of cooperation that they embody are taking place at an historic moment in Soviet-American relations. Along with our Soviet colleagues, we hope these current cooperative projects and those we anticipate in the future will play their part in replacing, on both sides, attitudes that flourish only in isolation, and that the pleasure and knowledge provided by such exhibitions will serve to cement the growing openness that has characterized the relationship between our two societies since 1985.

JAMES N. WOOD
Director, The Art Institute of Chicago

PHILIPPE DE MONTEBELLO
Director, The Metropolitan Museum of Art, New York

Acknowledgments

Many people were involved in the realization of this project. To be acknowledged at The Art Institute of Chicago are Martha Wolff, Curator of European Painting Before 1750; Gloria Groom, Assistant to the Curator of European Painting; Charles F. Stuckey, Curator, Department of Twentieth-Century Art; and Dorothy Schroeder, Assistant to the Director. For their help with the catalogue, we are grateful to Susan F. Rossen and Katherine A. Houck, as well as to Eleanor Ackerman, Anna Lisa Crone, Cris Ligenza, Amy Linenthal, Arthur Morey, Terry Ann R. Neff, Lisa Sandquist, Sue Snodgrass, and Susan Wise. At The Metropolitan Museum of Art, to be thanked are Mahrukh Tarapor, Assistant Director; Gary Tinterow, Associate Curator, Engelhard Curatorship of Nineteenth-Century European Paintings; Susan Stein, Special Exhibitions Associate, Department of European Painting; Deborah Feldman, and Anne M. P. Norton.

Sponsor's Foreword

Throughout years of traveling, I have visited many of the world's great museums. In their galleries, I have discovered that, while a single work of art communicates something about the person who created it, whole collections reveal the sensibilities of the men and women who assembled them. Ultimately then the relationships of nations are well described by the masterpieces protected in museums around the globe. In 1798, Friedrich Wilhelm of Prussia wrote of these masterpieces: "Only by making them public and uniting them in display can they become the object of true study, and every result obtained from this is a new gain for the common good of mankind."

Almost two centuries have passed since those words were written, and time has wrought remarkable change in the ways nations coexist. We trade in new common markets. We share media and medicine. We ponder solutions to global dangers. We have embraced exchange as the essential means for growth in the next century. More than ever, we rely upon the arts and culture as a unique "lingua franca" to facilitate this exchange, and upon museums as the halls of cultural diplomacy. For, in the classical beauty of a Poussin composition or the saturated color of a Matisse study, we find strains of an international language.

Sara Lee Corporation is thus proud to help bring to the United States magnificent French paintings from the Pushkin Museum in Moscow and the Hermitage in Leningrad, and to sponsor the first exhibition in the U.S.S.R. of Western medieval art from The Art Institute of Chicago and The Metropolitan Museum of Art, New York. In supporting an international dialogue between American and Soviet museums, we at Sara Lee seek to reaffirm the highest goals of cultural diplomacy.

JOHN H. BRYAN
Chairman and Chief Executive Officer
Sara Lee Corporation

State Hermitage Museum, Leningrad.

French Painting and Eighteenth-Century Russian Collectors

IRINA KUZNETSOVA, DIRECTOR
DEPARTMENT OF WESTERN EUROPEAN AND AMERICAN ART
PUSHKIN STATE MUSEUM OF FINE ARTS, MOSCOW

The eighteenth century was a period of unprecedented interest in art throughout Europe. The collecting of art was widespread and passionately engaged in by people of many social strata: crown princes and courtiers, prosperous members of the middle class, scholars and artists, bishops and actors. Much was published on art: treatises on aesthetics, debates about taste, scholarly studies of the art of classical antiquity, and numerous biographies of Renaissance and seventeenth-century painters. Admiration for old masters did not preclude interest in contemporary art. In Paris and London, public exhibitions of works of living artists were popular, provoking heated debate in the press. Nothing like this passion for art had ever been seen before.

Both ancients and moderns had equal claims as far as the taste of collectors was concerned. Italian paintings of the sixteenth and seventeenth centuries and any work by Peter Paul Rubens or Antony van Dyck brought a collection great prestige. Seventeenth-century Dutch art by the "little Dutch masters" and contemporary French painters, including Antoine Watteau, Jean Baptiste Siméon Chardin, and Claude Joseph Vernet, among others, became fashionable as well. The latter artists had abandoned historical painting in favor of a more direct representation of reality. By the early 1750s, Russians too had been seized by the Western European passion for collecting. The importation of Western art that began at the time was to play a vital role in the development of Russian culture.

Peter I (Peter the Great) (reigned 1682–1725) was the first czar to acquire Western painting actively. His agents abroad sent back to St. Petersburg hundreds of works of all kinds. Canvases were hung in Peter's palaces, in those of his courtiers in the capital, and in his retreat, Monplaisir, in Tsarskoe Selo. In 1714, the czar established his "Kunstkammer"; with its botanical, zoological, and mineral items, curiosities and works of art, it was the first public museum in Russia.

Peter was not a sophisticated collector of art. His personal taste ran to Dutch seascapes: The czar loved ships. But he understood the importance of art as a tool of enlightenment, as a means of bringing a new culture to his country. He thought of his art as a way to ornament the new kind of life he imagined for Russians. It would also, he believed, instruct and elevate the public, popularize his reforms, and enhance his military successes.

After Peter's death, in 1725, his policy of opening Russia to Western Europe and its traditions declined for several decades. That goal was revived during the reign of his daughter, Empress Elizabeth Petrovna (reigned 1741–61). Under the empress, political ties with France were strengthened and the influence of French culture in Russia grew. French became the accepted language of the court. Parisian fashions were adopted and French luxuries imported. Despite all this, there was little interest in the collecting of art under Elizabeth. The holdings of the small court galleries of her father's reign were not significantly increased.

But an unprecedented number of palaces were built in St. Petersburg during the empress's rule. Artist-decorators from the West were hired to paint ceilings, wall panels, and overdoors. While easel pictures were also acquired for the palaces, they were conceived of as decoration, as details of a larger artistic whole. In the late 1740s, one large purchase of Western art was made by the imperial court. One hundred fifteen paintings were acquired for the huge Rastrelli Palace at Tsarskoe Selo. But here too the individual works of art were subsumed to the architects' decorative scheme. Paintings were hung like tapestries, all together on a wall, separated from each other only by narrow, gilded frames. Entire walls were often covered from near the floor all the way to the ceiling. Individual paintings thus became small elements of a larger design. It had not yet occurred to collectors that one might admire an individual work of art for its content and its painter's vision and skill.

In addition to decorative artists, Western portrait painters began to work in Russia. In 1756, Louis Tocqué, one of the leading French artists of the time, was invited to St. Petersburg to paint an official portrait of Empress Elizabeth. During the two years Tocqué remained in Russia, he also completed a number of likenesses of members of the court. Frequent exchanges with the West, travel abroad, the availability of foreign literature and art, and the arrival in Russia of foreign artists broadened the tastes of the Russian nobility. In the second half of the eighteenth century, these conditions led to the significant increase in the number and size of private collections, as we shall see.

The most important artistic event of that period was the founding of the Hermitage, which decisively influenced all further museum development in Russia. The Hermitage was soon to become one of the richest museums in Europe. In their turn, the painting galleries of the Pushkin Museum are indebted to the Hermitage; any discussion of the Pushkin's collection of French art cannot be separated from the history of the Hermitage. The establishment of the Hermitage collection was undertaken at the beginning of the reign of Catherine the Great (reigned 1762–96) and continued until her death. It was a project in which she took considerable interest, acting often on the advice of the best Russian and foreign critics. Catherine was no more a connoisseur of Western art than Peter I. She regarded collecting as a crucial part of her mission to make her court an intellectual center and to be recorded in history as a leader of the Enlightenment. Russia was also involved in expensive wars in Turkey and elsewhere; Catherine hoped that, by importing Western art, at great expense, she could demonstrate to Europe Russia's limitless resources.

Catherine accomplished this goal by buying whole collections. The first major acquisition for the Hermitage was a large number of paintings from a Berlin merchant, Johann Ernst Gotzkowsky. The purchase was a coup; this group had been assembled originally for Frederick II of Prussia, who was unable finally to make the acquisition because the Seven Years' War (1756–62) had depleted his treasury. Gotzkowsky's collection included 225 works of varying quality, most of them Dutch and Flemish. The works of Frans Hals, Jacob Jordaens, and Rembrandt van Rijn are particularly noteworthy.

Catherine made a second sizeable purchase in 1769, with the acquisition of the magnificent collection of Count Heinrich von Brühl, prime minister to the Saxon prince and Elector Frederick Augustus II (Augustus III of Poland). Besides work by Dutch and Flemish masters, the collection contained the first three examples by Antoine Watteau to go to Russia. Watteau's *Savoyard* (no. 7) entered the Hermitage at about the same time.

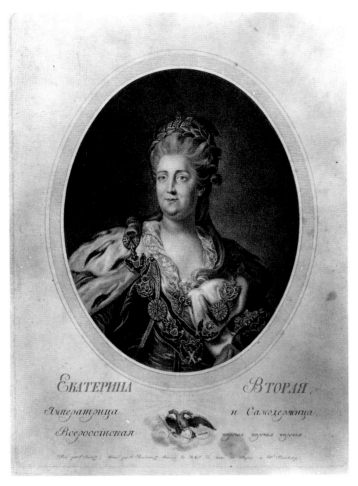

Catherine II of Russia, called
Catherine the Great, reigned 1762-96.

There was not yet however much French painting in Russia. Through Prince Dmitri Golitsyn (1738–1803) who, from 1754 to 1768, served as a diplomat in France, Catherine began to acquire more French work. Golitsyn, who took a genuine interest in the arts, was a friend of the encyclopedist and critic Denis Diderot and sculptor Étienne Maurice Falconet. He kept close watch over what was being sold at auction, never missing a chance to make a purchase for the Hermitage. Through him, Catherine acquired many valuable pieces, old and new alike, from different schools. In 1767, for example, the prince bought Jean Baptiste Greuze's *Paralytic* (no. 10) on the advice of Diderot, who greatly admired the painting. He commissioned *Still Life with Attributes of the Arts* from Jean Baptiste Siméon Chardin at about the same time. When the collection of the artist J. A. Aved was auctioned off, Nicolas Poussin's masterpiece *Tancred and Erminia* (no. 3) was purchased for the Hermitage. Other works by Poussin, *Victory of Joshua over the Amorites* and *Victory of Joshua over the Amalekites* (nos. 1–2), were also acquired at this time.

When, with the help of Diderot, Catherine purchased the famous Crozat painting collection, she became an indisputably major figure in the arts. Wealthy members of the French haute-bourgeoisie, the Crozats were prominent collectors, benefactors of artists, and philanthropists. Early in the eighteenth century, Pierre Crozat (1665–1740), a banker, became treasurer to the king; by this time, he had already achieved fame as an art collector

Prince Nikolai Borisovich Yusupov
(1751-1831).

and patron. At his mansion, he entertained painters such as Watteau and important contemporary critics, including P. J. Mariette and the Count de Caylus. When Crozat died, his collection of drawings — some 19,000 of them — was sold to benefit the poor. (His cut gems were sold at the same time to the Duke d'Orléans and later entered the Hermitage.)

More than 460 of the paintings in Crozat's collection, distributed among several heirs, were reunited by his youngest nephew, Louis Antoine Crozat (1700–1770), Baron de Thiers. A passionate bibliophile and collector of paintings, Louis Antoine increased the collection he had inherited and reassembled. Considerably finer than most private painting galleries, his "cabinet" contained works by Giorgione, Tintoretto, Titian, Rubens, Rembrandt, van Dyck, and others. French painters of the seventeenth and eighteenth centuries were also well represented. After the younger Crozat's death, Diderot informed the empress that the collection was to be sold. Catherine quickly agreed to buy it in its entirety, paying the heirs 460,000 *livres*. This established the Hermitage as one of Europe's leading art collections. A number of the Crozat pictures are now part of the Pushkin Museum.

Catherine's agents continued to collect art throughout Europe. In 1779, the Russian ambassador to England, Count Musin-Pushkin, learned that the heirs of the former British Prime Minister Robert Walpole were about to sell the contents of his famous picture gallery

at Houghton Hall. The ambassador quickly relayed this information to the empress, and she expressed interest in buying the whole collection. A deal was struck that same year. The removal of the paintings from England sparked controversy; protests were made in Parliament, including a futile demand that the precious cargo be impounded.

The Walpole collection contained no works by contemporary masters, nor were there any of the seventeenth-century Dutch paintings that were being so eagerly collected in France and Germany. Walpole had acquired mainly works by Italian and Flemish masters, along with canvases by Rembrandt, Esteban Murillo, Claude Lorrain, and Poussin (no. 4). Other important additions to the Hermitage were made during Catherine's reign, but the arrival in St. Petersburg of Walpole's collection marked the end of the first and basic stage in the establishment of the Hermitage painting gallery. (Several works from the Walpole collection were later transferred to the Pushkin Museum.)

During this period, many private collections were also being established. Russian nobles were enormously wealthy and could buy much of what attracted them on their frequent trips abroad. In the period following the French Revolution, moreover, many French collections were being broken up and sold off. As Golitsyn was discovering, the Paris art market was flooded.

Private collectors operated in the same spirit as Catherine; the possession of a private gallery was considered prestigious, proof of the owner's wealth and enlightenment. Few Russian collectors were deeply knowledgeable or appreciative of the arts. Most followed fashion; many even considered collecting a competitive activity. But there were a few with real understanding and sensitivity. Among them, Count Aleksandr Stroganov, Count Ivan Shuvalov, and Prince Nikolai Yusupov were the most outstanding.

The collection of Count Stroganov (1737–1811) was comparatively small. At the end of his life, it numbered only 150 paintings. But the works he selected were of the highest quality. Stroganov not only possessed sound judgment, but he was well acquainted with Europe's leading galleries and had studied major scholarly works on art. He personally compiled a catalogue of his collection (1793, republished 1800–11) that was as good as the best catalogues raisonnés of his day. It included not only detailed information about the works themselves, but also explanations of various national schools of painting. While the count collected some French examples, his major interest was in the art of Italian, Flemish, and Dutch masters; none of his works is included in the present exhibition.

Brief mention should also be made of Count Ivan Shuvalov, a remarkable cultural innovator who was instrumental in the founding of the University of Moscow and the St. Petersburg Academy of Fine Arts, both in 1757. Shuvalov headed the Academy until 1763 and bequeathed his collection to it. That collection formed the core of the Museum of the Academy, Russia's first picture gallery.

Prince Nikolai Borisovich Yusupov (1751–1831) was very interested in French art, and several paintings acquired by him appear here. At the death of his father, Yusupov inherited an enormous estate. He left military service and, in 1772, went abroad for the first time. He traveled in Western Europe for almost ten years, returning to Russia for brief periods only. He established himself, at various times, in Vienna, Paris, and Rome, where he met the famous people of his day. In the course of his active social life, he frequented the galleries and studios of the most fashionable artists.

Yusupov's discovery of artists and their work began to assume more and more importance for him, and he became an avid collector. In Paris, he was most attracted to the work of contemporary Rococo masters such as François Boucher, Carle Van Loo, and Jean Honoré Fragonard, but he also appreciated the Dutch genre painters. By the late 1770s, the collection housed at Yusupov's palace in St. Petersburg was famous, and foreign visitors were impressed by its quality.

Yusupov's interest in the arts made him invaluable to the imperial court. In 1782, he was part of the entourage of the Grand Duke and future Czar Paul I. Paul, who traveled and purchased art as the "Count of the North," was making a grand tour of Europe with his wife, Natalia Alekseyevna. Yusupov became a favorite of the royal couple. In January 1783, he was appointed Russian ambassador to the Kingdom of Sardinia at Turin, where he remained for six years. Yusupov was active as an art agent for the future empress, with whom he carried on a lively correspondence. For her, he sought out paintings and precious stones, commissioned new works, and conducted negotiations for the right to have Raphael's Vatican loggias copied. At the same time, he added seventeenth- and eighteenth-century Italian work to his own collection. On his way back to Russia in 1789, Yusupov was briefly detained in Paris. While there, he met the artist Jean Baptiste Greuze, who helped him contact and commission works from many French painters, among them Fragonard, Robert, Vigée Le Brun, and Vincent.

When his return to Russia and the onset of the French Revolution and Napoleonic wars stopped his collecting, Yusupov occupied himself with administrative duties connected with state sponsorship of the arts. He administered the court theaters and was appointed director of the Hermitage. As part of these responsibilities, he supervised tapestry manufacturing and the porcelain and glass factories. There are no Russian records of purchases made by him in the 1790s, but it appears that, during this time, he imported two major works by Claude Lorrain (nos. 5–6). They were acquired through intermediaries from the heirs of Pope Alexander VII, their original owner.

A second period of collecting began for Yusupov when, in 1801, he retired from government service and returned to Paris. Yusupov had always admired equally the work of old masters and new artists. French painting however had changed considerably since Yusupov, as a young man, had first traveled to the capital. Once again demonstrating the breadth of his understanding and intelligence, the prince now began to collect the art of contemporary masters. The Neoclassical canvases of Jacques Louis David and his followers impressed him. But he was also fond of the witty and refined work of the new generation of genre painters, buying compositions by Louis Léopold Boilly (see nos. 20–21) and Jacques François Joseph Swebach, among others. In 1808, he commissioned *Sappho, Phaon, and Cupid* from David (no. 22). He also ordered a large equestrian portrait of his son from Baron Antoine Jean Gros, Napoleon's favorite painter (1809; Pushkin Museum). In 1900, one critic, after having viewed the 130 French pictures Yusupov had collected, exclaimed, "Only the Hermitage, the Louvre, and Potsdam can compete with it."

Returning to Russia in 1811, just before the outbreak of war between France and Russia, Yusupov settled in Moscow, where he spent most of his time at Archangelskoe, his sumptuous estate on the outskirts of the city. Until his death, he continued to add to his collection, commissioning new works from French artists residing in Russia and purchas-

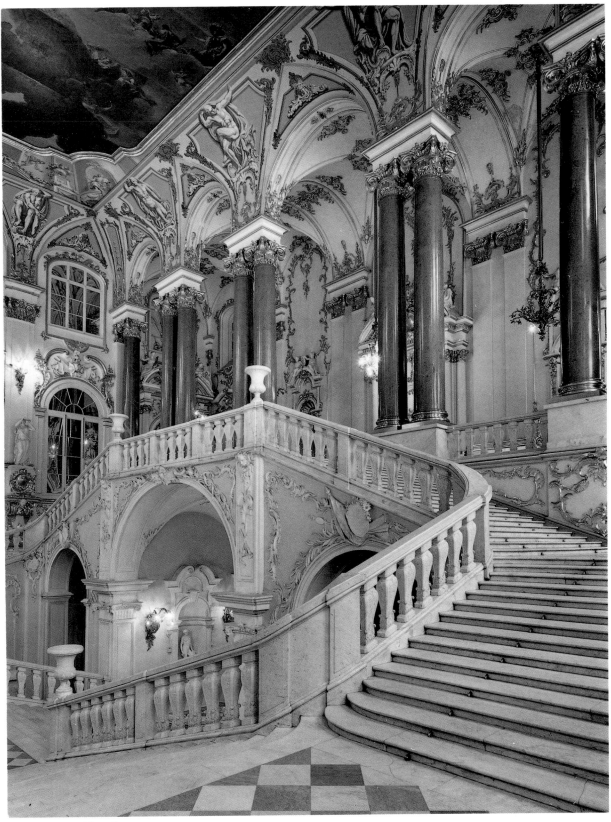

Main Staircase, Hermitage.

Gallery of eighteenth-century French art, Hermitage.

ing examples from other Moscow collectors. Thus, in the early 1820s, he bought François Boucher's masterpiece *Hercules and Omphale* (no. 8) from Prince Mikhail Golitsyn. Yusupov began, but never completed, a catalogue of his collection. With this in mind, he commissioned outline drawings of all his paintings. When these were finished in 1827, they numbered 502 and filled three thick albums. The text was never written however. The albums are still on display at Archangelskoe. One of the principal forces in the artistic life of Moscow, Yusupov was celebrated by Pushkin in his famous poem "To a Nobleman," which he wrote after a visit to Archangelskoe in 1829, when the collector was seventy-eight years old.

After Yusupov's death in 1831, his son moved most of the paintings from Archangelskoe to the family's palace in St. Petersburg. The collection was nationalized in 1918, after the Revolution; and the St. Petersburg residence of the Yusupovs became a museum. In the late 1920s, the collection was divided between the Hermitage, the Museum of Fine Arts in Moscow (later the Pushkin), and Archangelskoe (which became a museum). The collections of French painting in the two larger museums were greatly enhanced by this arrange-

ment. In particular, with Yusupov's masterworks by the Neoclassicists and late eighteenth- and early nineteenth-century genre painters, the Hermitage was able to fill in a major lacuna in its survey of French art.

The last quarter of the eighteenth century was indisputably the high point of early private art collecting in Russia. In addition to Yusupov, many other Russian nobles avidly collected French art during this period. The most popular French painters during the reign of Catherine the Great were Greuze, Vigée Le Brun, Vernet, and Robert. Greuze's *Paralytic* (no. 10), one of the first contemporary French paintings purchased by Catherine, has already been mentioned. Catherine's son, the future Czar Paul I (reigned 1796–1801), vis- ited the artist's studio in Paris in 1786 and commissioned *The Visit of the Priest* (c. 1786; Hermitage). Yusupov's collection had thirteen canvases by Greuze; the Demidoffs had over twenty. *The Spoiled Child* (no. 11) was part of the collection of Catherine's chancellor, Count Aleksandr Bezborodko.

The well-known portrait painter and favorite of Marie Antoinette, Elisabeth Louise Vigée Le Brun spent six of her ten years of exile following the French Revolution in Russia. During that time, she painted dozens of portraits of Russian high society (see no. 18). Consequently today many of her works can be seen in Russian museums. The art of Claude Joseph Vernet and Hubert Robert was highly prized in Russia, gracing many palaces and country estates. Vernet's *Death of Virginie* (no. 15) belonged to Paul I and entered the Hermitage after his death. The Hermitage boasts twenty-six works by Vernet and twice as many by Robert, drawn from various private collections.

In the last years before Catherine's death, almost no additions were made to the Her- mitage collection. But, with the accession of Alexander I (reigned 1801–25), the imperial court once again began to take an active interest in the arts. The new czar felt that art was an important tool in his proposed educational reforms. To demonstrate his support for the arts, he conferred honorary orders on several professors of the Academy. In a letter to Count Stroganov, then its president, Alexander expressed his hope that the practice and appreciation of the arts would be encouraged throughout Russia. Plans to make the Hermitage a public museum were discussed, but nothing finally was done. (The Hermitage was administered by the court, and private citizens were allowed to visit it only by imperial favor. Pushkin, for example, had to seek the help of a friend at court in order to see the collection.)

During the reign of Alexander, the Hermitage holdings were augmented mainly with old master paintings. Increasingly conservative in their taste, the administrators of the Hermitage neglected contemporary work. After the war with France in 1812, all purchases of French painting effectively ceased. It was many years before the traffic in French art resumed in Russia. Except for a short-lived revival in the 1820s, Russian interest in French painting remained low. Russian aristocrats continued to be attracted by French culture, but they were put off by the innovations of Romantics like Théodore Géricault and Eugène Delacroix—artists whose works were controversial even in France. The blunt realism of Gustave Courbet shocked the Russians even more. In the 1860s, however, Russian interest in French painting began to revive. And, by the end of the century, there was keen interest in the collecting of avant-garde works from France, which in itself constituted a lively and exciting chapter in the history of collecting in Russia.

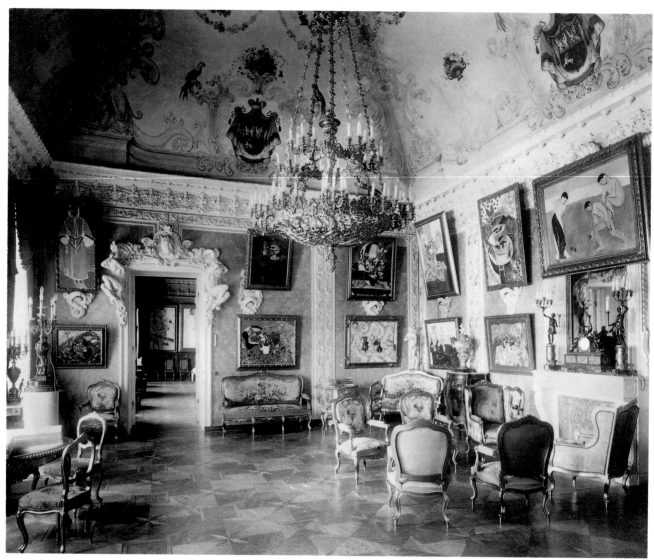

Salon of Sergei Shchukin, Moscow, c. 1914, featuring works by Henri Matisse.

Shchukin and Morozov

ALBERT G. KOSTENEVICH, CHIEF CURATOR
MODERN EUROPEAN PAINTING
STATE HERMITAGE MUSEUM, LENINGRAD

Several outstanding collections of modern French painting were assembled in Russia in the early part of this century. As described in the previous essay, a long tradition of artistic exchange existed between France and Russia. But the acquisition of works by Monet, Renoir, Gauguin, and Cézanne, rather than of the art of the established French Salon painters, was made by collectors who meant to break with tradition rather than follow it. They were collectors, that is, whose sense of tradition was different, more profound, than that of their predecessors.

When one recalls the exciting cultural life of Russian cities at the beginning of the twentieth century, it is not surprising that Russian intellectuals reacted with enthusiasm to cultural innovation at home and abroad. In 1912, the organizers of a huge exhibition in St. Petersburg, "One Hundred Years of French Painting," said of the show, "It was the first exhibition outside of France that represented the development of French art over the last century. . . . It did not focus our attention on established academic or salon painters, who have often enjoyed in Russia a greater reputation than they have deserved. It focused rather on painters who are leaders, artists who, in their time, opened new paths and still managed to preserve the wonderful old traditions of the French School."[1]

The history of the Russian collecting of French paintings falls into two distinct periods. The first, associated with St. Petersburg, reflects the tastes and interests of the imperial court and extends from the beginning of the eighteenth to the middle of the nineteenth century. The second period, from the late nineteenth into the early twentieth century, was centered in Moscow. Its leading figures were not aristocrats but entrepreneurs.

As might be expected, the new art of the Impressionists and their successors was collected not by members of aristocracy, but by the wealthy sons of more ordinary people, even the grandsons of serfs. These were men of a new type, who envisioned for their country major industrial and economic changes. In Moscow, in the second half of the nineteenth century, there arose, among merchants and industrialists, a handful of philanthropists whose enthusiasm for collecting art turned into a lifelong preoccupation. The Tretyakovs, a rich Moscow merchant family which immortalized itself by creating the Tretyakov Gallery of Russian Art, and later the Shchukins and Morozovs acted out of a conviction that they were, by buying art, rendering a service to Russian society. They loved art, but this passion went hand in hand with a businessman's initiative and thoroughness.

It was natural that Moscow should be the center of activity for these men. The mercantile class in St. Petersburg had too much reverence for the tastes and fashions of the aristocracy; not one independent, innovative collector appeared in that city. The merchants of Moscow, on the other hand, were more single-minded, more democratic, more genuinely interested in contacts with scholars and artists. Beginning in the mid-nineteenth century, the city's businessmen held regular gatherings in their homes to which they invited

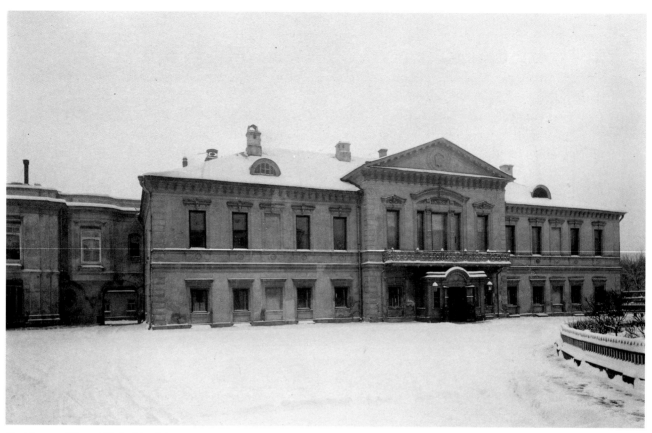

Residence of Sergei Shchukin, Moscow.

artists, musicians, and scholars. In 1881, the St. Petersburg writer P. B. Boborykin, a keen observer of his times, wrote in "Letters from Moscow" that "mercantile and industrial Moscow is beginning to serve as the subsoil of an intellectual kingdom."[2] That same year, P. M. Tretyakov, who had earlier opened his home to lovers of art, made access to his gallery free to all. And only ten years later, Sergei Ivanovich Shchukin (1854–1936), certainly inspired by the example of Tretyakov, embarked on his career as an art collector.

Shchukin belonged to a merchant family that was old by Russian standards. The Shchukins had been active in Moscow since the second half of the eighteenth century. In the mid-nineteenth century, Ivan Shchukin, Sergei's father, established himself in the business world of Moscow as a mogul in the textile trade. For the most part, he lived simply. But he had a box at the Bolshoi Theater and did everything possible to give his eleven children a good education. His sons studied in St. Petersburg and in Finland. Only his third son, Sergei, who stuttered badly, was tutored at home. The relative solitude in which Sergei passed his childhood and early youth had a great effect on him. His stuttering may have made him more daring. He grew up to be a man capable of decision, one who could stand up to tradition when necessary. He never mastered his speech defect, but he was prepared to take on the world.

When Sergei turned nineteen, his father took him to Germany to find a cure for his stuttering. While not ultimately successful, the treatment he received nevertheless

improved the young man's condition enough to allow him to enter the commercial high school in Gera. Sergei went from there to France and, when he returned to Moscow in 1878, began to assist his father in the family business, Shchukin and Sons. He turned out to be a much better businessman than his brothers and became head of the firm when his father died.

Sergei Shchukin's skilled management of manufacturing enterprises and his sensitivity to trends in foreign and domestic markets made him an important figure in financial circles. His personal security was clinched by the decisive action he took at the height of the general strike of 1905; he bought up all available manufactured goods which, when relative tranquility had returned to Russia, he sold at high prices. For this kind of boldness, he was nicknamed "Minister of Finance." In 1912, he became the Elder of the Moscow Merchant Guild.

In becoming an art collector, Shchukin was, to some extent, following family tradition. Three of his five brothers were leading art collectors, each with his own specialty. Sergei did not, at first, buy with the idea of establishing a collection. He simply wanted to furnish and decorate his home. But once he experienced the remarkable energy and innovation he found in studios, salons, and galleries, he began to collect art in the same way he had bought up manufactured goods, on a grand scale.

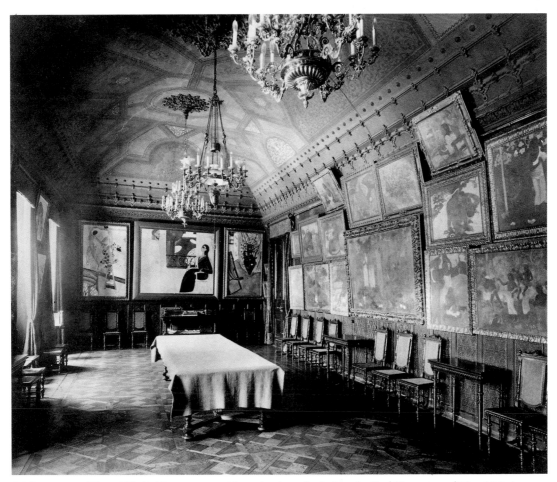

Dining room of Sergei Shchukin, c. 1914, with a selection of paintings by Paul Gauguin and Henri Matisse.

Sergei Ivanovich Shchukin (1854-1936).

Shchukin probably began collecting around 1890. At first, he limited himself to works by Russian artists. In the mid-1890s, however, he sold them. He knew he could not compete with Tretyakov in this field, and, for Shchukin, as for his predecessors in the period 1860–80, competition was an important aspect of art collecting. Shchukin's business dealings often took him to Paris, where he made his first purchases of French art. He did not frequent the Salon des Indépendants but rather visited the more respectable Salon, where he was intrigued by the landscapes of the Norwegian Fritz Thaulow, a painter favored by high-society clientele. Shchukin subsequently bought landscapes by Charles Cottet, Charles Guilloux, and Fernand Maglin.

So far, he had taken no bold steps, nor does he seem to have spent much money. He bought what he liked, and what he liked did not differ much from most people's taste at the time. Though his first selections were conservative in nature, Shchukin was being particularly cautious. He was by nature a touchy man, an autodidact who disregarded the advice of other people. He made mistakes in his early years of purchasing, but he was learning.

In 1897, Shchukin bought his first masterpiece, Claude Monet's *Lilacs of Argenteuil* (1873; Pushkin Museum), from the Galerie Durand-Ruel in Paris. Monet soon became his favorite painter. But Shchukin did not really understand the language of the new artists, for he did not always select the best canvases. He collected the Symbolist paintings of Emil René Ménard and Gaston de la Touche, painters whose works were more about literature than they were about art. But Shchukin continued his apprenticeship, and he learned quickly. At this time, the best collectors, those whose choices proved most insightful, had

begun to understand that it was the formal qualities of a work that were most important. Once Shchukin began to appreciate that fact, he proceeded with such single-mindedness that it is possible to recognize a "Shchukin type of painting."

From Monet, he moved on to Gauguin, van Gogh, Cézanne, and then to Matisse and Picasso. Not only did he alter and refine his view of what was good in painting, but he had a new sense of his mission as a collector: He wanted to build for Moscow a gallery containing the most influential and daring European art of the period. Shchukin became bolder and more prophetic each year. He began buying the works of Paul Gauguin and Paul Cézanne in 1903, long before these artists had achieved any widespread recognition. In 1904, he discovered Henri Matisse. He was determined to understand these painters and their works, wanting to be the best collector possible and hoping to expose his fellow Russians to the exciting art from abroad.

In 1908, before Shchukin's gallery had taken shape and before he had displayed his most innovative discoveries, the prominent critic P. P. Muratov wrote:

> S. I. Shchukin's painting gallery in Moscow is one of the most remarkable art collections in Russia. It has long enjoyed renown among artists and connoisseurs. In addition, it has exerted a decisive influence on recent Russian painting. Shchukin's gallery is destined to become the main purveyor of Western art trends in Russia, trends reflected so clearly in the works of Monet, Degas, Cézanne, and Gauguin.[3]

Once he had discovered the Impressionists, Shchukin did not buy much painting from other schools; he was not aiming to be comprehensive. Quite simply, he bought masterpieces. His selection of thirteen canvases by Monet begins chronologically with *Luncheon on the Grass* (1866; Pushkin Museum) and ends with *The Sea Gulls* (1904; Hermitage). Among his six Degas are *Dancer Posing for the Photographer* (1875; Hermitage) and *Dancers in Blue* (c. 1899; Pushkin Museum). Less attracted to Renoir, he bought two paintings by the artist that share common technical goals: *Lady in Black* (c. 1876; Hermitage) and *Girls in Black* (no. 27). He obtained his third and best Renoir, *Anna* (c. 1876; Hermitage), from his elder brother Pyotr. In 1899, Pyotr Shchukin, who specialized in Russian art, had bought a small group of Impressionist canvases at the Galerie Durand-Ruel, Paris, which he sold in 1912, shortly before his death, to Sergei, whose gallery he knew was the proper place for them.

But Shchukin did not limit himself only to the Impressionists. With remarkable foresight, he purchased a number of canvases that are now regarded as early twentieth-century masterworks. He had sent to Russia Vincent van Gogh's *Women of Arles (Reminiscences of the Garden at Etten)* (1888; Hermitage) and *Lilac Bush* (1889; Hermitage), two of the artist's greatest canvases of that time. His collection of sixteen works by Gauguin (see nos. 34, 36) was undoubtedly the best in the world at the beginning of the century. It was rumored that Shchukin paid 100,000 francs for one of his Gauguins, probably in the early 1910s, when the artist's work became expensive. But the Shchukin archive is lost, and there is no extant documentation on such purchases.

Yakov Tugendhold, one of the first historians of the collection, described it thus:

> "You enter a Gothic cathedral and see a painting on the wall. But you are so distant from it that you cannot make out what it depicts—and nevertheless you are captivated

by a major chord—this is the music of the painting," Gauguin once wrote (*Notes éparses*). I recall these words every time I enter Shchukin's gallery and my still uninformed gaze catches sight of a Gauguin canvas. It is strange how far he was from the thought that, one day, his Tahitian paintings would turn up in Moscow. How aptly his words describe Shchukin's walls and his hanging of the paintings. In them, the owner's taste is reflected. The pictures are placed close together, and at first you do not even notice where one ends and the next one begins. It is as if you have one huge fresco before you—an iconostasis.[4]

Shchukin knew that the paintings he bought stretched the boundaries of art and that, by acquiring them, he was risking his reputation. The artist Leonid Pasternak, father of the poet and novelist Boris, recalled, "Once [I was] at Shchukin's place. 'I'll show you something,' he said. Opening slightly a heavy drapery, he took out his first Gauguin (a Mauritanian Venus with a fan). Laughing and stuttering, Shchukin said, 'A ma..ma..madman painted it and a ma..ma..madman bought it.'"[5]

What seemed to others shocking or bizarre was, for Shchukin, the logical extension of universal principles dating back to the ancients. "In Paris," Matisse recalled later, "Shchukin's favorite pastime was to visit the Egyptian antiquities in the Louvre, where he found parallels with Cézanne's peasants."[6] Shchukin felt that his Cézannes were so great, so universal, that they could be compared with any famous works from antiquity. Among his eight Cézannes were a *Self-Portrait* (early 1880s; Pushkin Museum), *Mardi Gras* (1888; Pushkin Museum), *The Smoker* (no. 29), *Mont Sainte-Victoire* (no. 33), and *Lady in Blue* (c. 1900; Hermitage).

Shchukin was also an early admirer of Matisse. He understood Matisse's future importance well in advance of most others. For his main dining room, whose longest wall was dedicated to Gauguin, he bought Matisse's *Harmony in Red* (1908–1909; Hermitage). Later he hung *Conversation* (no. 43) there, as well. An entire hall was set aside for his works by Matisse. At Shchukin's invitation, Matisse came to Russia in the fall of 1911. By that time, Shchukin had acquired twenty-five works by the master; two years later, he had a dozen more. Most of them, including *Game of Bowls* (no. 41), *Nymph and Satyr* (no. 42), *Still Life with a Blue Tablecloth* (no. 47), *Conversation* (no. 43), *Family Portrait* (1911; Hermitage), *Madame Matisse* (no. 50), and *Arab Coffeehouse* (1912–13; Pushkin Museum), are major monuments of twentieth-century Western art. But certainly the most important works by Matisse collected by Shchukin are the large-scale panels *Dance* and *Music* (1909–10 and 1910; Hermitage), quintessential expressions of Fauvism.

In the final stage of his collecting career, Shchukin focused his attention on André Derain and Pablo Picasso. He had no Picassos when he first met this artist, through Matisse, in 1908. Six years later, he owned fifty-one. At first, Shchukin could not comprehend how the Spanish artist, after the striking work he had created in his Blue and Rose periods, could turn to Cubism. But once he understood Picasso's new direction, he did not allow the perplexity and outrage of others to stand in his way. Among his many Cubist works by the artist are *Nude with Drapery* (1907), *Still Life with Skull* (1907), *Woman with a Fan* (1908), *The Dryad* (1908), *Three Women* (1908), and *Musical Instruments* (1912), all of which are in the Hermitage.

Shchukin's intense buying sprees were not caused simply by changes in his own taste.

He wanted paintings of quality, but he knew he could not get too far ahead of the general public in his enthusiasms. He wanted his acquisitions to exert an active influence on Russian artistic consciousness. His home became a meeting place for Moscow artists and, by 1909, was open on Sundays to all who were interested in seeing new work. Shchukin himself often acted as a guide to his collection, and his explanations dazzled the young artists enrolled in the School of Painting, Sculpture, and Architecture, Moscow. They included Gontcharova, Larionov, Malevich, Saryan, and Tatlin, all of whom were to become important figures in the Russian avant-garde.

Ivan Abramovich Morozov (1871–1921) began to collect art later than Shchukin, but his achievements were just as outstanding. Morozov's ancestors were serfs who bought their freedom at the beginning of the nineteenth century. Ivan's great-grandfather had a silk-ribbon factory which he ran so successfully that, by the end of the century, his large family had become one of the most powerful industrial merchant dynasties in Russia. Ivan and his elder brother, Mikhail, lost their father as children; they were raised by their mother in a home where art was revered and where the leading members of the Moscow intelligentsia gathered. For two years, the Morozov brothers studied painting with the prominent Russian Impressionist K. A. Korovin. Ivan continued to paint landscapes late in his life. The brothers, only a year apart in age, were very different in character. Mikhail was a free spirit, a caustic journalist and an erudite historian who became notorious for extreme behavior such as an extraordinary gambling escapade in which he lost over a million rubles. In

Ivan Abramovich Morozov (1871-1921).

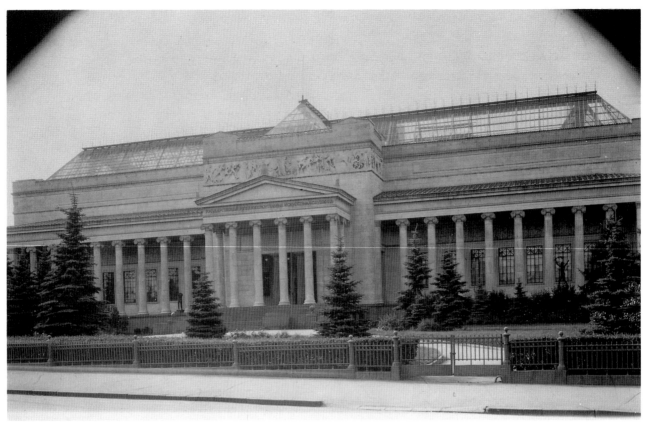

Pushkin State Museum of Fine Arts, Moscow.

the 1890s, the best Russian artists—Korovin, Pasternak, Serov, Vrubel—frequented his Moscow mansion.

Mikhail's excellent collection of Russian paintings later went to the Tretyakov Gallery. He bought foreign paintings, as well. He was the only Russian who acquired work by the Norwegian Edvard Munch and the Spaniard Anglada-Camarosa. And at the center of his collection were examples by French masters—Degas, Gauguin, Manet, Monet, and Toulouse-Lautrec. He also owned Renoir's large *Portrait of Jeanne Samary* (1878; Hermitage). And he was the first Russian to appreciate the Nabis, particularly Pierre Bonnard and Maurice Denis. Mikhail died in 1903, at the age of 33. But, by that time, he had exerted considerable influence over his brother, Ivan, who began to assemble his own collection with even greater enthusiasm.

It says something about Ivan Morozov's taste that his first Impressionist painting was by Alfred Sisley. While Shchukin considered this artist an imitator of Monet and owned only one work by him, Morozov liked the refined and restrained quality of his art. Unlike Shchukin, he was not looking for what was the most avant-garde or shocking. Morozov also admired Bonnard, considering him "his kind of artist." He was later to commission a large triptych, *Mediterranean* (1911; Hermitage), from the artist for the staircase of his home. That was complemented by a second ensemble of decorative panels, *First Day of Spring in the Country* and *Autumn: Picking Fruit* (1912; Pushkin Museum). They were followed by yet

another sequence commissioned from Bonnard, *Morning in Paris* and *Evening in Paris* (both 1911; both in the Hermitage).

In general, though he was much younger than Shchukin and began collecting later, Morozov was the more cautious, or at least conservative, of the two. Even when buying examples of Impressionism, he liked to consult with Russian artists whose work he knew and collected, such as Korovin, V. A. Serov, and S. A. Vinogradov. But, by 1907, Morozov had begun to purchase examples by many of the same artists who interested Shchukin. He brought back five Monet landscapes from Paris in 1908. From the Galerie Durand-Ruel, he selected *Garden at Montgeron* (1876–77), *Haystack at Giverny* (1899), and *Waterloo Bridge* (1903), all in the Hermitage. The dealer Ambroise Vollard became his major source. Through Vollard, he acquired Renoir's *Bathing in the Seine* (1869; Pushkin Museum) and later *Child with a Crop* (1885; Hermitage). He also owned, by this artist, *Girl with a Fan* (1881; Hermitage) and *Under the Trees* (no. 26). These constituted the core of a unique collection of works by Renoir.

In 1907–1908, he bought eight of Gauguin's greatest works from Vollard, including *Café at Arles* (1888); *The Discussion* (1891), *At the Foot of the Mountain* (1893), and *The Miraculous Source* (1894) (all now in the Hermitage except the first, which is in the Pushkin Museum). Together with *Landscape with Peacocks* (1892) and *The Great Buddha* (1899) (both in the Pushkin Museum), they show Gauguin's remarkable artistic development.

At about the same time, Morozov obtained his first works by Cézanne, *Girl at the Piano* (1868–69), *Tall Pine near Aix* (1895–97) (both in the Hermitage), *Still Life with Curtain* (no. 31), and *Mont Sainte-Victoire* (no. 32). Morozov was one of many visitors to the memorial exhibition for Cézanne at the Salon d'Automne of 1907 on whom the show had enormous impact (a copy of the catalogue with his annotations still exists). He told the French critic Félix Fénéon that he ranked Cézanne first among painters, adding that he could prove Cézanne was a genius from the paintings in his own collection.[7] At the time, Morozov's eighteen Cézannes, chosen with great taste and enthusiasm, may have been the best selection anywhere of the artist's work.

Morozov's patience and care were legendary. The Russian critic Sergei Makovsky wrote in 1912:

> I remember that, on one of my first visits to his gallery, I was amazed to see an empty spot on a wall completely covered by Cézannes. "That spot is for a blue Cézanne [landscape from the artist's last period]," Morozov explained. "I've been looking for one for a long time but can't settle on one."

> This spot for the Cézanne remained empty for more than one year; and, only recently, a magnificent new "blue" landscape, selected from dozens of others, took its rightful place on the wall. It is this conscious and systematic good taste which gives Morozov's collection that noble character of distinction and wholeness so often lacking in collections of modern painting, including those in museums.[8]

In a decade of active collecting, Morozov's views underwent an evolution, though not so dramatic as those of Shchukin. In every respect, Morozov's taste was less adventurous than Shchukin's. His Matisses, mainly early still lifes, are calmer; his *Still Life with "Dance"* (no. 44) is composed with an almost Cézanne-like balance. Morozov was close to Albert Mar-

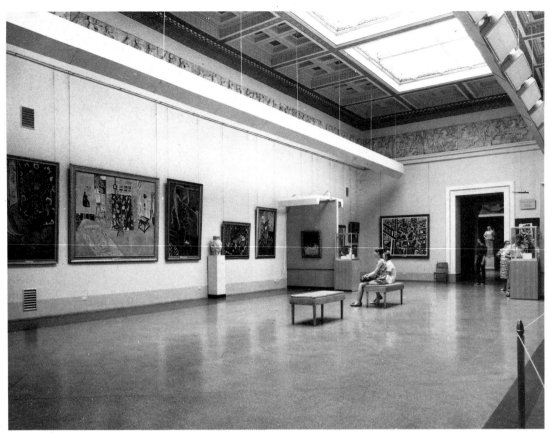

Gallery of paintings by Henri Matisse and other modern masters, Pushkin Museum.

quet and owned several of his finest works, such as *Harbor of Naples* (1909) and *Notre Dame in the Rain* (1910), both in the Hermitage. Morozov also admired less well-known painters such as Louis Valtat, Henri Charles Manguin, and Othon Friesz. B. N. Ternovetz, curator of the Morozov collection after its nationalization, wrote:

> Unlike Shchukin, Morozov was always cautious and strict in his selection of paintings. He feared everything rough, unestablished, and impetuous, preferring peaceful searches in the deposits of Vollard's warehouse. Shchukin, by contrast, had the temperament of a wanderer, which led him to previously unknown shores. Morozov was methodical in nature and had a clear plan for his collection. He put [it] together masterpiece by masterpiece, as if he were stringing a necklace.[9]

Both Morozov and Shchukin encouraged the arts in Russia in every possible way. They commissioned artists directly and remained in constant contact with them. Both encouraged active participation in artistic life and made their collections accessible to citizens of Moscow. The two collectors were aware that they were involved in a common enterprise and (possibly because their tastes were different) did not often directly compete with one another. They considered their galleries national treasures.

World War I put an emphatic end to the activities of Shchukin and Morozov. Shortly after the October Revolution, both their collections were nationalized. In 1918, they were

reestablished as the First and Second Museums of Modern Western Painting in Moscow (the Second Museum actually opened the following year), and were then, five years later, merged as the State Museum of Modern Western Art. Other private collections were brought into this institution, the first of its type in the world, but none was as exceptional as those of Shchukin and Morozov. Nationalization was typical of the Revolutionary epoch, and made it possible to keep priceless treasures inside Russia, as well as to protect them during a difficult period.

Shchukin and Morozov both emigrated, and their lives ended while living abroad. Surely they had mixed feelings about their fate. They were treated unceremoniously; yet, by making their collections the property of the entire nation, the Soviet state acknowledged the supreme artistic value of the works they had collected. It is significant that Shchukin, even after he left Russia, continued to declare, "I collected not only for myself but for my country and for the great Russian people."[10]

The Museum of Modern Western Art remained in existence until 1948. Its closing reflected the post-war hostility of the cultural leaders at that time toward avant-garde art. But the rationale for an independent museum had ceased to be appropriate by mid-century. The museum's collection was not growing, and it became a less and less accurate reflection of "modern Western art," even though the history of European art from Impressionism to Cubism was demonstrated there better than anywhere else. "Modern" art was no longer the last word but rather a chapter in the history of humankind, a link in a chain. It made sense to join old and new in larger museums designed to show the developments that led to the work of the remarkable painters of the turn of the century. The holdings of the museum were divided between the Pushkin Museum in Moscow and the Hermitage in Leningrad. Once the subjects of bitter arguments and attacks, these modernist works finally took their place among the classical masterpieces from which they naturally follow.

NOTES

1. N. Wrengel and S. Makovsky, "Introduction," *One Hundred Years of French Painting (1812–1912)*, exh. cat. org. by *Apollon* and the Institut français of St. Petersburg (St. Petersburg, 1912), p. 13 (in Russian).
2. P. B. Boborykin, "Letters from Moscow," *European Herald* 3 (1881) (in Russian).
3. P. P. Muratov, "Shchukin's Gallery, Essay on the History of the Most Modern Painting," *Russian Idea* 8 (1908), p. 116 (in Russian).
4. Y. Tugendhold, "The French Paintings of S. I. Shchukin," *Apollon* (1914), p. 18 (in Russian).
5. L. O. Pasternak, *Notes of Different Years* (Moscow, 1975), p. 63 (in Russian).
6. H. Matisse, *Ecrits et propos sur l'art* (Paris, 1972), p. 118.
7. F. Fénéon, "Quelques Grands Collectionneurs: Ivan Morosoff," *Bulletin de la vie artistique* (May 15, 1920), p. 356.
8. S. Makovsky, "French Paintings in the Collection of I. A. Morozov," *Apollon* (1912), pp. 5–6 (in Russian).
9. B. N. Ternovetz, *Letters, Diaries, Articles* (Moscow, 1977), p. 119 (in Russian).
10. P. A. Buryshkin, *Mercantile Moscow* (New York, 1954), p. 142.

Note to the Reader

The catalogue entries were written by members of the curatorial staffs of the Pushkin and the Hermitage museums:

A. B.	A. Babin
M. B.	M. Bessonova
E. D.	E. Deryabina
A. K.	A. Kostenevich
N. S.	N. Serebryannaya

Background material was added, where deemed necessary for American audiences, by the editors. Documentation for each painting can be found beginning on page 153.

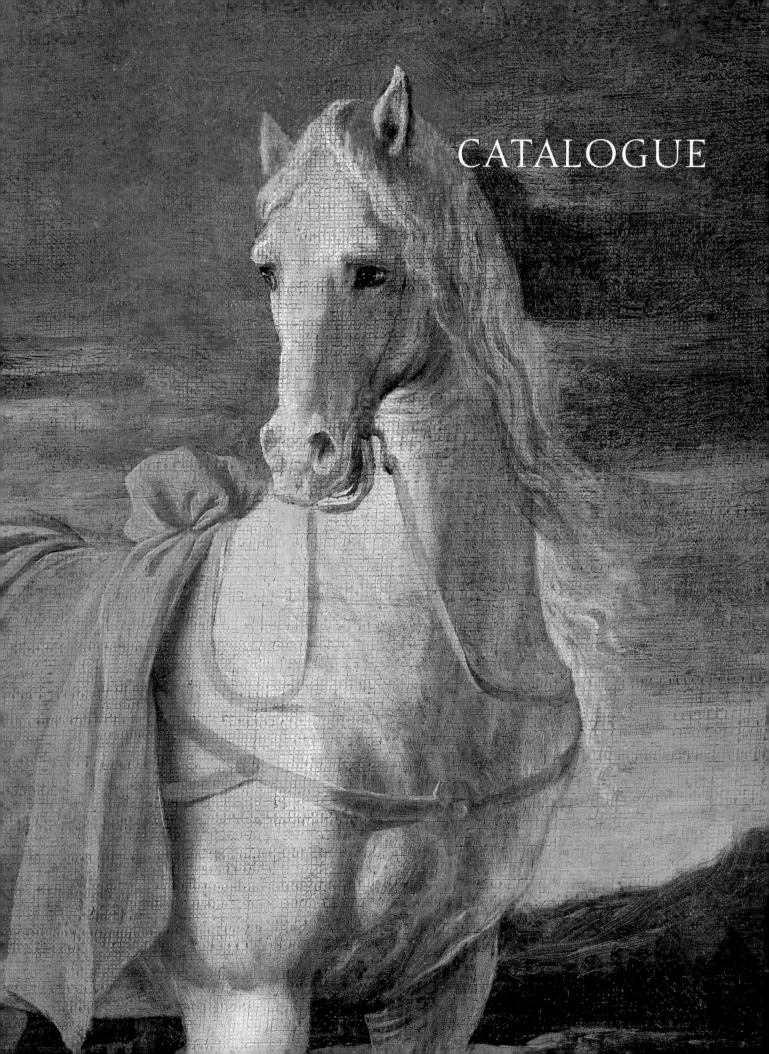

CATALOGUE

NICOLAS POUSSIN

1594 Les Andelys — Rome 1665

Born to a peasant family, Poussin was trained first in Rouen and then in Paris. By 1624, he was in Rome, where he remained until his death, returning to France only once (1740–42), to fulfill a commission for Louis XIII. While he counted such Italians as Cardinal Francesco Barberini among his patrons, he worked mainly for a sophisticated French clientele, including Cardinal Richelieu. He devoted himself to the painting of elevated historical, mythological, and biblical subjects, characterized by classical balance, intellectual strength, and moral probity. His influence on subsequent French painting was immense.

1. *Victory of Joshua over the Amorites*, c. 1625/26

Oil on canvas, 94 × 134 cm
Moscow, Pushkin Museum, Inv. no. 1046

2. *Victory of Joshua over the Amalekites*, c. 1625/26

Oil on canvas, 97.5 × 134 cm
Leningrad, Hermitage, Inv. no. 1195

POUSSIN WENT TO ROME in 1624 with letters of introduction from the poet Giambattista Marino that would gain him access to Cardinal Barberini. The cardinal however was away from the city from March 1625 to the fall of the following year. Without a patron, Poussin pursued his own interests. It is evident from the theme of this pair of paintings, *Victory of Joshua over the Amorites* (no. 1) and *Victory of Joshua over the Amalekites* (no. 2), that the artist spent his first years in Italy completing work he had conceived earlier. At the same time, of course, he discovered the art of Rome.

The battle shown in *Victory of Joshua over the Amorites* is related in Joshua 10: 12–14. The Israelites, under Joshua's command, were fighting the Amorites. God ordered hail to rain down on the Amorites, giving the leader and his army the chance to continue the battle and to triumph. Here Poussin depicted the fierceness of combat with unusual directness. The warriors, modeled in strong chiaroscuro, throw themselves forcefully onto one another. At the apex of a triangle composed of dead, wounded, and struggling figures and horses rides Joshua, resolutely directing his men.

The second painting recounts a battle described in Exodus 17: 8–13. When the Amalekites attacked Israel, Moses urged Joshua to lead the defense while he, Aaron, and Hur went to the top of a hill to enlist God's help. Whenever Moses raised his arms, Israel had the advantage, and when he lowered them, the Amalekites did. As he tired, Aaron and Hur held up his arms, so that Joshua would be victorious. Above the melee can be seen the small figures of Moses and his companions, who support their leader's uplifted arms. Just below is the dashing figure of Joshua, helmeted and seated on his horse, gesturing compassionately toward his embattled troops.

Poussin had been interested in depicting battle scenes for some time. Before leaving Paris, he did several drawings of battles which are now in the royal collection at Windsor

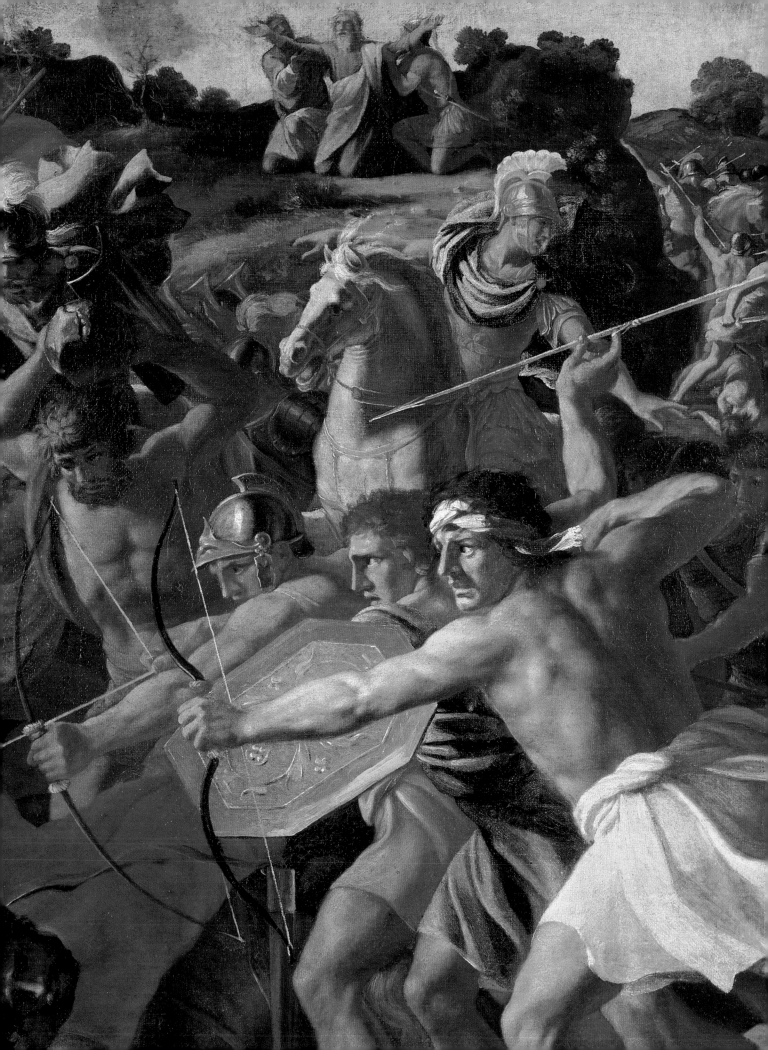

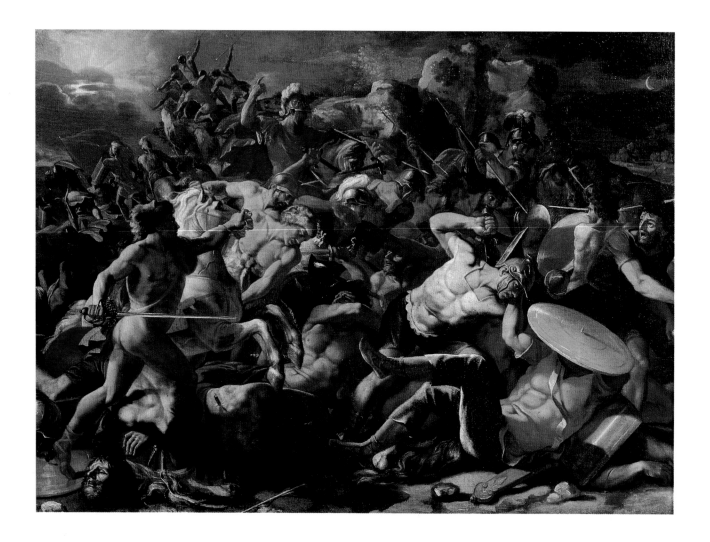

Castle; these are similar to illustrations he did in 1622/23 for Marino. None of these draw-
ings is a study for the paintings of Joshua's battles, but they demonstrate that he had such
subjects in mind. Based on these drawings, Blunt (1967) believed that Poussin originally
planned to do a more extended series of battles. A painting in the Vatican of *Gideon's Battle
with the Midianites*, attributed to Poussin, is the same size as the Hermitage painting and is
close in style, although some scholars doubt that it is by Poussin. A drawing in the Fitzwil-
liam Museum, Cambridge, England, may either be a preparatory sketch or a copy of the
Amorites composition.

The influence of Mannerist painting in both works indicates that Poussin was working
out ideas that had long interested him. The figure of the nude warrior in the *Amorites* and
the group at the right of the *Amalekites* are inspired by Polidoro da Caravaggio's *Perseus and
Phinias* (Paris, Musée du Louvre). The man about to throw a stone in the *Amalekites*
strongly resembles a figure in Giulio Romano's *Martyrdom of Saint Stephen* (Genoa, S.

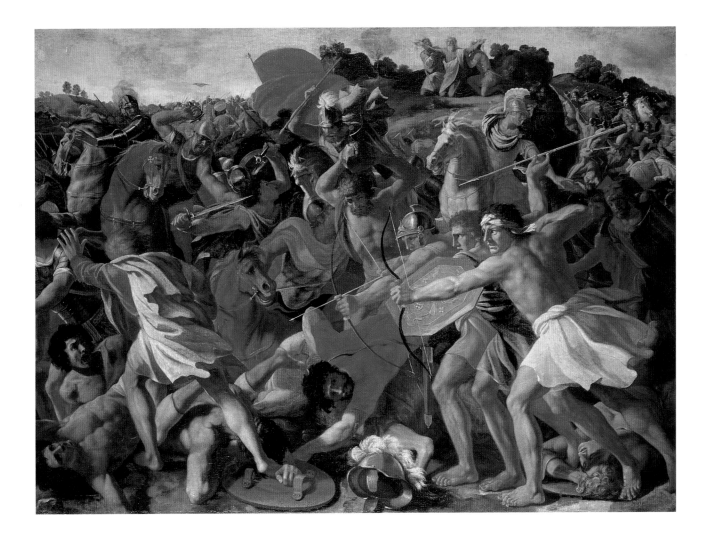

Stefano). Spatially the composition of the *Amorites* opens from bottom to top in a manner recalling the style of the School of Fontainebleau. In both paintings, the tumble of almost palpable muscular bodies depicted close to the picture plane shows that the artist was familiar with the dense figural compositions typical of the bas-reliefs on Roman sarcophagi. He also clearly knew Raphael's frescoes in the loggias of the Vatican. On the other hand, it is possible that Poussin could have been familiar with this body of work while still in Paris, through the prints of Etienne Delaulne and Antonio Tempesta.

Some scholars believe that the two paintings were completed before the artist left Paris, since their strong Mannerist feeling does not seem to indicate the influence of painting in Venice, a city Poussin seems to have visited on his way to Rome. Poussin's early biographers, Bellori and Félibien (both 1725), however, both noted that Poussin himself mentioned two battle scenes that he completed during Barberini's absence from Rome, in other words, in 1625/26. N.S.

3. *Tancred and Erminia*, c. 1630/31

Oil on canvas, 98 × 147 cm
Leningrad, Hermitage, Inv. no. 1189

THE STORY DEPICTED IN THIS PAINTING, of the crusader knight Tancred and his beloved Erminia, princess of Antioch, was told by Torquato Tasso in his epic poem *Gerusalemme liberata* (XIX:19). In combat with the infidel Argante, Tancred is victorious but is critically wounded. The distraught Erminia decides to sacrifice her magical hair to bind Tancred's wound, thus saving his life. She is clearly acting impulsively, out of desperation. Near death, Tancred appears unmoved, perhaps unaware even of the presence of Erminia and his devoted servant, Vafrin.

In this painting, Poussin stripped the subject of extraneous detail, focusing on the central, standing figure of Erminia. A stream of light, like a spotlight, calls attention to her dilemma and her resolve. By her act of sacrifice, Erminia acknowledges her love for Tancred. Framing this expressive group are two horses, their poses reversing one another. The powerful white horse to the right seems alarmed by what is going on, staring directly at Erminia. Poussin's twilight setting intensifies the dramatic mood. The warm colors, the gold reflections on the chain mail, and the richly saturated shadows reflect Poussin's interest in sixteenth-century Venetian painting.

After some hesitation, Blunt (1966) dated the Hermitage picture to 1631/33. Mahon (1962) placed it after *The Plague of Ashod* (Paris, Musée du Louvre) and *The Kingdom of Flora* (Dresden, Staatliche Gemäldegalerie), documented in 1631. The most likely date is 1630/31.

There is another version of the same subject in the Barber Institute of Fine Arts, Birmingham, which emphasizes the heroic aspect of Erminia's act rather than her emotional state. It is more severe in style, with the figures modeled in sharp relief. While there is some debate as to which of the two versions is earlier, the weightier composition of the Birmingham picture is typical of Poussin's earlier works.

Interestingly the picture was not engraved or mentioned in the seventeenth century, a situation that applies to several paintings by Poussin treated in a similarly poetic manner. E. Kochina suggested (verbally to author) that this relative neglect may be related to the taste of the period. N.S.

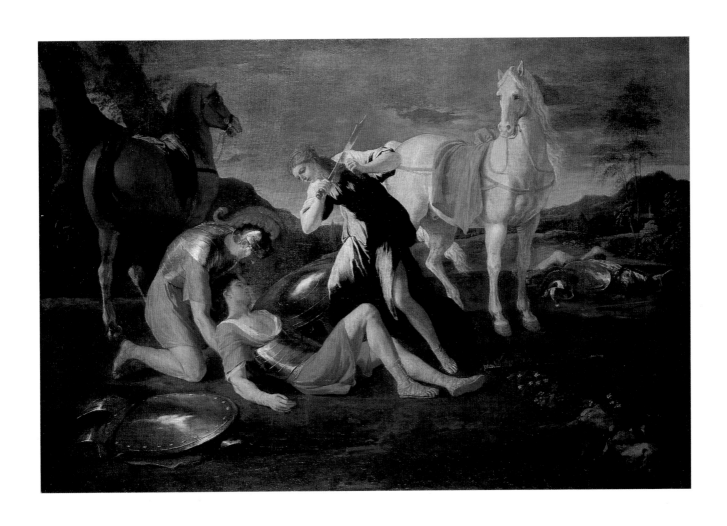

4. *The Holy Family with Saints Elizabeth and John the Baptist*, 1655

Oil on canvas, 174 × 134 cm
Leningrad, Hermitage, Inv. no. 1213

IN THE IMPOSING CHARACTER AND CLARITY of its interwoven figures, this painting has as its point of departure Raphael's late images of holy families. Yet, as Thuillier (1974) pointed out, Poussin moved beyond Raphael to seek even greater monumentality in late works such as this. Indeed the figures have the almost architectonic balance and calm grandeur of gesture that give Poussin's work from the mid-1650s on its characteristically austere serenity.

The painting's date, 1655, derives from its identification with the "great Virgin" made for Paul Fréart de Chantelou. He was one of Poussin's most important patrons, owning a significant group of paintings by the artist. The idea for such a picture was first mentioned in correspondence between Chantelou and Poussin in 1647, the year Chantelou became one of the *maîtres d'hôtel* to the young King Louis XIV. In the intervening years, the project for the picture is frequently mentioned in correspondence between Chantelou and Poussin. It was not completed and sent to the collector until 1655.

A related painting from about the same time is the *Holy Family with Saint John the Baptist* (Sarasota, Ringling Museum). The Hermitage has two drawings that are preparatory to the Leningrad and Sarasota paintings. Blunt (1966) noted the existence of three copies of a similar composition. N.S.

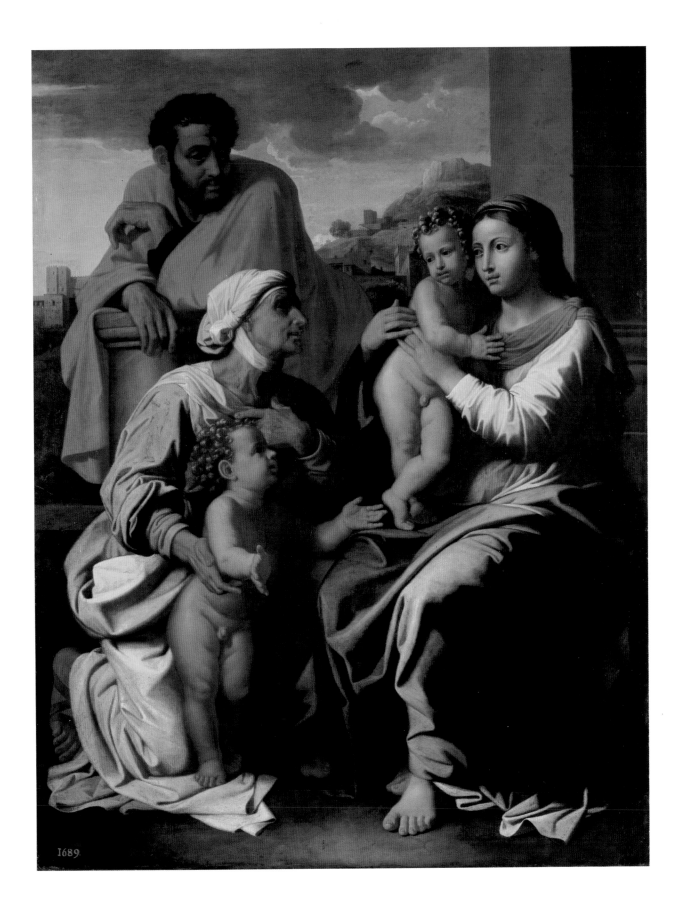

1689.

CLAUDE GELLÉE, CALLED CLAUDE LORRAIN

1600 Chamagne — Rome 1682

Claude first went to Italy as a youth, in about 1613, and settled there by 1627. He devoted himself to landscape painting, incorporating pastoral, mythological, and religious subjects into his ideal landscapes. His early work was influenced by Agostino Tassi and Adam Elsheimer. He rapidly developed the balanced compositions and serene light that were the hallmarks of his style. His work was sought after by some of the most discerning collectors of his day, in Italy and elsewhere. Because his paintings were widely imitated, beginning in the mid-1630s, he made drawn copies of all his works in an album known as the Liber Veritatis.

5. *Landscape with Battle on a Bridge*, 1655

Oil on canvas, 100 × 137 cm
Signed and dated, lower right: *CLAVDIO IV 1655*
Moscow, Pushkin Museum, Inv. no. 1283

6. *Landscape with the Rape of Europa*, 1655

Oil on canvas, 100 × 137 cm
Signed and dated, lower right: *CLAVDIO IV ROMAE 1655*
Moscow, Pushkin Museum, Inv. no. 916

CLAUDE OFTEN PAINTED paired landscape compositions that complement each other and were conceived as a whole. *Landscape with Battle on a Bridge* and its pendant, *Landscape with the Rape of Europa*, share the same dimensions, a common horizon line, and a coordinated massing of their compositional elements. Both feature the same magnificent smooth sea, shining sky, and powerful trees. Claude's drawings of these compositions in the *Liber Veritatis* indicate that they were both painted for Cardinal Fabio Chigi and completed just as he was elected Pope Alexander VII in 1655. The drawing in the *Liber Veritatis* that records the composition of *Battle on a Bridge* is inscribed on the reverse "fai pp Alessandri" ("made for Pope Alexander"), while that on the reverse of the drawing corresponding to the *Rape of Europa* reads: "faict al [?] Cardinale. . . / creato pero giusto pap. . ." ("made for Cardinal . . . who has just been created pope") (see Kitson 1978, p. 137, for these inscriptions).

The combat depicted in the middle ground of *Battle on a Bridge* has been interpreted as that of Constantine and Maxentius. This battle between two rivals for imperial power took place in 312 on the banks of the Tiber River near the Mulvian Bridge (the Ponte Molle). Before going into battle, Constantine had a vision of a flaming cross bearing the words, "In this sign, thou shalt conquer." Constantine, who was already sympathetic to Christianity, adopted the cross as his emblem and won a decisive victory. An autograph replica, corresponding in all details to the Pushkin painting, is in the Virginia Museum of Fine Arts, Richmond. A painting of the same subject from the late 1630s, in the collection of Mrs. J. Seward Johnson, anticipates the Pushkin painting in its general structure, though the composition is oriented in the opposite direction.

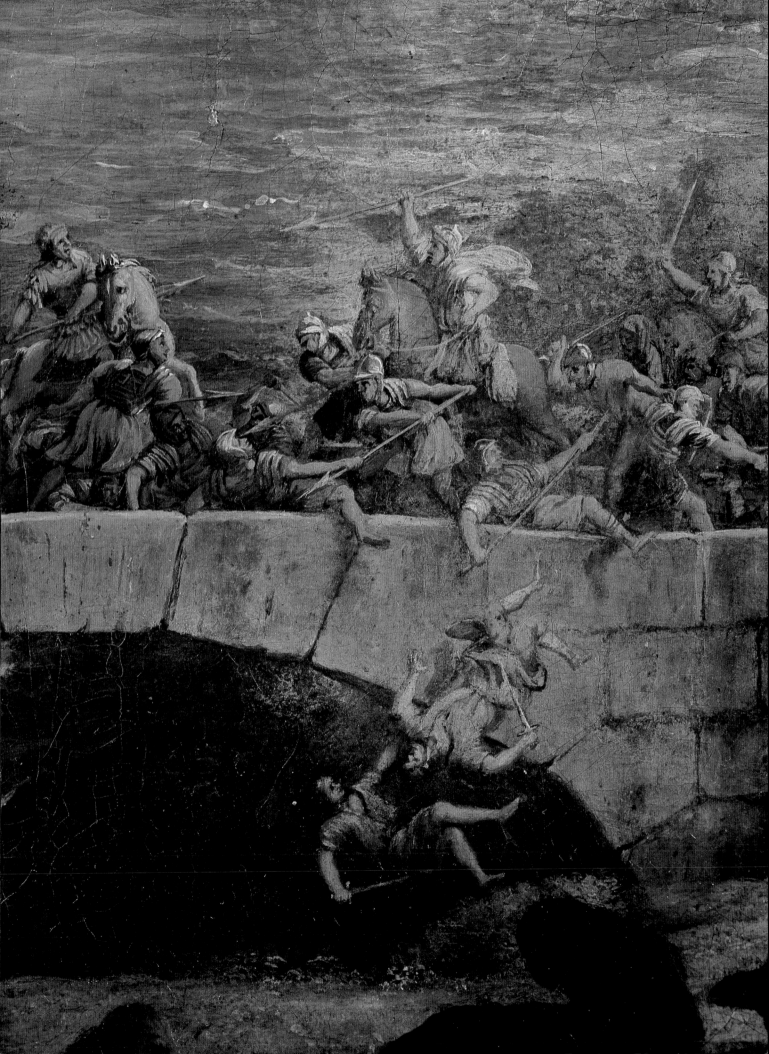

The companion piece depicts Jupiter's transformation into a bull and his abduction of Europa, which is recounted in Ovid's *Metamorphoses*. Claude's treatment of the subject in the Pushkin picture is peaceful and idyllic. He painted the subject frequently; indeed it was one of the first mythological scenes he executed, in a large painting of 1634 in the Kimbell Art Museum, Fort Worth. This is one of his most important early paintings. Other versions of the subject are a canvas of 1647 belonging to the Rijksdienst voor Beeldende Kunst, The Hague; one in a private English collection that is dated to 1658, based on its *Liber Veritatis* drawing; and finally a painting dated 1667 in the collection of H. M. Queen Elizabeth II. This last work is almost identical in size to the one in the Pushkin Museum and is, in fact, based on the *Liber Veritatis* drawing in which Claude recorded the composi-

tion of the Pushkin painting. However the painting in Moscow is more powerful in its treatment of space, thanks to a lower horizon line and a greater expanse of sky above the level of the trees. The figures are also placed very far forward in the Moscow *Rape of Europa*, allowing the eye to penetrate freely the painting's depth.

Claude's paired landscape compositions are linked not only by their common horizon line and balanced grouping of forms, but often according to other principles as well, such as the opposition of different times of day. In the case of this pair, the idyllic treatment of the rape of Europa contrasts with the confusion and horror of the battle scene, though both are set within a grand conception of nature.

ANTOINE WATTEAU

1684 Valenciennes — Nogent-sur-Marne 1721

Watteau first studied in his native city of Valenciennes near the border of France and Flanders and arrived in Paris in 1702. There he studied with Claude Gillot, who encouraged his interest in the theater, and with Claude Audran, who taught him to paint elegant and witty decorations. His exquisite color harmonies and virtuoso brushwork were inspired by Venetian painting and by the art of Peter Paul Rubens. His paintings were, for the most part, small-scale cabinet pieces intended for a devoted private clientele. In 1717, he was received into the Academy as a painter of fêtes galantes — *images of elegant, amorous figures in parklike settings — a category created especially for him.*

7. *The Savoyard*, c. 1716

Oil on canvas, 40.5 × 32.5 cm
Leningrad, Hermitage, Inv. no. 1148

THIS APPARENTLY SIMPLE IMAGE of a roving peasant musician and his performing animal is one of Watteau's best-known works. The painting's charm results in part from the rapid brush strokes with which the artist suggested the clear winter light and the unpretentious village setting. Yet the single figure presented in a stagelike clearing has been shown to have a more pointed, satirical meaning.

Itinerant musicians were a frequent sight in eighteenth-century Paris. They were known as Savoyards, because they usually hailed from Savoy, then one of the poorest parts of Europe. This young musician carries a marmot, a kind of thick-furred rodent like the woodchuck. For a long time, this picture was regarded as a realistic portrayal of a folk type. Sterling (1957), for example, noted the apparent sympathy of the artist for the good-natured, country boy and his pet. Adhémar (1950) attempted to identify the model, and even suggested that it was a self-portrait. In fact, a drawing from life was probably the basis for this painting; a sketch in the Petit Palais, Paris, shows the same figure in reverse. However, as Posner (1975 and 1984) recently pointed out, the painting has thinly veiled erotic connotations, since *la marmotte* was also a term used in eighteenth-century France to signify the female sex organs. This meaning is reinforced by the picture's lost companion piece, *The Spinner*, which showed a girl holding a distinctly phallic distaff. Both pictures were reproduced in the *Receuil Julienne*, a collection of engravings after Watteau made at the behest of the artist's friend Jean de Julienne.

It has been suggested that, like the marvelous watercolor landscape (Haarlem, Teyler Museum) it resembles, which includes the same church spire, the painting represents Gentilly in the Bièvre valley. It has also been argued that the town is Valenciennes, Watteau's birthplace. However the location may be imaginary, especially given the simplicity of the church's architectural outlines. While some critics consider the painting to be an early work, assigning it to 1702, others placed it c. 1707–1709, when Watteau was working in the home of his teacher Claude Audran. Mathey and Parker (1957-58) proposed a slightly later date based on preparatory drawings. Nemilova (Hermitage cat. 1986) suggested a date of c. 1716 because of the painting's free execution and its compositional structure, a date with which Rosenberg (1984–85 Paris) concurred. E.D.

FRANÇOIS BOUCHER

1703 Paris 1770

Boucher probably studied first with his father and then with the court painter François Lemoyne, who influenced his early style, as did Antoine Watteau (see no. 7). He won the Prix de Rome in 1723, but did not leave for Italy until 1728. Returning to Paris in 1731 or earlier, he was received into the Academy in 1734 as a history painter and rose to become its director and also first painter to the king in 1765. He painted portraits, landscapes, pastorals, and genre scenes, as well as history paintings of religious and mythological subjects, all boldly and sensuously executed. His oeuvre also includes designs for tapestries (he became director of the Gobelins tapestry factory in 1755), porcelain, and the opera.

8. *Hercules and Omphale*, early 1730s

Oil on canvas, 90 × 74 cm
Moscow, Pushkin Museum, Inv. no. 2764

LONG CONSIDERED ONE OF BOUCHER's greatest works, *Hercules and Omphale* has belonged to some of the most important private collectors in France and in Russia. In this vigorous erotic scene, there is none of the simpering coquettishness or playfulness usually associated with Boucher. The bold colors and forceful lines of the animated composition suggest real passion.

Omphale was queen of Lydia. As punishment for a murder, Hercules was made her slave for one year. The queen forced him to do women's work as well as to service her sexual needs. Omphale took possession of his attributes, the lion skin and club, and Hercules adopted the distaff. But in Boucher's scene, these attributes are held by two cupids at the lower right, and the mutual passion of Hercules and Omphale becomes the subject of the picture. The soft pink of Omphale's flesh is complemented by the crumpled bluish fabric, whose texture Boucher conveyed beautifully. The straight, bold lines of the figure's limbs, the tumbling swags of drapery, and the cavorting cupids all contribute to the painting's great vitality.

In the sale catalogue of the Randon de Boisset collection in 1777, *Hercules and Omphale* is described as having been executed in the style of Lemoyne. Indeed its light, shimmering palette is reminiscent of the work of Boucher's teacher. But Lemoyne's painting of the same subject (1724; Paris, Musée du Louvre) is calm and balanced, in contrast with Boucher's dynamic work.

In the absence of any documentation or closely comparable paintings, it is difficult to date the painting precisely. But it was undoubtedly finished while Boucher was still a young man, probably in the early 1730s. Fragonard, who studied with Boucher, made a copy of this painting. It was described in the catalogue of the de Sireul sale (Dec. 3 ff., 1787, under no. 37), but subsequently disappeared.

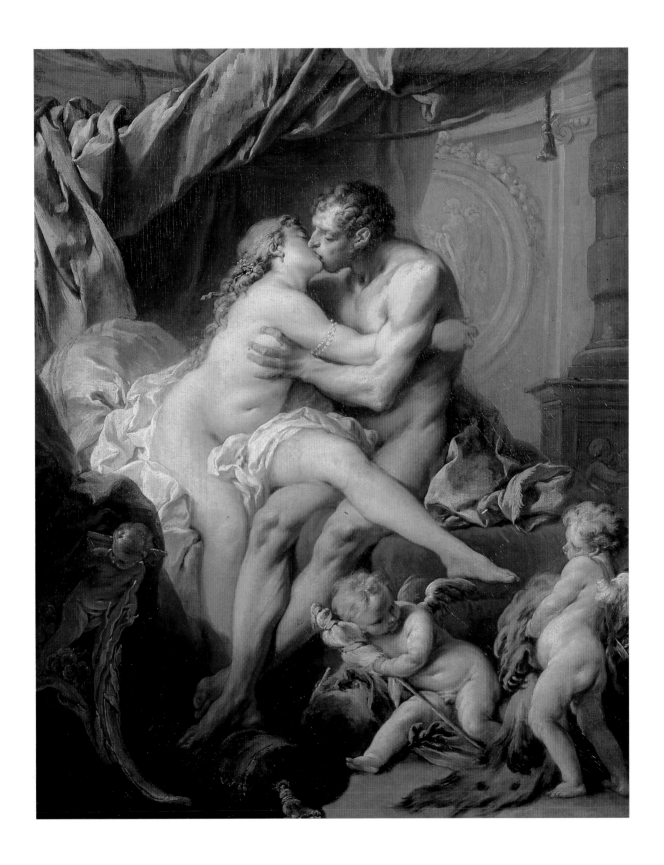

9. *Rest on the Flight into Egypt,* 1757

Oil on canvas, 139.5 × 148.5 cm
Signed, lower right: *F. Boucher 1757*
Leningrad, Hermitage, Inv. no. 1139

EVEN WHEN THEIR SUBJECT MATTER is religious, the paintings of Boucher are always decorative and festive. *Rest on the Flight into Egypt* is one such painting. Curiously, about the time *Rest on the Flight* was painted, Boucher made several other religious works for his major patron, Madame de Pompadour. These include a *Nativity* (Pushkin Museum) and a small painting of *The Infant Jesus and Saint John the Baptist* (Florence, Galleria degli Uffizi), both dated 1758. The group of the Christ Child and the young Saint John is very similar in the smaller painting to that in *Rest on the Flight,* and both hark back to seventeenth-century Italian prototypes. Yet, as Boucher presented them, their form and manner hardly differ from that of his cupids, children personifying the genius of art, or the infants who play in his genre scenes.

In 1766, Boucher was made an honorary member and professor of the Academy of Fine Arts, St. Petersburg. Plans to bring him to the Russian capital as a teacher were discussed but were never carried out. The heightened interest in his art at this time may have been a factor in Catherine the Great's purchase of this work, perhaps at the sale of Madame de Pompadour's collection, with the help of an agent. In any case, the painting is listed in the Hermitage catalogue of 1774. E.D.

JEAN BAPTISTE GREUZE

1725 Tournus — Paris 1805

Greuze studied in Lyons as a youth and then in Paris. He exhibited at the Salon from 1755 but stopped in 1769, when he was accepted into the Academy as a genre painter rather than as a history painter. Instead he exhibited the portraits and moralizing genre scenes in which he specialized at the Salon de la Correspondance (from 1779 to 1785) and in his studio. Championed by encyclopedist and art critic Denis Diderot and other pre-Revolutionary moralists, Greuze achieved great fame. By the 1780s, however, his work was eclipsed by the more strictly Neoclassical art that heralded the downfall of the ancien régime.

10. *The Paralytic*, c. 1763

Oil on canvas, 115 × 146 cm
Faint monogram on tablecloth, right: *JG*
Leningrad, Hermitage, Inv. no. 1168

THIS PAINTING WAS EXHIBITED at the Salon of 1763, where it aroused considerable interest. Diderot, in particular, was attracted to the work and used it to illustrate several of his views on art and life: "Greuze is truly the man for me. Putting aside for a moment his small compositions, about which I have positive comments to make, let me go immediately to his picture of filial piety, which might best be called 'In Return for a Good Education'" (in fact, the painting quickly took on the alternative title *Filial Piety*).

The composition's faults — the affectation and theatricality of the scene — did not escape Diderot. Nor did he fail to observe the work's technical defects. He pointed out, "The color is good, though not so good, still, as that of Chardin." But he found something touching even in the painting's faults. There was, for Diderot, a singular poignancy in the fact that the son-in-law rather than the daughter ministers to the sick man: "The painting tries to show that the paralyzed man should receive particular help from the person least obligated to wait on him. This proves that the choice of husband the father made for his daughter is a good one. And this explains the tenderness of his expression and of the conversation he is engaged in. Take away the son-in-law and the subject of the painting would be altered."

For Diderot, the appeal of these kind of images lay in their affirmation that family dramas can attain the nobility of heroic tragedy. They produce feelings in a spectator that are close to ordinary experience. "To begin with," Diderot wrote, "the genre pleases me. It is moral painting. Well! Hasn't the brush been consecrated to debauchery and vice long enough? Should we not be pleased to see it compete with drama in an effort to move, instruct, correct, and invite us to virtue? Be brave, my friend Greuze. Paint moral pictures and go on painting them!"

Greuze was a careful observer of everyday life, drawing upon the world he saw in the streets, marketplace, churches, and theaters. In the actual preparation of his compositions, he was very demanding. As many as nine preliminary studies for *The Paralytic* exist in the Hermitage. They were acquired in 1769 by I. I. Betsky, President of the St. Petersburg Academy of Fine Arts. From these drawings, one can reconstruct almost all of the picture

piece by piece: the head of the paralyzed man, the figure of the wife, two variants of the son-in-law, two variants of the boy with the cup, the boy covering the father's feet, a study of the dog, and even a sketch of part of a hand. A signed study of the entire composition is in the Musée des Beaux-Arts, Le Havre.

While it was feared that, because of its depressing subject and appropriately somber palette, *The Paralytic* might not find a buyer, Catherine the Great, with Diderot's assistance, acquired the painting in 1766. An engraving by J. J. Flipart, dedicated to the empress, was made in 1767. According to Grimm (cited in Diderot 1875–77), the acquisition required negotiations with the French court: "After the success of his painting of the paralytic at the last Salon," Grimm recounted, "Greuze was asked to bring it to Versailles to be shown to the king and the royal family. He was given twenty *écus* for this trip. Since the painter had not found a buyer for the work, which had cost him 200 *louis* to prepare, he was given permission to sell it to the Imperial Academy of Fine Arts in St. Petersburg, thereby extending the reputation of the painter to the furthest boundaries of Europe." E. D.

11. *The Spoiled Child*, early 1760s

Oil on canvas, 66.5 × 56 cm
Leningrad, Hermitage, Inv. no. 5725

WHILE THIS WORK WAS well received at the Salon of 1765, it was considerably less successful than other works by Greuze. Its subject matter, rather than its technique, perplexed and annoyed viewers. The critic for the *Mercure de France* acknowledged that the painting was beautiful and had all the qualities that had made Greuze famous. But he wondered why the painter had chosen excessive parental indulgence as his subject. Diderot thought the content unclear. He asked, "Is it the dog who is spoiled, or the child?" He continued: "[The picture] is agitated, the dim light flickering from all directions, irritating the eye. . . . The head of the child is simply beautiful, but beautiful in a painterly way. The boy is a beautiful *painted* child, but not the sort a mother would wish for. . . . It is the dog that has some reality to him. . . . There are also too many accessories, too many details. The composition is heavy and disorganized. The mother, child, dog, and utensils should have produced a stronger effect." Despite such criticism, which was echoed by other reviewers, the painting eventually came to be recognized as a fine example of the art of Greuze.

Preparatory studies and sketches for the painting are preserved in the Hermitage, the Albertina in Vienna, and the Museum Boymans van Beuningen in Rotterdam. A finished drawing in the Sterling and Francine Clark Art Institute in Williamstown, Massachusetts, presents a variation on the Hermitage composition. Rather than indulging her son's misbehavior, the mother in the drawing scolds her son. The theme of child rearing reflects an important social trend at mid-century that placed new emphasis on the sanctity of marriage and family life and for which the writings of Jean Jacques Rousseau proved deeply significant. Greuze's interest in principles of child rearing can be seen in many of his compositions. Apparently Greuze planned to do a companion piece for *The Spoiled Child*, reflected in a drawing of a seated girl feeding a dog in the Cabinet des Dessins, Musée du Louvre, Paris.

The Spoiled Child was probably painted in the early 1760s. Miller (1923) believed it was executed before 1763, because it may have been sold that year from the collection of the Duke de Choiseul-Praslin, but different data suggest that this sale occurred in 1793. The white inventory number in the left-hand corner of the canvas is connected to the Bezborodko collection in St. Petersburg, where the painting was by 1798. E. D.

JEAN HONORÉ FRAGONARD

1732 Grasse — Paris 1806

Fragonard studied briefly with Jean Baptiste Siméon Chardin and then with François Boucher (see nos. 8–9). In 1752, he won the Prix de Rome and entered the Ecole royale des élèves protégés, directed by Carle Van Loo. He did not begin his years of study in Rome until 1756. There, in addition to making the required copies of Renaissance and Baroque paintings, he studied the Italian landscape. In 1761, he returned to Paris in the company of the engraver and collector the Abbé Richard de Saint-Non. Though he became an associate member (agréé) of the Academy in 1765, he was never received as a full member and rarely exhibited at the Salon. His genre scenes (often with amorous content), landscapes, and other subjects, painted in a dashing and highly personal style, were destined for private patrons. He traveled to Italy again in 1773–74, returning through Germany. Even though Fragonard's work was unconcerned with the goals of the Revolution, its artistic leaders acknowledged his achievement by appointing him curator of the newly organized Museum of Arts in 1793.

12. *The Stolen Kiss*, late 1780s

Oil on canvas, 45 × 55 cm
Leningrad, Hermitage, Inv. no. 1300

IN THIS COMPOSITION, A YOUNG MAN chastely kisses a young woman who has entered the room looking for her scarf. Her reaction shows that she both accepts the kiss and is worried that the couple might be seen by the group playing cards around a table in a room glimpsed through the doorway at the right. In this skillfully composed scene, with its half-opened doors and dramatic poses, the atmosphere is tense and electric.

The engraving of this painting, made in 1788 by Nicolas François Regnault as a pair to Maurice Blot's highly successful engraving after Fragonard's *The Bolt* (c. 1778; Paris, Musée du Louvre), suggests a connection between these two paintings of amorous subjects. However a number of factors, including differences in scale and style—the paintings are separated by about ten years—indicate that they were not conceived as pendants. In *The Bolt*, a young man embraces a girl, at the same time hastily locking the door of her bedroom against intruders. As Rosenberg (1987–88 Paris) pointed out, *The Bolt* is at once a passionate and lyrical work, while *The Stolen Kiss* is more bourgeois and discreet.

Rosenberg quoted the Goncourt brothers, nineteenth-century writers on art, on Fragonard's late style: "Here are the coats of Metsu trimmed with ermine and the white satin dresses of Terborch; the ever-present costume that soon everyone would begin to fight over so that one is no longer sure who signed [the painting]: Fragonard or Boilly. Here too began...the cold, dry, and miniaturizing style of Fragonard, so different from the vivacious touch of his earlier paintings—resulting in sketches whose originality escapes us and makes us think they are copies." Indeed the very detailed elaboration of the texture of furniture, clothing, and rugs in *The Stolen Kiss*, as well as the enamel-like painting technique, has led several scholars to doubt Fragonard's authorship and attribute the painting to Marguerite Gérard (1761–1837). The sister of Fragonard's wife and his favorite student, she painted mainly small scenes from daily life and portraits. Her paintings are not very dra-

matic, but abound in marvelously painted accessories and luxurious fabrics. On the other hand, Fragonard and Gérard are believed to have painted a series of works in collaboration. They include *The Reader* (Cambridge, England, Fitzwilliam Museum) and *The First Steps* (Cambridge, Mass., Fogg Art Museum).

Did Fragonard's painting technique and style change in the 1780s under the influence of the fashion for genre paintings by seventeenth-century Dutch masters, or did he indeed produce paintings such as *The Stolen Kiss* with his sister-in-law? These questions remain unresolved. Nevertheless what is striking about *The Stolen Kiss* is the sophistication of its composition and the subtlety of the facial expressions, which were undoubtedly the work of Fragonard himself. They were painted with great vitality: The expressions of the two lovers are fleeting, enveloped in a smoky light, in contrast to the sharpness of the surrounding objects. Moreover we cannot ignore the inscription on Regnault's engraving, made in Fragonard's lifetime: "The stolen kiss. Engraved by N. F. Regnault after the painting of H. Fragonard, painter to the King." At this time, Fragonard was at the height of his fame and did not need to pass off his sister-in-law's work as his own. E. D.

CLAUDE JOSEPH VERNET

1714 Avignon — Paris 1789

The son of a coach painter, Claude Joseph Vernet lived and worked in Rome for nearly twenty years, specializing in landscape painting. Without being eclectic, he absorbed much of the tradition of Claude Lorrain (see nos. 5–6) and of Claude's Italian contemporary Salvador Rosa. His seascapes, idyllic landscapes, and urban scenes attracted to him a large, international clientele. He was received into the Academy as a marine painter in 1753 and exhibited frequently at the Salon. In 1754, after receiving a royal commission to paint the ports of France that would occupy him for many years, Vernet resettled in Paris, and was honored with lodgings in the Louvre.

13. *View of the Park of the Villa Ludovisi*, 1749

Oil on canvas, 74.5 × 99.5 cm
Signed and dated on the right, on an album held by the artist: *Joseph Vernet, Roma 1749*
Leningrad, Hermitage, Inv. no. 3684

14. *View of the Park of the Villa Pamphili*, 1749

Oil on canvas, 76 × 101 cm
Signed and dated, lower right, on the revetment: *Joseph Vernet f. Romae 1749*
Moscow, Pushkin Museum, Inv. no. 2769

IN MAY-JUNE 1746, ONE OF VERNET's most important patrons, the Marquis de Villette, ordered eight paintings from the artist, leaving their subjects to his imagination. The paintings were to be executed in pairs, two each year beginning at the time the order was placed. The artist, whose handwritten notes about the commission still exist, chose to depict port and seaside views, dramatic vistas of rocky terrain with waterfalls, a nocturnal fire at sea and a storm, and two garden images — all with figures. Vernet always completed commissions punctually, following conditions and deadlines exactly as laid out in his contracts. The first pair was finished in 1746. One of these is lost, but the second, *Romantic Landscape*, which at one time belonged to Prince Nikolai Yusupov, is now in the Pushkin Museum. The Hermitage owns another picture from the series, *An Italian Harbor*. With the exception of these and the fourth pair, depicting the gardens of the Ludovisi and Pamphili villas in Rome (nos. 13–14), the other pictures in the series are apparently lost. The artist completed the fourth pair on schedule in 1749. He described the pendants simply as: "two more [paintings] in gardens with small, fashionably dressed figures" and "for M. de Villette, two views and gardens."

The view of the park of the Villa Ludovisi includes the villa's walls and handsome portico, a complex sculptural fountain, sculptures, and large vases. For all its detail, the setting does not accord with the villa's plans or engravings made of it at the time. Vernet evidently altered the relationship of the villa and park for compositional reasons. Into this idealized view, he introduced several figural groups. At the left, two women and a man seem to have been surprised by a fountain that was mechanized to go off unexpectedly. Another woman pauses to examine the wet hem of her skirt. In the foreground, the artist

included an image of himself holding an album. He is accompanied by his English wife, Virginia Parker, his son Louis Livio, and the boy's governess. This same group, with the son represented at different ages, appears in other works by Vernet, including the above-mentioned *Italian Harbor*.

The second view in this pair shows the gardens of the Villa Pamphili in Rome. Campilio Pamphili, a nephew of Pope Innocent X, had purchased a huge vineyard outside Rome and commissioned the architect-sculptor Alessandro Algardi to design a residence there in the mid-seventeenth century. The area around the villa was beautifully landscaped and the garden opened to the public. The view here shows the "avenue of fountains," which still exists on the west side of the park. The foreground figures here cannot be identified, though they might be portraits. In the background, near a semicircular amphitheater, is a group of dancers.

This exhibition reunites this pair of paintings, which, except for two exhibitions in the U.S.S.R. and one in London, have been displayed separately at the Hermitage and Pushkin museums since 1930. The artist's choice in both of dramatic, deep perspectives links the paintings, with the tall, architectural hedge to the left of the Villa Pamphili echoing the severely foreshortened exterior wall of the Villa Ludovisi. The dark clouds at the top of each picture and long shadows indicate the coming of dusk. The lively spontaneity, pale, luminous colors, and clear light of a summer day lend these two compositions their special charm. E. D.

15. *The Death of Virginie*, 1789

Oil on canvas, 87 × 130 cm
Signed and dated, lower left: *J. Vernet. f. 1789*
Leningrad, Hermitage, Inv. no. 1759

THIS PAINTING DEPICTS an episode from *Paul et Virginie*, by Jacques Henri Bernardin de Saint-Pierre. The novella, written in 1787, recounts the tragic love affair of a young couple, which begins on a remote, idyllic island. Paul and Virginie are separated when she is called to France by a rich aunt. Virginie eventually turns her back on civilization and her new-found wealth to return to her great love but dies in a shipwreck just off shore, despite her lover's desperate attempt to save her. Inconsolable, Paul dies two months later.

Vernet's painting shows Virginie's death scene, which Saint-Pierre considered his greatest literary achievement. For him, it embodied the biblical story of the fall of mankind from earthly paradise and the end of the Golden Age. *Paul et Virginie*'s theatrical and sentimental qualities inspired works by many artists. Vernet's was the first painting to be based on the story and was planned in collaboration with the writer, with whom Vernet was on close terms. According to contemporary memoirs, Saint-Pierre first read his tale aloud at the salon of Suzanne Necker, wife of the finance minister to King Louis XVI and mother of the famed author Madame de Staël. Despite its enthusiastic acceptance by the women present, Jacques Necker ridiculed the piece. Offended and embarrassed by his patron's criticism, the writer returned home determined to burn the manuscript. He was prevented from doing so by Vernet, who was Saint-Pierre's house guest at the time. The painter told the writer how much he liked the work and persuaded him to save it. While this account may be apocryphal, Vernet certainly admired the story.

According to a letter written by Vernet in January 1789, he received twelve copies of the story and sent the author a hasty sketch inspired by it. This preparatory study must have depicted another episode, because in his next letter, written in May, the artist said he had still to choose the most dramatic and interesting moment in the plot. A week later, he wrote Saint-Pierre again, inviting him to come and see a new sketch, hoping he would approve it.

Vernet's composition, undertaken in his seventy-fifth year, is masterful in its use of dramatic light and dark contrasts to express this tragic event. It was a new departure for him in another way as well: A leading scholar on Vernet, Ingersoll-Smouse (1926), discussed the painter's intention here as a step toward history painting. Comparing it with the moralizing tendencies of Greuze (see nos. 10–11), she called it "the pinnacle of [Vernet's] late style. . . and of the sensibility" of the age in which he lived. E. D.

HUBERT ROBERT

1733 Paris 1808

Nicknamed "Robert des ruines," Hubert Robert specialized in images of ruins. In Rome after 1754, he was deeply influenced by the art of the Italian view painter Gian Paolo Panini and architect-etcher Giovanni Battista Piranesi. The twelve years Robert spent in Italy were a time of great excitement over the recent discoveries of ancient sites such as Herculaneum and Pompeii. A year after his return to Paris in 1765, he was received into the Academy as a painter of architecture. His appointment as designer of the king's gardens in 1778 entitled him to lodgings in the Louvre; he was named keeper of the king's paintings in 1784. Imprisoned during the early years of the Revolution, he eventually became a part of the arts administration under Robespierre.

16. *Flight*, c. 1780

Oil on canvas, 50 × 42 cm
Signed, lower right: *H. Robert*. Inscribed on the arch of the bridge: *Malo Gal Lasciva Puella*
Leningrad, Hermitage, Inv. no. 7732

THE SUBJECT OF THIS PAINTING was identified by Nemilova (1956) as drawn from Virgil's *Bucolics* (*Eclogue* III: 64–65), based on her linking of the inscriptions on the picture and a drawing by Robert entitled *Pursuit* (Valence, Musée des Beaux-Arts). Undoubtedly a preparatory study for the Hermitage painting, the drawing, which is done in reverse to the painting, features a landscape that is much less prominent than that of the canvas. A Latin motto, on a stone at the bottom right of the drawing, reads: "Et fugit ad / salices / et se cupit / ante videri" ("Then runs off to the willows, and hopes to be seen first"). It is a line from a song composed by the shepherd Damoetas in honor of his beloved, the beautiful sea nymph Galatea. Examination of the painting reveals several carelessly written or partially erased Latin words which belong to the first line of Damoetas's song: "Malo me Galatea petit, lasciva puella" ("Galatea, a playful girl, throws an apple at me").

Robert interpreted the ancient story freely. He dressed the characters in contemporary clothing and set the scene in a typical French landscape with a village house nearby. The landscape is somewhat unusual for Robert, since it does not include the architectural monuments and magnificent ruins in which he specialized. Nonetheless it is the man-made structures — a makeshift bridge of planks, an arched stone bridge, railings, and stairs — that lead the eye through the lower parts of the composition to the figures and then to the shady trees and cloud-filled sky above. While Denis Diderot liked Robert's work, he had strong views on how ancient monuments and landscapes ought to be portrayed and criticized Robert several times for compromising his images by populating them with eighteenth-century figures.

This painting is one of a pair. Its counterpart, *Nest Robbers*, is also in the Hermitage. Nemilova, following Kamenskaya (1939), assigned *Flight* to the year 1780, because it is so close in style to Robert's *Mill at Charenton* (formerly Paris, Levi collection), which was painted in that year. The Valence drawing is also dated to c. 1780. E. D.

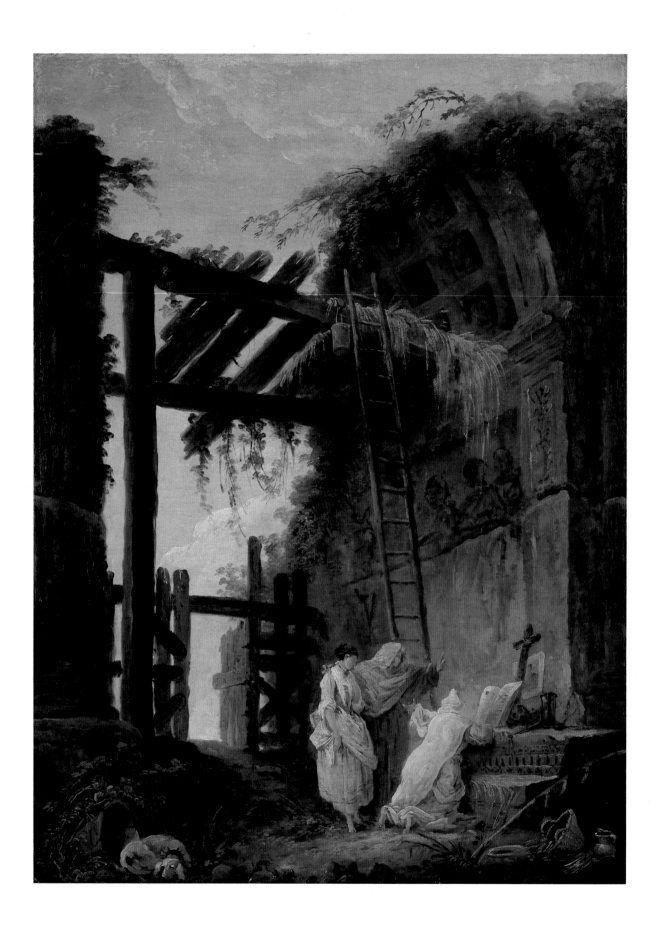

17. *Landscape with a Hermit*, c. 1780

Oil on canvas, 60 × 48 cm
Leningrad, Hermitage, Inv. no. 8580

NEMILOVA (1956) SUGGESTED that Robert's source for this composition may be a tale by La Fontaine, *The Hermit*. According to this story, a monk who has become interested in gaining the love of a young woman comes to her mother disguised as the Holy Spirit. He orders the mother to take her daughter to a nearby monk (to himself, that is) because, from their union, a great pope is to be born. After three visits from him, the mother complies, but the sly monk, setting the trap, does not immediately agree to accept the girl. The two finally make love, but the tale ends on an ironic note: The young woman gives birth to a strapping baby girl. This painting records the first encounter of the daughter, her mother beside her, as the monk refuses the young woman with false piety.

Though all editions of La Fontaine claim this story was taken from Boccaccio's *Decameron,* no such account appears there. The tale is much closer, in fact, to "The Producer of Popes, or God's Man," included in a fifteenth-century collection, *Cent nouvelles nouvelles,* which La Fontaine consulted often. In fact, the author borrowed not only the plot but also some of the story's expressive language.

Similar elements are found in several paintings by Robert from 1760 to 1790. For example, *A Hermit in the Colosseum* (1790; formerly Leonardo Vitelli collection) has almost the same features: ruins with an arch, wooden doors built into the opening in the arch, a monk kneeling before a crucifix being approached by two women. A painting in the Museum of Art and Archeology, University of Missouri, Columbia, presents a similar group in a cave setting. Scenes of this type have often been confused with portrayals of the Temptation of Saint Anthony. A painting in the J. Paul Getty Museum, Malibu, has been connected to a fragment by La Fontaine describing young maidens stealing flowers, brought to an image of the Blessed Virgin, in the presence of a monk deep in prayer (see V. Carlson, "A Roman Masterpiece by Hubert Robert: *A Hermit Praying in the Ruins of a Roman Temple,*" *The J. Paul Getty Museum Journal* 15 [1987], pp. 117–24).

Nemilova (Hermitage cat. 1986) related the Hermitage picture, on the basis of style, to other works by Robert of the period 1780/90. She corroborated her dating by connecting it to a very similar drawing on the same subject by Jean Honoré Fragonard, commissioned by the Duke de Choiseul and engraved as part of a group of illustrations for an edition of La Fontaine's *Fables* published in 1795. Since the duke died in 1785, she posited that Fragonard's sheet could not have been made later. The fact that the two images are so similar—they share fluted columns, crude scaffolding, and wicker baskets strewn around the foreground—made her think that the two artists may even have collaborated on the subject. On the other hand, Cayeux (Valence 1985) believed this dating to be too late. E. D.

ELISABETH LOUISE VIGÉE LE BRUN

1755 Paris 1842

Perhaps the most prominent woman artist of her time, Vigée Le Brun was encouraged in her career by several artists, including Claude Joseph Vernet (see nos. 13–15) and by her husband, J. B. P. Le Brun, the art dealer and critic, who facilitated her study of the old masters. Despite her lack of formal training and her gender, she received numerous portrait commissions, including many from Queen Marie Antoinette, and honors (in 1783, she was received into the Academy in one of four slots designated for women artists). Vigée's long association with Marie Antoinette and the French nobility forced her into extended exile during the Revolutionary years. During this nomadic period of her life, she lived in Italy, Austria, Russia, England, and Switzerland, executing portraits of royalty and aristocrats. She returned to France in 1802, where she wrote her memoirs.

18. *Count Grigori Chernyshov*, 1793

Oil on canvas, 56 × 44 cm
Leningrad, Hermitage, Inv. no. 7459

VIGÉE LE BRUN SPENT THE YEARS 1795–1801 in St. Petersburg and Moscow, where she amassed a large fortune depicting many members of the imperial court. She painted portraits of the Empress Maria Fyodorovna, the daughters of Czar Paul I, and the Grand Duchess Elizaveta Alekseyevna, later the wife of Czar Alexander I. She also painted many prominent aristocrats in both cities.

This portrait of Count Grigori Ivanovich Chernyshov (1762–1830) exhibits the elegance and polish of Vigée's best works. The son of Count Ivan Grigorievich Chernyshov, General Field Marshall of the Russian navy, Grigori spent his entire life at court as a diplomat and steward of the imperial household. For all his titles, he held no responsible positions and received his ranks and honors simply as a member of the court. But, in 1799, he was appointed assistant to Count A. L. Naryshkin, director of the imperial theaters, and was put in charge of touring performance troupes from abroad. He did this only briefly, losing his position with the accession of Alexander I in 1801. He continued to write plays in French and gay, witty verses in the manner of Gresset. His passion for the theater is indicated in this portrait by the mask he holds.

Like his father, Chernyshov loved luxury and was careless, living lavishly both in St. Petersburg and abroad, as well as at his estate in Orlov province. Only the protection of the emperor prevented him from going bankrupt. His kind and cheerful nature, intelligence, excellent education, and elegant manners assured his success in society. Chernyshov's son Zahar and son-in-law Nikita Muravyov participated in the Decembrist Rebellion of 1825. Both were stripped of all rights and privileges and exiled to Siberia. His beautiful daughter Alexandra voluntarily followed her husband into exile.

According to Vigée's memoirs, she painted this portrait in Vienna in 1793, during the first stage of her exile. The present exhibition marks the painting's first visit to the West in almost two hundred years. E. D.

FRANÇOIS GÉRARD

1770 Rome — Paris 1837

The son of an Italian mother and French father, Gérard moved to Paris when he was twelve years old. In 1786, he entered the studio of David (see no. 22). He worked in Rome from 1791 to 1793 and received lodgings in the Louvre upon his return to Paris. He was awarded the Legion of Honor and elected a member of the Institute in 1812. The artist did book illustrations, decorated palaces, and executed paintings with religious, mythological, allegorical, and historical subjects, as well as portraits. Called "the painter of kings and the king of painters," he depicted many of the most illustrious figures of his generation. The artist managed to remain in favor from the Revolution through the Bourbon Restoration. During the Empire, he was named first painter to Napoleon's first wife, the Empress Josephine; he was also first painter to Louis XVIII, who made him a baron.

19. *Josephine*, 1801

Oil on canvas, 178 × 174 cm
Leningrad, Hermitage, Inv. no. 5674

MARIE JOSEPHINE ROSE Tascher de la Pagerie (1763–1814) was born on the island of Martinique into a wealthy Creole family. She was first married to Viscount Alexandre de Beauharnais, a general and deputy of the National Assembly, who was executed for treason during the Reign of Terror in 1794. After her husband's death, Josephine was imprisoned briefly but was soon freed, thanks to the intervention of Viscount Barras, a Revolutionary leader and Josephine's lover. In 1796, she married General Napoleon Bonaparte. He was made first consul in 1800. With his coronation as emperor in 1804, she became empress and remained so until she was divorced in 1809. She retained her title and a friendship with Napoleon until her death.

Seated on an open terrace at Malmaison, her favorite residence, the first consul's wife received here a more direct and intimate treatment than in later, more official portraits when she became empress. She was depicted by Gérard as the epitome of high fashion, reclining in the antique manner on a Neoclassical banquette, with her hairstyle, Empire dress, and sandals all inspired by ancient prototypes.

An etching of the canvas by Pierre Adam bearing the motto "F. Gérard pinxit 1801" has established the painting's date, as has its inclusion in a book by T. C. Brun-Neergaard that year. A pencil study for the portrait is in the Musée des beaux-arts, Rouen; an oil study is in Versailles. A copy by the artist was obtained for Malmaison in 1928 from the Parisian antique dealer Polovstov. Another variant of the portrait is in the Napoleonmuseum, Arenenberg, Switzerland.

Josephine had a son and a daughter from her first marriage (her second marriage was childless). After her death, this portrait was inherited by her son, Eugène Beauharnais, Duke of Leuchtenberg. Later the descendants of the duke took it from Munich to St. Petersburg. This portrait has not traveled to the West since it left Munich in the mid-nineteenth century. A. B.

LOUIS LÉOPOLD BOILLY

1761 Le Basse—Paris 1845

A painter and engraver, Boilly was basically self-trained. He is perhaps best known today for his scenes of everyday life done in a smooth and detailed manner, derived from the work of Dutch seventeenth-century genre painters such as Gerard Dou, Metsu, and Terborch (Boilly in fact owned several Dutch pictures). But he also produced a vast number of portraits. Exhibiting at the Salon from 1791 to 1824, he worked for a clientele that was private rather than official.

20. *Young Artist*, 1800

Oil on canvas, 65.5 × 54 cm
Signed and dated, lower left: *L. Boilly 1800*
Moscow, Pushkin Museum, Inv. no. 1260

AT THE END OF THE EIGHTEENTH and beginning of the nineteenth centuries, there were more women active as artists than ever before. Women were permitted to study with master artists (Jacques Louis David, for example, had many women students), and in 1791, the doors of the Salon were opened to everyone. The list of successful women who exhibited at the Salon is a long one: it includes Marie Guillemine Benoist, Constance Marie Charpentier, Marguerite Gérard, Adélaïde Labille-Guiard, Constance Mayer, Angélique Mongez, Vigée Le Brun (see no. 18), and many others. This new phenomenon did not go unnoticed by such keen observers of contemporary life as Boilly. Among the many works on the theme of studio life by Boilly is a group in which the central figure is a woman artist.

In addition to the Pushkin picture, there is a large canvas on the same subject, completed in the late 1780s, in the Hermitage. Like *Young Artist*, it features two female figures. Another such painting, exhibited at the Salon of 1800, is in the National Gallery of Art, Washington, D.C. It is possible that these two paintings depict two daughters of the French sculptor Jean Antoine Houdon, and that they were preparatory to the composition showing Boilly's friend at work in the presence of his wife and three daughters, which was exhibited in 1804 as a "Family Portrait" (this work is now in Cherbourg, Musée Henri Thomas).

A veritable minor masterpiece, *Young Artist* exhibits Boilly's gift for composition, the confident precision of his drawing, and his exquisite, light palette. With their refined contours and smooth surfaces, the forms in this painting appear almost silky, without the dryness and rude character that can characterize Boilly's more routine work. The many details of the surroundings are also executed with great care but are not a bit distracting.

21. *The Billiard Party*, 1807

Oil on canvas, 56 × 81 cm
Signed and dated, lower right: *L. Boilly 1807*
Leningrad, Hermitage, Inv. no. 5666

THIS COMPOSITION DEPICTS a Paris billiard hall during the Empire period. The game shown here is called *carambole*, a form of billiards that is played on a table without pockets, with one red and two white balls. In this view of Parisians amusing themselves, a great deal of activity is taking place around the table. The young woman taking her turn is seen from the back; her dress, rendered almost transparent by the light, reveals her curvaceous form. To her right stands the imposing figure of a top-hatted gentleman; a young girl clings affectionately to him as he awaits his chance to play. People converse in small groups. Children and dogs play on the floor. A mother nurses her infant. Refreshments are being served. Yet Boilly did not allow these details to overwhelm his composition. The strong, dramatic light cast by the skylight above helps focus the eye on the game and central players.

Many studies and variants of the work exist. A drawing for the group of mothers with children on the left side of the composition is in the collection of Eliot Hodgkin, London. A drawing for the figure of the young woman shooting with the cue stick was sold at auction in 1935, and other studies of several of the heads have been sold more recently. A variant, for a long time in the collection of E. Gasnier-Guy, along with its companion piece, *Game of Cards*, with the central player turned more in profile and with fewer figures and a different background, may have been the canvas Boilly showed in the Salon of 1808 (or it may have been done later; an engraving of this composition was made by F. Villain in 1828). A pencil sketch in the collection of Clifford Duits, London, relates more closely to this composition than to that of the Hermitage. A. B.

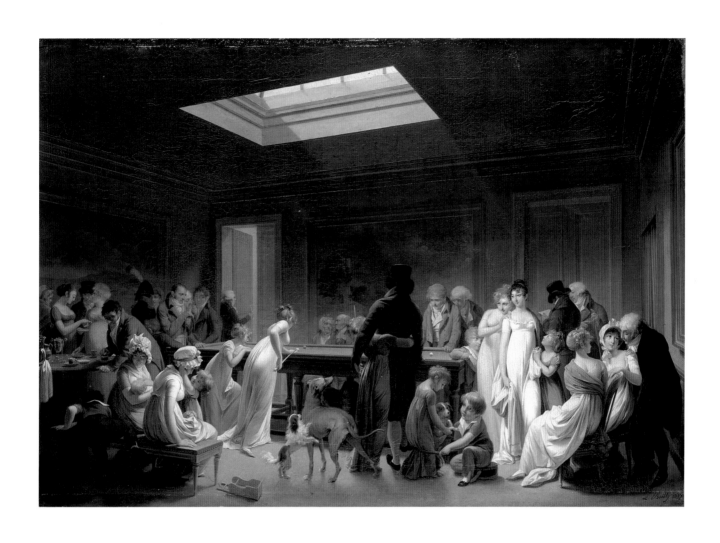

JACQUES LOUIS DAVID

1748 Paris — Brussels 1825

The leader of the Neoclassical movement in France, David began his career, on the advice of François Boucher (see nos. 8–9), in the studio of Joseph Marie Vien. In 1774, he won the Prix de Rome and the next year went to Italy, where he studied until 1780. Returning to Paris, he was received into the Academy as a history painter in 1783. He played an exceptionally active role in the Revolution, serving as deputy to the Convention, which voted to behead Louis XVI. Appointed artistic director of the new regime, he was a major figure in the abolition of the Academy. Many of his works during this period depict classical subjects that extol the ideals of civic responsibility and duty. David was imprisoned twice for his revolutionary activities. For Napoleon, he painted important statements of the emperor's power. After the fall of Napoleon in 1815, David was exiled to Brussels. He included among his students Gérard (see no. 21), Girodet-Trioson, Gros, and Ingres (see nos. 23–24).

22. *Sappho, Phaon, and Cupid,* 1809

Oil on canvas, 225.3 × 262 cm
Signed and dated, lower left: *L. David, 1809*
Leningrad, Hermitage, Inv. no. 5668

THE LEGEND OF THE UNREQUITED LOVE of the ancient Greek poet Sappho for the young boatman Phaon is told in Menander's *Leucadia,* written in the Hellenistic age. According to Menander, Sappho, in despair because Phaon rejected her, threw herself into the sea from the Leucadian rocks. In this scene, in which Sappho and Phaon appear happy together, there does not seem to be any hint of the poet's imminent suicide, except perhaps the mountain seen in the background.

It has been argued that David, who did not read Greek, could not have known Sappho's work. But on the scrolls in Sappho's lap is a Greek inscription, which translates as: "Happy, close to the gods in bliss, is the one who sits near you and sighs for you." This line is from the beginning of Sappho's first ode. Above it, the artist, explaining the text, placed Phaon's name. (In fact, Phaon's name does not appear in any of the extant odes by the late seventh/ early sixth-century B.C. poet.) Many poets have translated Sappho's first ode—Boileau in France and Derzhavin in Russia, among them. Thus both the artist and Prince Nikolai Yusupov, who commissioned the painting, might have known the work in translation.

Yusupov, who spent much time in Paris, attempted to order the work from David in 1787 (according to a letter of Hubert Robert [see nos. 16-17] to Yusupov) but only succeeded twenty-one years later. In discussing the subject of the commission, Yusupov and David then settled on the story of Sappho and Phaon. The terms were agreed to on July 9, 1808: Yusupov was to pay David 12,000 *livres.* It was expected too that he would consult on the work as it progressed. The following September, David wrote the prince, "I have just sketched on canvas the composition with the passionate Sappho and her beloved Phaon, in whom Cupid has at last kindled a fire of love." David chose to paint the moment when Sappho completes her ode to her lover and he touches her face with his hand.

On March 21, 1809, David wrote Yusupov, who was still in Paris: "I would like you to see the finished composition for the picture of Sappho and Phaon; I have it in in my

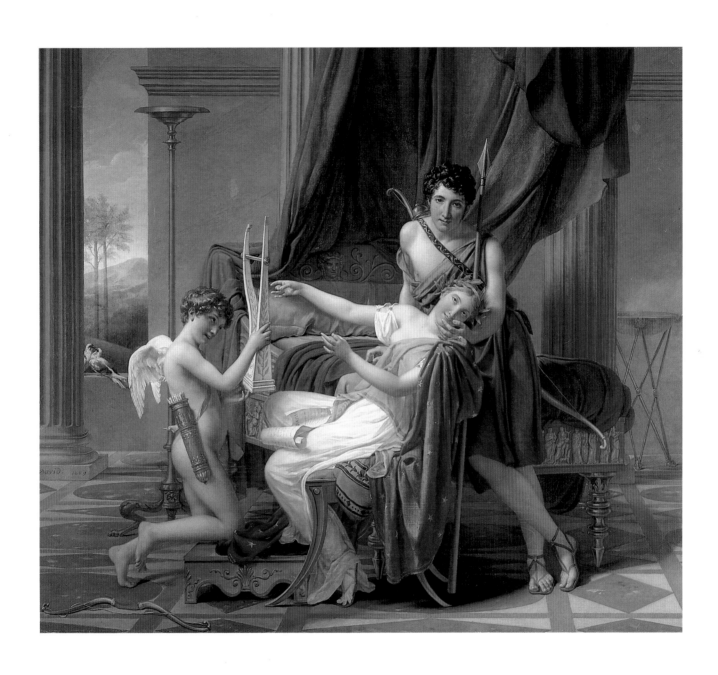

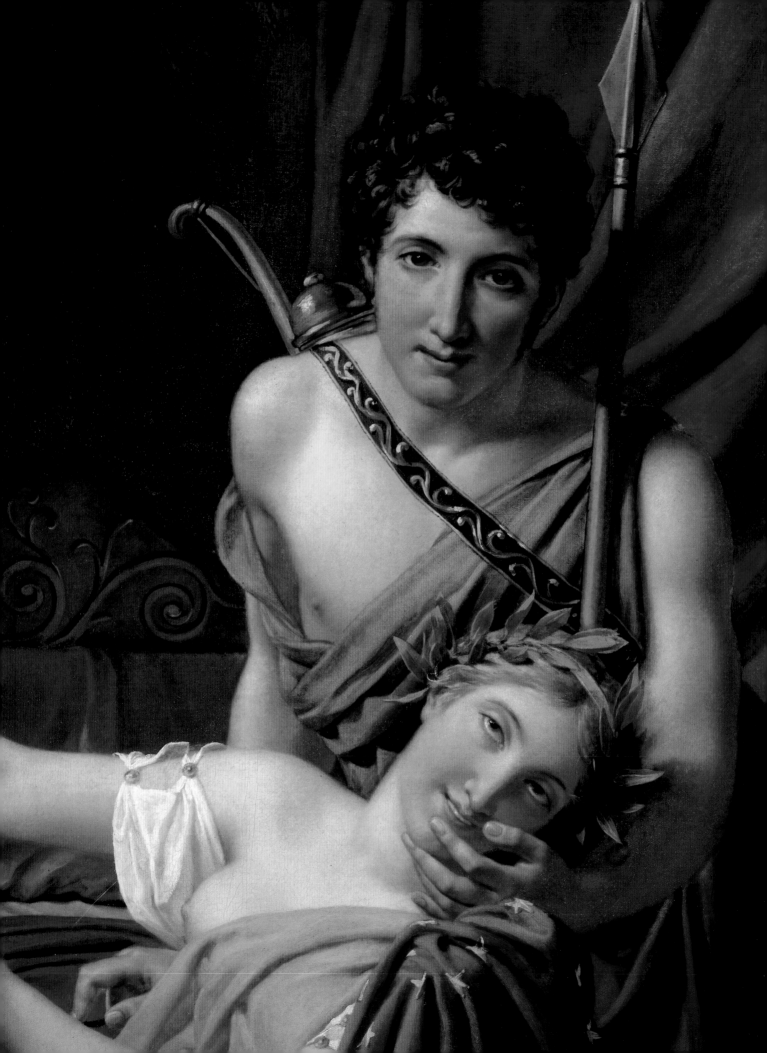

studio in the quarter of the Sorbonne, or I can bring it to you; I await the effect it will have on you in order to proceed directly with the picture." Apparently Yusupov asked for several alterations. Changes in the Hermitage painting can be detected in the figure of Cupid and in the pair of doves at the far left. Cupid was originally farther to the left and was posed with his back to the spectator (rather like Cupid in Agnolo Bronzino's *Allegory* in the National Gallery, London). In the final work, which David completed in November 1809, Cupid has a distinctly classical look. Yusupov's coat-of-arms can be seen on the censer at the far right.

David drew upon many works, from those of the ancients to his own, in creating this painting. Phaon's head resembles a famous second-century B.C. bust of Antinoüs as Dionysus, which exists in many copies. Undoubtedly the artist found ancient prototypes for the figures of Sappho and Cupid, as well. The ancients called Sappho "the tenth muse," as the bas-relief, apparently representing the Muses, on the bed to the right of Phaon reminds us. Sappho is perhaps the figure holding a flute at the far right, next to the poet Alcaeus (on several Greek vases, these two writers are represented involved in a competition). On the left side of the bed, the figures of Cupid and Sappho may derive from a fourth-century B.C. terracotta depicting them. The style of these reliefs resembles that of David's two monumental drawings of an antique frieze (Grenoble, Musée de peinture et sculpture, dated 1780; and Sacramento, Crocker Art Gallery). The composition of *Sappho, Phaon, and Cupid* relies on the artist's earlier *Paris and Helen* (1788; Paris, Musée du Louvre). In the Hermitage painting, the female figure sits and the male figure stands; in the Louvre picture, this is reversed. A drawing dating to about 1804 (Lille, Musée des beaux-arts), as Adams (1977-78) observed, provides a link between *Paris and Helen* and *Sappho, Phaon, and Cupid*.

Close examination of the surface of the canvas reveals the drawing of the floor beneath the figures. This indicates that the artist first painted the interior and then added the figures. There are no extant drawings or sketches for the Hermitage painting. In a letter to Yusupov of May 31, 1814, David noted, "I have in Paris not a trace [of the painting]." He asked that a small sketch be made for him. This request was apparently not honored, since no such sketch seems to have survived. But in 1822, David's student Alexandre Charles Guillemot exhibited at the Salon a work entitled *The Love of Sappho and Phaon*, based on the Yusupov canvas (Guillemot's painting is now in the Musée des beaux-arts et d'archéologie, Rennes). This is the first visit of *Sappho, Phaon, and Cupid* to the West since it left Paris for Russia in 1811. A.B.

JEAN AUGUSTE DOMINIQUE INGRES

1780 Montauban — Paris 1867

*The son of an artist, Ingres studied in Toulouse before going to Paris in 1796, where he spent two years
in the studio of Jacques Louis David (see no. 22). He won the Prix de Rome in 1801 but was unable to
take up his stipend until 1807. He remained in Italy until 1824, when he returned to France, following
the success in Paris of his* Vow of Louis XIII *(Montauban, Cathedral) at the Salon. He received the
Legion of Honor in 1824 and became a member of the Institute in 1825. He exerted enormous influence
as a teacher, first as a professor at the École des beaux-arts, Paris, from 1829, and then as director of
the French Academy in Rome, from 1834 to 1842.*

23. *Count Nikolai Guryev*, 1821

Oil on canvas, 107 × 86 cm
Signed and dated, lower left, on the parapet: *Ingres, Flor. 1821*
Leningrad, Hermitage, Inv. no. 5678

IN 1820, AT THE INVITATION of his friend the sculptor Luigi Bartolini, Ingres moved to
Florence, where he remained for four years. It was here that he painted this portrait of
Count Nikolai Guryev, as Guryev traveled through Italy with his wife, Marina Guryeva,
née Naryshkina, on their honeymoon. The count is depicted against a dramatic landscape
background of Tuscan hills and umbrella pines. Nikolai Dmitrievich Guryev (1792-1849)
fought in the campaigns against Napoleon from 1812 to 1814 in defense of Russia. In 1816,
he was promoted to colonel and, in that same year, retired; he re-entered military service
in 1818 as aide-de-camp to Alexander I. In the year Ingres painted his portrait, Guryev
began his diplomatic career as the Russian envoy first to The Hague, and then to Rome and
Naples. He also served as secretary in the Ministry of Foreign Affairs.

In its polish, cool manner, and monumentality, this painting follows the direction
taken by Ingres in such portraits as that of François Marius Granet (1807; Aix-en-Provence,
Musée Granet) and that of Bartolini (1820; Paris, Museé du Louvre), which reflect the
artist's interest in the work of the Italian Mannerists, particularly Jacopo Pontormo and
Agnolo Bronzino. In the same year that Ingres did his portrait of Guryev, Bartolini made
a marble bust of Guryev's wife, which is also in the Hermitage. A.B.

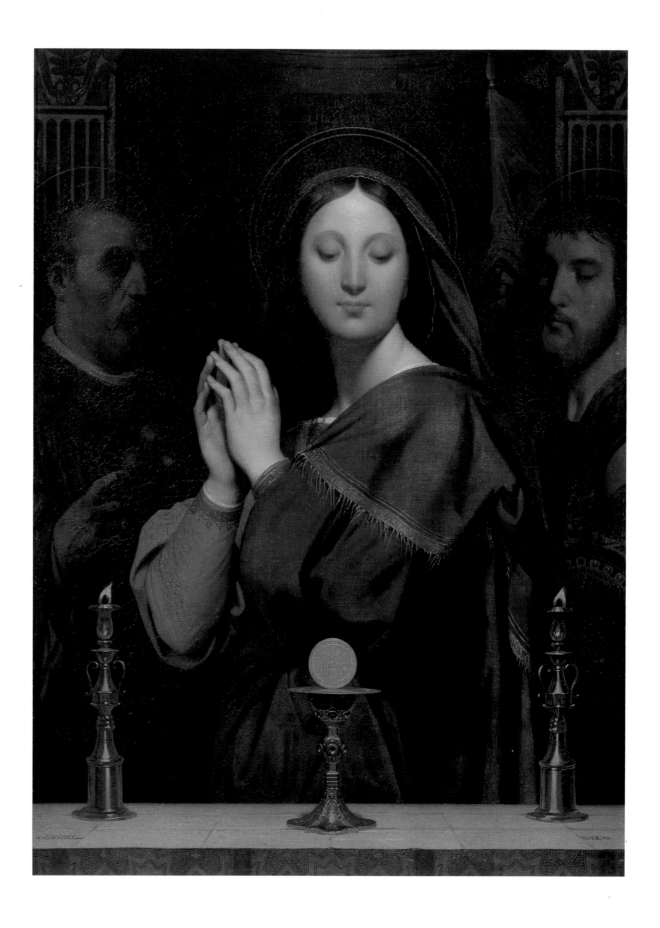

24. *Virgin with Chalice*, 1841

Oil on canvas, 116 × 84 cm
Signed and dated, lower left: *A. D. Ingres pinx*; lower right: *Rome 1841*
Moscow, Pushkin Museum, Inv. no. 2761

COMMISSIONED BY GRAND DUKE ALEKSANDR NIKOLAEVICH, the future Alexander II, *Virgin with Chalice* was completed by Ingres while he was in Rome serving as director of the French Academy. Ingres received 10,000 francs for the painting and, when completed, it was taken to St. Petersburg and exhibited at the Academy of Fine Arts, where it was poorly received. Because Alexander disliked the representation of the Virgin, he gave the painting to the Academy three years later. Ingres tried to repurchase the work at this time, but was unsuccessful. *Virgin with Chalice* was exhibited subsequently with other works of western European painting from the collection of Count Kushelev-Bezborodko.

Ingres depicted the Virgin standing between saints Nikolai and Aleksandr Nevsky, the patron saints of Czar Nicholas I and the crown prince, respectively. Nikolai is seen to the left with three gold balls that he reputedly gave to three young women to save them from prostitution. At the right is the warrior saint Aleksandr Nevsky, grand duke of Kiev and vassal of the Mongols, carrying a banner of victory.

Possessing a classical harmony reminiscent of Raphael, whom Ingres venerated, *Virgin with Chalice* served the artist as the prototype for a series of numerous variations on this subject. Ingres painted one version with saints Louis and Helen (1852; London, private collection) for the wife of his friend Marcotte; and a circular version, for the French Ministry of the Interior (Paris, Musée d'Orsay), with angels and curtains reminiscent of similar elements in Ingres's *Vow of Louis XIII* (1824; Montauban, Cathedral). Ingres completed his last essay on this theme (Bayonne, Musée Bonnat) for his wife on December 31, 1866, at the age of eighty-seven, just before his death two weeks later.

EDOUARD MANET

1832 Paris 1883

Manet, born into a well-to-do Parisian family, trained for a naval career but, in 1850, entered the École des beaux-arts as a pupil of the painter Thomas Couture. He supplemented his studies by copying the old masters in the Louvre and by traveling to museums in Germany, Holland, Italy, and Spain. The exhibition of his Luncheon on the Grass *at the 1863 Salon des Refusés, and then of his* Olympia *two years later (both Paris, Musée d'Orsay), with their revolutionary technique and provocative content, aroused hostility among critics and public alike. While this notoriety was difficult for the artist, it earned him a reputation as a rebel and a following among younger painters who later formed the nucleus of the Impressionists. Although he was friendly with some of them and eventually adopted their brilliant palette and broken brushwork, Manet refused to participate in their independent exhibitions and continued to submit his paintings to the official Salon.*

25. *The Bar*, c. 1878

Oil on canvas, 72 × 92 cm
Moscow, Pushkin Museum, Inv. no. 3443

THE CAFÉ-CONCERT, an open-air combination restaurant, bar, concert and dance hall, was common in late nineteenth-century Paris. Late in 1878, according to Chegodaev (1985), Manet explored the theme of the café-concert in four paintings. The first was *The Bar*, followed by *At the Café* (Winterthur, Oskar Reinhart collection), *Café-Concert* (Baltimore, The Walters Art Gallery), and *The Plum* (Washington, D.C., National Gallery of Art). While most scholars have dated *The Bar* to 1878, some (Moreau-Nélaton [1926] and Barskaya [1961]) dated it to 1879.

Rouart and Wildenstein (1975) located the site depicted in the Pushkin canvas as an open-air cabaret at the Porte Clichy. They also suggested that this painting was inspired by *The Drunkard (L'Assommoir)*, the 1877 novel by Manet's friend Emile Zola. Zola's story about the courtesan Nana was supposedly written in response to Manet's famous painting of the same name (1868; Paris, Musée du Louvre). A Hermitage researcher, Anatoli Podoksik, however has suggested that *The Bar* is a preparatory work for a painting on the theme of horse racing, and that the two figures seated at the table are watching a race and possibly even counting out money for a bet.

As Bessonova and Barskaya (1985) put it: "Done in quick, free brush strokes, this study seems to provide a glimpse of Manet's daily stroll through Paris, during which he made sketches, picked up subjects, colors, and hues. Later he re-created on canvas the atmosphere in both its literal and figurative meaning. . . . As in *The Waitress* [or *Girl Serving Beer*, 1878; Paris, Musée d'Orsay], it [*The Bar*] is based on a view of life within which complex psychological conflicts are being played out. The white canvas priming in the unfinished figure of the man sitting with his back towards the viewer imparts a special luminosity to the image."

Three drawings for the painting exist. One, from a sketchbook, depicts the head of the figure in profile (Paris, Musée du Louvre, Cabinet des Dessins). Another (New York,

Carole Anne Slatkin collection) is a study for the entire composition. This was dated by A. Hanson (in Philadelphia Museum of Art and The Art Institute of Chicago, *Edouard Manet*, exh. cat., Philadelphia and Chicago, 1966, pp. 184–85) to 1878. The third (Paris, private collection) is so close to the painting as to be considered a preparatory drawing. Interestingly, in both of the latter sketches, the tree at the right of the painting is placed on the far side of the counter or, if one accepts the cabaret location of the scene, between the outdoor tables. M. B.

PIERRE AUGUSTE RENOIR

1841 Limoges — Cagnes-sur-Mer 1919

At the age of thirteen, Renoir was apprenticed to a porcelain painter, for whom he decorated plates with flowers and copies after Rococo paintings. In 1862, he entered the studio of Charles Gleyre, where he met the future Impressionist painters Claude Monet, Alfred Sisley, and Frédéric Bazille. In 1874, he helped organize the first official Impressionist exhibition. Renoir's preference for figurative compositions and a technique of smoothly blended colors applied in thin layers distanced him from his Impressionist colleagues. After a trip to Algeria and Italy in 1881, he began a series of paintings with large female nudes, inspired by the classicism of Raphael and J. A. D. Ingres (see nos. 23–24) and posed in landscape settings. Although nearly paralyzed by arthritis in his later years, Renoir not only continued to paint but also took up lithography, engraving, and sculpture, with the help of an assistant.

26. *Under the Trees, Moulin de la Galette, 1875*

Oil on canvas, 81 × 65 cm
Signed, lower right: *Renoir*
Moscow, Pushkin Museum, Inv. no. 3406

IN THE EARLY AND MID-1870S, Renoir often went with his friends to the Moulin de la Galette, a popular outdoor drinking and dancing establishment in the Montmartre district of Paris. This public dance hall was near the studio he moved to in 1876, the year in which he painted *The Swing* as well as his masterpiece on the theme, the monumental *Ball at the Moulin de la Galette*, both in the Musée d'Orsay, Paris. The sashed and shirred striped dress of the model Estelle in the latter reappears as the central motif of *Under the Trees*. The three compositions all share the same carefree mood, characteristic of Renoir's paintings of bourgeois leisure activity from this period, as well as the use of soft brush strokes to suggest the flickering of warm sunlight. These similarities have led several scholars to date the Pushkin painting to 1876. A differing view was voiced by Renoir's early biographer the dealer Ambroise Vollard (1918), who placed the painting in the 1880s — a date that should not be totally discounted, given that the Moscow *Moulin de la Galette* exhibits wider and flatter brushwork than the Musée d'Orsay paintings.

As his models for this and other related works, Renoir used his friends, including several artists. They not only posed for Renoir but also helped him carry his large canvases to and from the dance hall. The finished picture however was no doubt produced in the artist's Montmartre studio, where he may have worked from portrait sketches that no longer exist. According to a label on the stretcher of this picture, which indicates the date 1875, the woman in the striped dress is Nini, one of Renoir's frequent models (she is featured, for example, in the *Theater Box*, known as *La Loge*, 1874, in the Courtauld Institute Galleries, London). Claude Monet is seated behind her; the painter Pierre Franc-Lamy is standing; and another painter, Frédéric Cordey, is seated next to a second, unidentified young girl. Daulte (1971) believed the standing man to be Sisley and the man seated on the right to be the painter Norbert Goeneutte. M. B.

27. *Girls in Black*, c. 1880/82

Oil on canvas, 81.3 × 65.3 cm
Signed, lower right: *A R.*
Moscow, Pushkin Museum, Inv. no. 3329

WITH ITS CONCERT and dance halls, Montmartre, where Renoir took a studio in 1876, became the primary source for the attractive *parisiennes* who populate his canvases from this time. In *Girls in Black*, two fashionably dressed young women are engaged in conversation in a busy café.

While Daulte (1971) dated it to 1881, this lively painting was probably executed between 1880 and 1882, as Feist (1961) suggested. Feist also noted a resemblance between the dreamy-eyed woman on the left of this painting and a portrait of an unknown woman in the Pushkin Museum (inv. no. 10306), which he assigned to c. 1882/85. An oil study for the left-hand figure exists in a private collection, New York (Daulte 376). Compositionally and technically, *Girls in Black* displays Renoir's shift from his Impressionist technique, wherein he painted with small brush strokes of vibrating color, to a more classic style in which he employed well-defined contours and large areas of smoothly applied pigments. M. B.

PAUL CÉZANNE

1839 — Aix-en-Provence — 1906

The son of a prosperous banker, Cézanne received informal artistic training in his native Aix and in Paris. At the Académie Suisse, he met Camille Pissarro and, through him, other Impressionist painters. Under the tutelage of Pissarro, in the village of Pontoise, Cézanne abandoned the darkly Romantic themes and heavy colors of his earlier works for the viewpoint, subject matter, and palette of the Impressionists, exhibiting with them twice (1874, 1877). In 1882, he returned to Aix, where he lived and worked in relative isolation. Trying to reconcile the naturalism of Impressionism with the tradition of structural and formal analysis that pervades classical French painting, he produced portraits and figure studies of his wife and other villagers, compositions of bathers in outdoor settings, still lifes, and landscapes of the environs of Aix, particularly Mont Sainte-Victoire and the Bay of Marseilles, as seen from the village of L'Estaque. Cézanne's first one-person exhibition, at the gallery of Ambroise Vollard in Paris in 1895, introduced his art to many younger artists; from this time, he was to exert enormous influence on modern art movements, particularly Cubism.

28. *The Smoker*, c. 1890/92

Oil on canvas, 92.5 × 73.5 cm
Leningrad, Hermitage, Inv. no. 6561

CÉZANNE BEGAN WORKING on a series of card players and smokers in the early 1890s, while still in Aix. Although the motif is an old one, with roots in seventeenth-century art, Cézanne found something new in the theme. Avoiding local color and anecdote, he made his smokers symbols of aloofness from everyday turmoil. The same tranquil, immobile poses can be found in earlier images of seated figures by the artist, such as the *Portrait of a Man* from the 1860s (Paris, Musée Marmottan), *A Young Man with a Skull* (c. 1896/98; Merion, Pennsylvania, Barnes Foundation), and *A Young Woman Leaning on Her Elbow* (c. 1900; New York, Rosenthal collection). The air of detachment that fascinated the painter is however most convincing in Cézanne's paintings of smokers.

In the 1890s, Cézanne often used local peasants as models. The man depicted here appears as well in two related pictures, a canvas in the Pushkin Museum (no. 29) and one in the Kunsthalle, Mannheim, for which there is a watercolor sketch (1890/91; Merion, Pennsylvania, Barnes Foundation). The sitter in the Mannheim version assumes the same pose but seems less aloof, because of the relatively realistic treatment of the eyes, in contrast to the orbital black brush strokes of the eyes in the Hermitage *Smoker*. While the wall behind the sitter in the Mannheim picture is unadorned, the artist introduced into both the Pushkin and Hermitage compositions details of other paintings. Featured on the wall in the Hermitage canvas is a still life with apples (*Fruits with a Black Bottle*, 1871; Berlin, Staatliche Museen), and a corner of what appears to be a composition with bathers. Both seem to allude to life's temptations and ephemeral nature.

Cézanne's *Smokers* have been given different dates by various scholars. Venturi (1936) dated them 1895/1900. Cooper (1983) did not find them similar to works documented to these years and moved the date back to 1893/94. Reff (1977) dated them even earlier, to 1890/92. His dating is the most convincing. A. K.

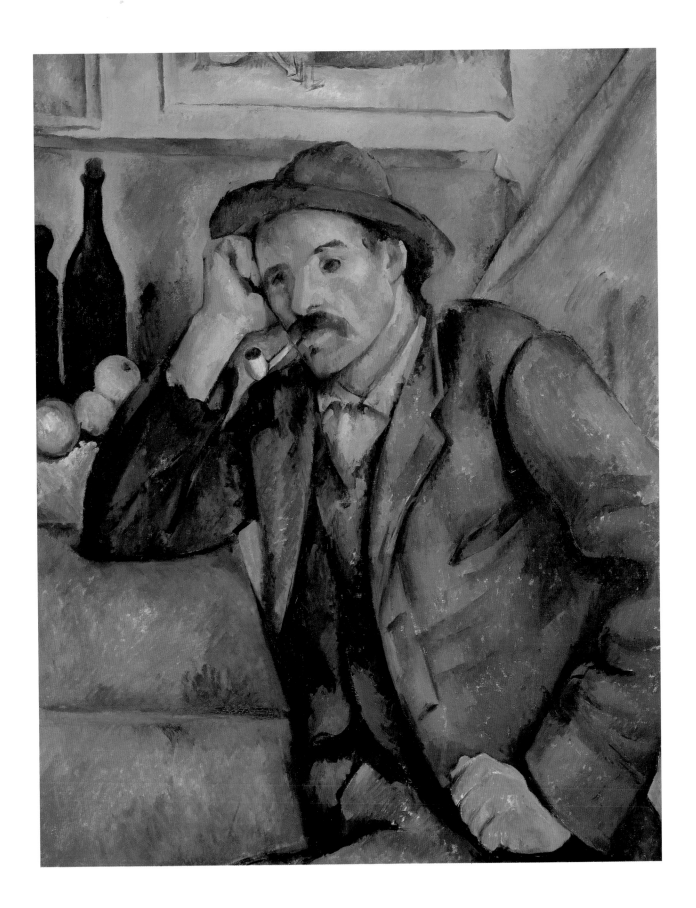

29. *The Smoker*, c. 1890/92

Oil on canvas, 92.5 × 73.5 cm
Moscow, Pushkin Museum, Inv. no. 3336

CÉZANNE'S IMAGES OF card players and smokers are contemporaneous with his series of bathers. But the chronology of the card players and smokers remains unclear. It is possible that the artist moved from multifigural compositions to single, more monumental images. However it is also possible that Cézanne worked simultaneously on several canvases, using the same models—residents of Aix—in varying compositions. The Pushkin and Hermitage (no. 28) *Smokers*, for example, depict the same man. He appears again in a related painting in the Kunsthalle, Mannheim, and in a watercolor sketch for this composition (1890/91; Merion, Pennsylvania, Barnes Foundation). Thus Hoog (1978a Paris), who pointed out that this model posed for the right-hand figure in Cézanne's *Card Players* (Paris, Musée d'Orsay), believed that the paintings of peasants seated indoors with cards or pipes were executed at the same time or in following years, with the aid of sketches and drawings.

In contrast to the village pub setting of the card player images, in the Moscow and Leningrad pictures the smokers are posed in the artist's studio. The figure in the Pushkin canvas is seated at a table; his head, turned toward the viewer, leans on his right hand, a traditional pose indicating contemplation or melancholy. As in the Leningrad *Smoker*, the artist included his art in the background. The painting whose lower left side is seen at the right may be the portrait of the artist's wife (c. 1885) that is in The Detroit Institute of Arts, slightly altered, or another portrait in the Musée d'Orsay, Paris.

The woman's right arm, echoing the position of the left arm of the seated smoker, connects the "real" painting and the "painted" one. Her self-containment, indicated by the oval of her curved limb, isolates her from the surrounding space and may possibly be an allusion to the artist's own diffidence and his self-imposed exile. Certainly Venturi (1936) was not correct in thinking that the smokers represented to Cézanne "peasants with a clear conscience," pure like the land on which they worked. The lonely, contemplative figure of the smoker in the artist's studio, juxtaposed with the portrait of Madame Cézanne, might provide a further clue to understanding the artist's personal identification with this theme.

From such works as *The Smoker*, there is a clear path to Pablo Picasso's depictions of café life in his early Blue and Cubist periods, as well as to the Cubist works by members of the French and Russian avant-garde such as Braque, Chagall, Gris, Malevich, and Popova. In relation to Cubism, Cézanne's *Smoker* is especially interesting, both for the freedom with which the artist depicted the table and for his hard-edged treatment of the drapery and tablecloth, which transforms the table into an architectural construction. M. B.

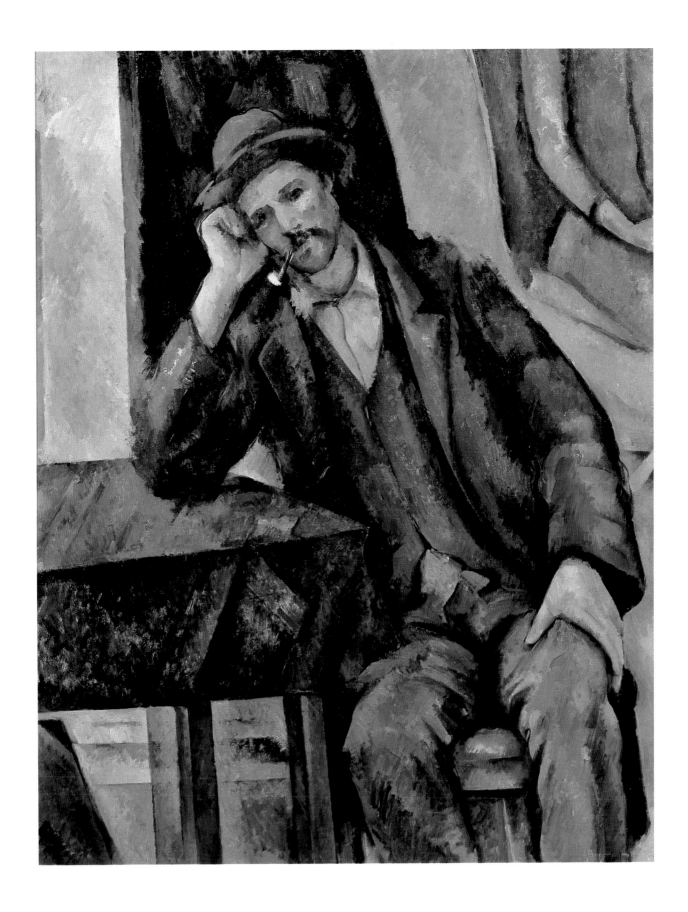

30. *Still Life with Peaches and Pears*, c. 1890/94

Oil on canvas, 61 × 90 cm
Moscow, Pushkin Museum, Inv. no. 3415

OVER AND OVER, CÉZANNE executed still lifes with similar objects displayed on the same work table. Reff (1977) discussed the problem of dating these compositions according to the objects alone, since they traveled with the artist between his house and studio in Aix and his studio in Paris. At various intervals during the 1890s, for example, Cézanne did still lifes which, like the Pushkin canvas, contain the same milk pitcher with floral decorations. These include one, dating from the late 1890s, in The Museum of Modern Art, New York; and another in the Nasjonalgalleriet, Oslo, which Venturi (1936) dated to c. 1888/90 and Reff (1977) to 1890. Closest in composition to the Moscow work, the Oslo version depicts the milk pitcher and a platter of fruit on a table with an open front drawer. But it lacks certain features, including the sugar bowl and tablecloth, which energize the composition in the Pushkin painting. Moreover, in the Oslo still life, the pitcher is placed in the center and serves to stabilize and balance the composition. In the Pushkin version, Cézanne achieved a dynamic balance in a different way, situating the pitcher off-center and setting it against the white peaks of the tablecloth and the light blue wall. The strong diagonal sweep from the lower left to the elegantly curved legs of the *guéridon* at the upper right is kept in check by the high vantage point, which allows our eyes to rest on the still-life arrangement in the foreground. The complexity of this composition, in comparison with the Oslo work, suggests a later date, of about 1890/94.

Bursting with energy and vitality, *Still Life with Peaches and Pears* is a splendid example of the sheer pictorial force that Cézanne was able to inject into his still lifes. With the earthiness of the fruits and mountainous qualities of the white cloth silhouetted against the blue wall, the composition manifests a topography that rivals his landscapes. M. B.

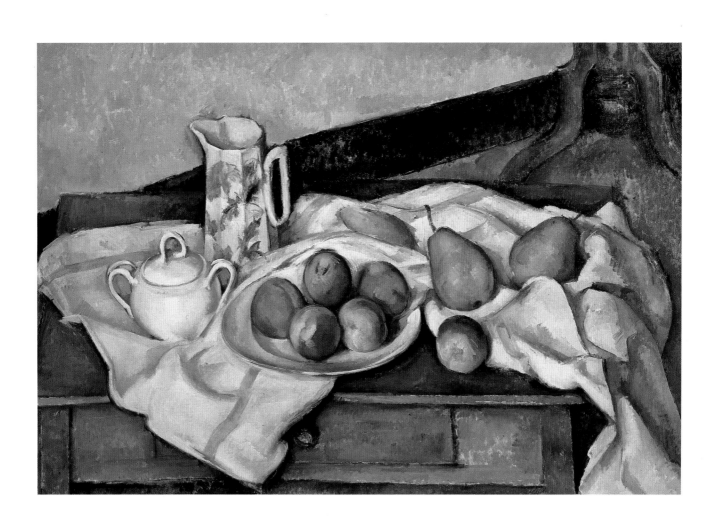

31. *Still Life with Curtain*, c. 1894/95

Oil on canvas, 55 × 74.5 cm
Leningrad, Hermitage, Inv. no. 6514

IN GENERAL, THE DATING OF Cézanne's late still lifes remains problematic. While biographical details about his sitters may assist in arriving at approximate dates for his portraits, his still lifes contain objects, such as the milk pitcher in *Still Life with Peaches and Pears* (no. 30) or the floral curtain in this painting, that are known to have been used by the artist in both his studios in Paris and in Aix-en-Provence. For the Hermitage painting, scholars have offered a number of dates. Venturi (1936) placed the work around 1895, while Gowing (1954), Barskaya and Georgievskaya (1975), and Rewald (1978a Paris) believed it to be from 1899. Sterling (1958) assigned it to the years 1895/1900. On the other hand, basing his arguments on stylistic comparisons, Cooper (1983) noted the absence here of sharp contours and dark shadows in the drapery folds, which are typical of Cézanne's works in the late 1890s, and dated the painting to 1894/95.

The painting is closely related to a canvas in the Barnes Foundation, Merion, Pennsylvania, which is unfinished. Dated to 1892/94, the Barnes still life is less detailed than the Hermitage painting and probably preceded it. Nonetheless the cloth on the right side of the table in *Still Life with Curtain* is apparently unfinished. This does not in any way detract from the painting's quality or effect. Toward the end of his life, Cézanne frequently considered as unfinished images that today we think of as perfect. Consciously or intuitively, the artist stopped work on this canvas when he realized that more "finish" would ruin its overall structure. A. K.

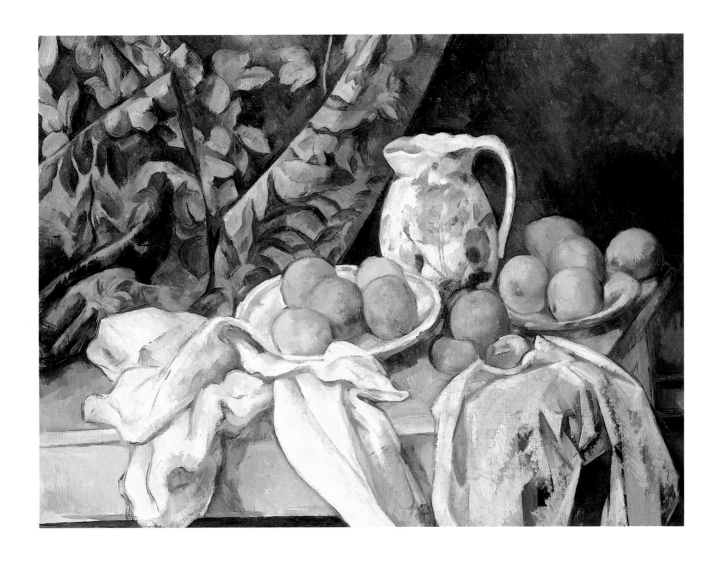

32. *Mont Sainte-Victoire*, c. 1882/85

Oil on canvas, 58×72 cm
Moscow, Pushkin Museum, Inv. no. 3412

IN THIS VIEW OF HIS beloved Mont Sainte-Victoire, Cézanne focused on the plain leading to the mountain as seen from the Valcros road. The small house to the right of the composition reappears in a related pencil sketch in the Kunstmuseum, Basel.

Warm orange hues create a sense of sunlight which pervades the landscape. While the middle ground, containing bushes, boulders, and a hut, is rendered with solid and firmly outlined forms, the sky and foreground are painted in sketchy, fluid strokes. Cézanne's predominantly orange palette, manner of execution, and conception of the landscape suggest a relatively early date for the painting. Although the artist moved away here from the influence of Impressionism—the forms and their interrelationships are clearly defined, the colors intense—he had not yet developed the proto-Cubist style so evident in later views of Mont Sainte-Victoire (see no. 33).

This canvas has been dated as early as 1878/79 by J. Rewald and as late as 1882/85 (Venturi 1936). The latter date has been supported by Bessonova and Barskaya (1985), who compared the style of the Moscow painting with that of another image of Mont Sainte-Victoire in the Barnes Foundation, Merion, Pennsylvania, executed in these years. The dating of the Pushkin picture is however complicated by a label written by Cézanne's son on the back of a photograph of the painting in the Paris archives of the art dealer Ambroise Vollard. The label states that the landscape was executed in 1880, the year to which Meier-Graefe (1922), an early biographer of Cézanne, also ascribed the picture. M. B.

33. *Mont Sainte-Victoire*, c. 1906

Oil on canvas, 60 × 73 cm
Moscow, Pushkin Museum, Inv. no. 3339

FOR A LONG TIME, this painting was thought to date from 1905, the year before the artist's death. This dating was based on a label found on the back of the canvas that includes the words "Exposition 1905," from which it has been inferred that the painting was exhibited in the 1905 Salon d'Automne in Paris. Another piece of evidence cited in support of this date is a painting (France, private collection) by Maurice Denis, believed to have been executed about 1905, depicting Cézanne, with Denis and the artist Ker Xavier Roussel, at work on a landscape near Aix that is thought to be this canvas. In describing this visit with Cézanne, Denis did not mention any canvas by name, but his commentary is interesting: "He spoke with us for about half an hour, and after breakfast made a date with us at the site of his motif. This motif, a view of Sainte-Victoire (the big mountain dominating its environs) was far away; he got there by car. We saw him at work in a valley of olives. I sketched him..." (M. Denis, *Journal* [Paris, 1957], vol. 2, p. 31). Rewald (1977) disputed the 1905 date. He dismissed the label as one that was added by Vollard's gallery; and he dated the Denis painting to 1906, based on sketches done at Aix by Denis in which one sees the same view of Mont Sainte-Victoire from Les Lauves as depicted in the Moscow painting. In addition, Rewald published Denis's photographs, taken from that same visit to Aix, showing Cézanne at work on the motif of the mountain, presumably the painting included in Denis's canvas. A date of 1906 for the Pushkin painting was also favored by Gowing (1977), based on a stylistic comparison with Cézanne's last landscapes, which display a similar dark palette and square, regular pre-Cubist forms. If Rewald and Gowing are correct, then the Moscow composition may indeed be the canvas Denis saw the artist working on during his January visit to Aix and is thus one of Cézanne's last versions of this theme.

The works related to *Mont Sainte-Victoire* are a watercolor (1902/1906; London, Tate Gallery) and a study in pencil and watercolor (1902/1906; New York, The Museum of Modern Art) of Mont Sainte-Victoire from the same vantage point at Les Lauves. A watercolor (London, Tate Gallery), similar in composition and chromatic structure, was dated by Venturi (1936; no. 1529) to 1904/1906. These last works formed the basis for Reff's (1977) conclusion that this group, including the Pushkin painting, should be dated about 1902/1906.

In the inventory of the Museum of Modern Western Art in Moscow is a note that states: "...Henri Matisse, during his stay with S. Shchukin in Moscow, varnished this picture." Since Matisse was in Moscow in 1911, the picture was in Sergei Shchukin's possession by that time. M. B.

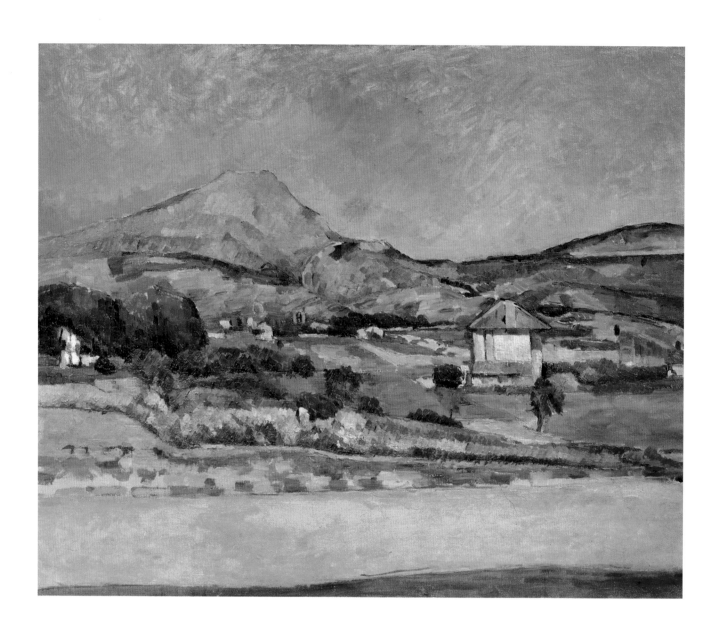

PAUL GAUGUIN

1848 Paris — Hivaoa (Atuana), Marquesas Islands 1903

A successful stockbroker, Gauguin began taking informal painting lessons in 1872 from Camille Pissarro and participated in three Impressionist exhibitions (1880–82). His full-time artistic career began in 1883, when he lost his job following a slump in the Paris Stock Exchange. In 1887, he traveled to Martinique; in 1888, he lived and worked in Brittany with Emile Bernard and in Arles with Vincent van Gogh. He developed a new approach to painting called Synthetism and a pictorial style that corresponded to literary symbolism. Dissatisfied with contemporary society, he left for Tahiti in 1891. He returned to Paris in 1893, and left for his second and final trip to Tahiti in February 1895. He moved to the Marquesas Islands in 1901, where he died.

34. *Self-Portrait,* c. 1888/89, 1891/93, or after

Oil on canvas, 46 × 38 cm
Signed, lower left: *P. Go*
Moscow, Pushkin Museum, Inv. no. 3264

THIS UNDATED SELF-PORTRAIT has generated considerable scholarly controversy. Rewald (1938), Sterling (1958), and Cooper (1983) have assigned it to 1888/89. Wildenstein (1964) dated the painting to 1888 and listed, as justification, Sterling's opinion that the artist's self-portraits from 1888–89 show him with a mustache that curls upward, while, after 1890, it droops downward. Wildenstein further suggested that van Gogh's mention of "a self-portrait just completed by the artist [Gauguin]," in a letter to his brother, Theo, in January 1889, may also allude to the Pushkin portrait.

Recently Cachin (1988–89) argued that the background of *Self-Portrait* represents a portion of the figure of the woman in *In the Waves (Ondine)* (1889; Cleveland Museum of Art). This identification is questionable, since neither the red of Ondine's hair nor her proportions coincide exactly with those of the figure in the Pushkin painting. Alternatively the bright, yellow band at the left resembles the yellow background of many paintings from Gauguin's Tahitian period. A similar yellow band is seen in the background of the *Self-Portrait with a Hat* (Paris, Musée d'Orsay), painted during Gauguin's visit to Paris from Tahiti in 1893–94. This self-portrait is identical in format to the Pushkin painting, and both are signed *P. Go* (on the front in the Pushkin canvas and on the back in the Musée d'Orsay portrait). These factors, as well as the inclusion in the background of the Paris portrait of an important painting by the artist (*Manao Tupapau* (1892; Buffalo, Albright-Knox Art Gallery), suggest that a later dating for the Moscow painting is possible. Unfortunately, as the paint has been damaged by the application of wax to the surface, significant details have been obscured. Some scholars have attempted to place the Hermitage picture in the final period of Gauguin's life, noting that the canvas is of the rough burlap or hemp used by Gauguin in the Marquesas Islands. It may be one of the three paintings that the artist sent in 1903 from the Marquesas to the French collector Gustave Fayet and that Gauguin mentioned in a letter to his friend Daniel de Monfreid. It may also be the self-portrait that Shchukin purchased from Fayet. But such arguments are debatable: The identification of

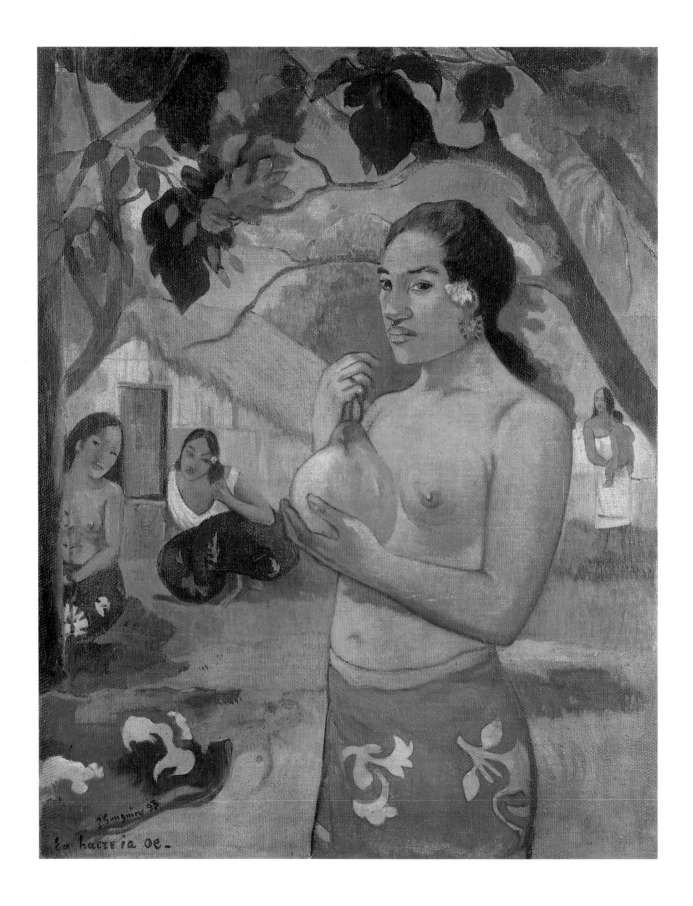

the Hermitage self-portrait as the one purchased by Shchukin from Fayet is not confirmed; and Gauguin used the coarser, and cheaper, burlap support throughout his life. X-ray photographs, presently being studied, may shed light on this controversy; for example, they betray differences in the way the figure and background were painted. M. B.

35. *Woman Holding Fruit*, 1893

Oil on canvas, 92 × 73 cm
Signed, dated, and inscribed, bottom left: *P. Gauguin, 93 Ea haere ia oe.*
Leningrad, Hermitage, Inv. no. 9120

GAUGUIN WAS INSPIRED, shortly after he arrived in Oceania, to paint a composition with a single, large-scale Tahitian figure in the foreground, like an Eve of a pagan paradise. *Woman Holding Fruit* was preceded by a similar vertical canvas entitled *Ea haere ia oe* (1892; Stuttgart, Staatsgalerie). In comparison with the Stuttgart painting, the Hermitage version is less clumsily drawn and has a much stronger compositional coherence and more emphatically decorative rhythm. The central figure of the woman, in particular, is silhouetted by arabesque lines recalling the smooth linear drawings of J. A. D. Ingres (see nos. 23–24), whose work Gauguin admired.

The Stuttgart painting probably depicts Titi, for a short time the artist's mistress, carrying a small animal, perhaps a dog. Her pose, impassive expression, and gesture of clutching the animal against her side have linked this figure with a later sculpture, *Oviri* (1894/95; Paris, Musée d'Orsay), and with the figure in *The Idol* (1898; Pushkin Museum). In the Hermitage painting, the female is Tehamana, the artist's young Tahitian wife, who was pregnant at this time. Carrying herself with great dignity, Tehamana holds a fruitlike receptacle, perhaps a symbol of the life she is bearing, a theme echoed by the woman at the right carrying a baby in her arms.

All of the figures in the painting are based on drawings made by Gauguin in 1891–92. In particular, the crouching figure seen second from the left appears repeatedly in the early Tahitian paintings, including *Landscape with Black Pigs and a Seated Tahitian Woman* (1891; Scotland, Cargill collection), *Te Fare Hymenee* (*The House of Songs*) (1892; Lausanne, Josefowitz collection), and in *Nafea faa ipoipo* (*When Will You Marry?*) (1892; Basel, Kunstmuseum), for which a large-scale preparatory pastel is in The Art Institute of Chicago.

The inscriptions on both the Hermitage and Stuttgart canvases are Tahitian phrases meaning "Where are you going?" According to the Danish ethnographer and Gauguin scholar Bengt Danielsson, this is a customary island greeting. The Hermitage painting however is better known by the title describing the central woman holding the fruitlike receptacle, which has been referred to as a mango or breadfruit. A painted-glass window of 1892, showing a woman, nude to the waist, holding a similar vessel, was apparently executed before the Stuttgart painting, and may be considered an archetype for the Hermitage picture (this piece was taken out of Tahiti by the writer Somerset Maugham and is now in the Berman collection, United States). However the object in the Hermitage painting is more likely a gourd used to carry water. This identification is supported by a watercolor

from Gauguin's manuscript *Noa Noa* (Paris, Musée du Louvre, Cabinet des Dessins), entitled *Tahitian Legend*, which precedes the Hermitage painting and which shows, at the right, a Tahitian woman, naked to the waist and in the same pose, holding a water vessel. In this event, the question and title, "Where are you going?" could have practical as well as symbolic significance. A. K.

36. *Sunflowers*, 1901

Oil on canvas, 73 × 92.5 cm
Signed and dated, lower right: *Paul Gauguin, 1901*
Leningrad, Hermitage, Inv. no. 6516

ALTHOUGH THIS PAINTING was executed in Hivaoa in the Marquesas Islands, Gauguin had been interested in painting similar motifs from the beginning of his career. The compositional elements of a still life arranged on a chair next to an open window, for example, are found in the early painting *To Make a Bouquet* (1880) in the Jäggli-Corti collection, Winterthur.

The choice here of sunflowers however must have been consciously associated with Vincent van Gogh, with whom Gauguin lived in Arles from late October to late December 1888. Van Gogh's paintings of sunflowers are well known; Gauguin executed a portrait of van Gogh painting sunflowers (1888; Amsterdam, Rijksmuseum Vincent van Gogh).

Gauguin returned to this motif in 1901, when he painted a series of still lifes, including the one in the Hermitage. Although one canvas in this group, *Sunflowers in an Armchair* (Zurich, Emile Bührle Foundation), is compositionally very close to the Leningrad painting, it is smaller and lacks much of the mystery of the larger, Hermitage *Sunflowers*. Noticeably absent in the Zurich version is the impassive head of the Tahitian woman, framed by the window, her oriental features evoking a Buddha-like effigy (a figural type, in fact, that Gauguin once attempted to reproduce in a woodcarving). An analogous head appears in a drawing that Gauguin created to illustrate his manuscript "Avant et après" (see J. Rewald, *Gauguin's Drawings*, New York, 1958, no. 119).

In the Hermitage *Sunflowers*, the "eye" placed in the center of the tallest flower reinforces the spiritual resonance of this composition. One sees here the influence of Odilon Redon's fantastic visions, such as the "eye-flower" which hovers over imaginary plants in his early lithographs. The motif of an eye surrounded by rays—an all-seeing eye—is a common symbol in Christian mysticism, while the sunflower itself, as its name suggests, is a traditional symbol for the sun.

As in the majority of Gauguin's works, the symbolism of this painting remains elusive. In returning to themes that had interested him earlier, the artist seems to have been trying to repossess aspects of the world he had abandoned for Oceania. The intention was probably conscious. In the fall of 1898, for example, Gauguin asked his friend Daniel de Monfreid to send him sunflower seeds from France, since they did not then grow in Tahiti. Like the sunflowers, the armchair in the Hermitage canvas is European, while the woven basket belongs to the tropics and the Buddha-like head to the Orient. Gauguin's *Sunflowers* is a moving attempt to reconcile his past and present lives. A. K.

PIERRE BONNARD

1867 Fontaine aux Roses—Le Canne 1947

By 1888, Bonnard had abandoned his legal studies to enroll at the Académie Julian, Paris. It was there that he met the artists with whom he would associate during the next ten years, including Maurice Denis, Félix Vallotton, and Edouard Vuillard. Calling themselves the Nabis, after the Hebrew word for prophet, they were influenced by the pictorial symbolism espoused by Paul Gauguin. Inspired by Japanese prints, Bonnard developed a style of strong color contrasts and sharply defined lines for decorative effect rather than the definition of volume. He produced ensembles, posters, and prints in this manner. In the early 1890s, Bonnard began to paint in a more Impressionist style, developing the luminous palette that established him as one of the leading colorists of his generation.

37. *Mirror over Washstand*, 1908

Oil on canvas, 120 × 97 cm
Signed, upper right: *Bonnard*
Moscow, Pushkin Museum, Inv. no. 3355

BETWEEN 1907 AND 1910, the artist completed a series of paintings depicting a female nude in the same interior with a mirror above the sink. He took up the theme again briefly between 1915 and 1920. In all these paintings, Bonnard was fascinated by the relationship between reality and illusion magnified by the presence of a mirror as a pictorial element. Indicating three-dimensional space on a two-dimensional surface is, by definition, an excursion into illusion; adding the notion of space reflected in a mirror further complicates the problem—offering an opportunity to create a picture within a picture. The inclusion of a mirror also serves to reflect the actual space occupied by the artist, as well as the space he observes. The seated woman seen here reflected in the mirror and holding a cup may represent Bonnard's companion Maria Boursin, who called herself Marthe de Méligny and who was to become his wife in 1925.

In the various versions he did on this theme, Bonnard assumed different viewpoints. In a painting from the same year as the Moscow picture, *Nude Seen against the Light* (Brussels, Musées royaux des beaux-arts et de l'art moderne), for example, the woman is the central focus; her diagonally posed figure leads the eye to the left third of the composition, occupied by a tub, vanity table, and mirror. In another variant, *The Mirror* (Paris, Musée national d'art moderne), the still life is the subject, while in two later versions, *Nude before a Mirror* (1908/1909; Basel, private collection) and *Reflection in a Mirror* (1909; Winterthur, Kunstmuseum), the majority of the canvas depicts the reflected space, bounded by the mirror frame. In the Moscow painting, as well as in *The Mirror in the Green Room* (1909; Indianapolis, John Herron Art Institute), the toiletry set on the washstand is brought into close focus and given an importance equal to that of the nude and the surrounding interior, so that the painting encompasses not one but several different genres. The composition of *The Mirror* (1908; Paris, Musée national d'art moderne) is analogous. In all of these works, the still life hovers on the border between the real and reflected interior space, becoming, in fact, the key to the compositional balance of these complex and, at the same time, sensuous interiors. M. B.

38. *The Beginning of Spring, Small Fauns*, c. 1909

Oil on canvas, 102.5 × 125 cm
Signed, lower right: *Bonnard*
Leningrad, Hermitage, Inv. no. 9106

IN THIS COMPOSITION, two fauns enchant nature, awakening spring with their pipes. Bonnard depicted Dionysian mythological figures in naturalistic settings in two other canvases. The earliest, a small work finished in 1907, shows a faun and is variously titled *The Afternoon of a Faun*, *The Ravaged Nymph*, and *Pan and the Nymph* (Dauberville [1968], no. 471). Another, entitled *Faun*, painted a year after the Hermitage picture and more decorative, is in a private collection, Switzerland. In this canvas, Bonnard developed the compositional idea he had essayed in the Hermitage picture, placing in the left-hand corner a satyrlike, goat-legged creature making music.

Several years earlier, in 1902, Bonnard had dealt with pastoral motifs in his illustrations of Longus's *Daphnis and Chloë*, which had been commissioned by his book publisher, the dealer Ambroise Vollard. Like many of the artists associated with Symbolism, Bonnard was an admirer of Stéphane Mallarmé's poem "The Afternoon of a Faun" (1865) and of Claude Debussy's prelude of the same name (1894). (The second was to be reinterpreted in 1912 in the scandalous production of Nijinsky and the Ballets Russes.)

While Charles Terrasse (1927), the artist's nephew and biographer, suggested a 1910 date for the painting, it is likely that, as Jean and Henry Dauberville, heirs to the Galerie Bernheim-Jeune in Paris and authors of the catalogue raisonné of Bonnard's paintings, have suggested (1968), this canvas was executed in 1909. The fact that Bonnard stayed in Vernouillet during the spring of that year, where he painted a similar scene, entitled *Rainy Landscape* (Helsinki, Ateneumin Taidemuseo) and purchased by Bernheim-Jeune in 1909, supports the earlier date for the Hermitage painting. Preceding the Helsinki version moreover is a work from The Phillips Collection, Washington, D.C., entitled *First Spring*, dated 1908 and exhibited in the Salon d'Automne of that year, as well as another landscape, *The Thunderstorm* (Switzerland, formerly Hahnlöser collection), from the same year. Both of these feature details of the landscape at Vernouillet and were probably painted in 1907/1908, after Bonnard's stay there in 1907.

In the Hermitage painting, Bonnard replaced the children seen in *First Spring* and in *The Thunderstorm* with the pair of fauns. These arcadian additions, juxtaposed with very particular architectural structures and a road winding toward the mist-covered horizon, provide evocative counterpoints between fantasy and reality. A. K.

39. *Summer in Normandy*, c. 1912

Oil on canvas, 114 × 128 cm
Signed, lower right: *Bonnard*
Moscow, Pushkin Museum, Inv. no. 3356

IN THE SUMMER OF 1912, Bonnard acquired the villa "Ma Roulotte," in the village of Vernonnet, northwest of Paris along the river Seine. The rolling landscape of this area inspired Bonnard to do a number of large-scale decorative paintings of landscapes on the theme of the seasons. Many of these, including the Pushkin painting, probably executed in the summer of 1912, were exhibited at the Galerie Bernheim-Jeune in Paris during May and June of the following year.

In *Summer in Normandy*, Bonnard depicted the people surrounding him at Vernonnet. In the shadow of the awning framing the foreground, Marthe de Méligny (Bonnard's long-time companion, and, in 1925, his wife) reclines on a lounge chair; on her lap is a favorite family pet, the basset hound Evi. Marthe's darkened form is contrasted with that of a friend, shown in full sunlight. In the use here of a prismatic palette to suggest the sun-drenched landscape into which the silhouettes of figures and forms are dissolved, the painting can be compared to another decorative landscape, from c. 1912/13, formerly in the Helena Rubenstein collection.

The Pushkin painting inspired a poetic passage by Bonnard's nephew and biographer, Antoine Terrasse (1967). Praising the artist's use of light and shadow, the resemblance of the female forms to shapes in nature, and the intermingling of the figures, he concluded that the overall effect expresses "the enigma that confronts the dreamer, or someone who is awakened suddenly in a landscape devoured by the sun." M. B.

40. *Summer, The Dance*, c. 1912

Oil on canvas, 202 × 254 cm
Signed, lower right, on the stool: *Bonnard*
Moscow, Pushkin Museum, Inv. no. 3358

PAINTED IN GRASSE, where Bonnard periodically lived and worked after 1912 in the villa "Antoinette," *Summer, The Dance* manifests the vividly decorative manner that characterizes other works by Bonnard on the theme of the seasons that were exhibited at Galerie Bernheim-Jeune in Paris in May–June 1912. The Daubervilles (1968) dated the painting to 1912, the year it was purchased by the Galerie Bernheim-Jeune.

Beginning in 1911, Bonnard developed a series of decorative canvases showing figures in close harmony with nature. These pastoral "families" represent members of the artist's own family, pets, and close friends. In all cases, the figures seem almost to melt into their natural surroundings. The painting is filled with independent scenes which, taken together, contribute to the sense of idyllic life. At the left of the Pushkin painting, a friend of Bonnard, dressed in a white tropical suit and hat, assumes the role of a shepherd playing reed pipes in the midst of the Arcadian setting. He is accompanied by a dog and quietly grazing goats. A woman in a dark dress plays with a small child. Cats stroll next to a picnic table in the lower right corner. The center area is reserved for the dancing girls who give the painting its name.

This motif is repeated in *Early Spring in the Country* (1912; Pushkin Museum), one of four monumental decorative paintings on the theme of the seasons commissioned by Ivan Morozov for the vestibule of his Moscow residence. The artist explored the idea of a large-scale decoration made up of multiple activities in an earlier decorative triptych, *The Mediterranean* (1911; Hermitage), also ordered by Morozov. Together these works embody Bonnard's feelings about the beautiful Mediterranean region, where he was to spend an increasing amount of time, as well as his vision of ideal existence. M. B.

HENRI MATISSE

1869 Le Cateau-Cambrésis — Nice 1954

The greatest French artist of the twentieth century, Matisse is celebrated especially for the color and harmony of his paintings. He studied briefly with Adolphe William Bouguereau and then with Gustave Moreau. He moved through a brief Pointillist phase; by 1905, however, in the Salon d'Automne, Paris, Matisse spearheaded a radical new movement, Fauvism, which exalted intense and pure color for decorative, symbolic, or emotional expression. Matisse soon abandoned his Fauvist manner for more subtle and subdued effects. In 1913, he made two trips to Morocco, which deeply influenced his style, palette, and themes. He found Paris less and less appealing, preferring the warmth and brilliant sunlight of southern France. By 1921, he had settled permanently in Nice. In the 1940s, the war and Matisse's own poor health caused him to vanish from the public eye. When he re-emerged, the world saw for the first time the monumental paper cutouts on which he had concentrated his energies at the end of his life.

41. *Game of Bowls*, 1908

Oil on canvas, 113.5 × 145 cm
Monogrammed and dated, lower left: *H.M. 08*
Leningrad, Hermitage, Inv. no. 9154

THIS PAINTING IS PART of a series of works in which Matisse explored the theme of peace and innocence in the Golden Age. The series includes, among others, *Joy of Life* (1905–1906; Merion, Pennsylvania, Barnes Foundation), *Le Luxe I* and *II* (1907, Paris, Museé national d'art moderne; 1907–1908, Copenhagen, Statens Museum for Kunst), and *Bathers with a Turtle* (1908; St. Louis Art Museum). This last painting, in which three female figures focus on a turtle, is very close compositionally to *Game of Bowls*. In both canvases, nude figures are shown at play, concentrating on a single action, and are isolated against a landscape reduced to three horizontal bands indicating land, water, and sky.

The meaning of *Game of Bowls* does not lie in a narrative content or the expression of a psychological state. Instead it is symbolic. Because the symbolism is subjective rather than literal, it is ambiguous. The activity depicted, the popular European game of pitching bowls (French: *boules*), seems less a recreation than a ritual, such as divining one's fate. The green of the life-giving earth and blue of the water and sky are presented in dramatic, yet solemn, simplicity. The river, painted unnaturalistically at the top of the canvas, may symbolize at once the river of life and the river of death; in this context, it is interesting to note that the Egyptians employed green to represent Osiris, god of reproductive powers and of the world beyond the grave. It would appear that the disposition of the landscape, the use of the same number of figures as balls, and the evocative, albeit not joyous, color scheme all serve a symbolic function.

In keeping with the primordial state of mankind that is expressed in this painting, the composition is daringly and energetically simplified. As Flam pointed out, the canvas displays the spontaneous and sketchy quality of a very large watercolor. Pablo Picasso recalled that Matisse developed this reductive style by watching his sons, Pierre and Jean, who at this time were just learning to draw: The crude contours and clumsiness of their work showed their sophisticated father how to simplify and to extract the essence of a form.

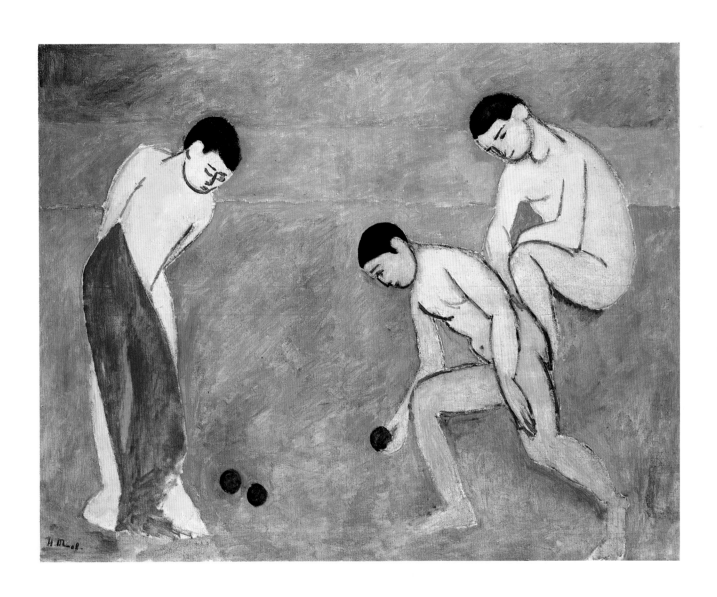

Yet, since Matisse evolved this style over several years, it is wrong to place too much credence in this explanation. Although Flam suggested that the painting was done shortly after the artist moved into his new studio on the Boulevard des Invalides in Paris, that is, in the spring of 1908, there is a reference in the catalogue of the Museum of Modern Western Art, Moscow, to a tag formerly on the painting which read: "Collioure Paris Ber." Thus it appears that the painting was sent to Matisse's dealer, the Galerie Bernheim-Jeune, from Collioure, where Matisse had spent the summer working. By early 1909, the collector Sergei Shchukin owned the painting, which was reproduced in the Moscow journal *The Golden Fleece* as *A Ball Game*. A. K.

42. *Nymph and Satyr*, 1909

Oil on canvas, 89 × 116.5 cm
Signed and dated, lower right: *Henri Matisse. 09–*
Leningrad, Hermitage, Inv. no. 9058

IN THE SPRING OF 1907, Matisse made a ceramic triptych for Karl Ernst Osthaus's private museum in Hagen, Germany. On each side panel is a dancing nymph or bacchante; the central part depicts a satyr surprising a sleeping nymph. The composition is a mirror image of the Renaissance master Correggio's *Jupiter and Antiope* (1528; Paris, Musée du Louvre). Matisse's teacher Gustave Moreau had required his students to become familiar with the works of the old masters; the fact that the composition is reversed from that of Correggio's painting suggests that Matisse took the idea from an engraving.

The inspiration for the painting *Nymph and Satyr* differs from that of the central ceramic panel in several ways. The Osthaus piece is purely decorative in character; it has no landscape background, but rather features a decorative border of grape clusters. The satyr is shown traditionally, with a goatlike lower body; the nymph is partially draped and her pose close to that of Matisse's *Blue Nude* (1907; Baltimore Museum of Art), which was completed just before the triptych. In the Hermitage painting, the figures have been generalized and all specific attributes discarded, transforming a mythological subject into a much broader, symbolic theme. In its treatment of the concepts of sexuality, life, and fate, *Nymph and Satyr* becomes a link between *Game of Bowls* (no. 41) and Matisse's later pair of paintings *Dance* and *Music* (1909–10, 1910; both in the Hermitage).

Nymph and Satyr was made on commission for Matisse's patron Sergei Shchukin, who was probably familiar with the Osthaus triptych. A preparatory pencil drawing exists in a private collection. Pentimenti visible beneath the green paint indicate that, in the process of executing the painting, Matisse altered the figures' poses. The artist worked on the canvas in January 1909. He wrote, on February 7, to his friend the critic Félix Fénéon that he had just finished a painting for Shchukin entitled *Faun Catching a Nymph Off Guard*. The bold sensuality of the painting, unusual for Matisse, may be a more personal allusion. The redhaired nymph bears a resemblance to the painter Olga Meerson, whom he painted (1911; Houston, Museum of Fine Arts) and with whom he was infatuated. A. K.

43. *Conversation*, 1909

Oil on canvas, 177 × 217 cm
Leningrad, Hermitage, Inv. no. 6521

IN CREATING THIS PAINTING, Matisse insisted he had not wanted to do a portrait but rather a large composition. Although it depicts Matisse and his wife, Amélie, *Conversation* is about the problem of dark blue—a problem Matisse had been grappling with since, dissatisfied with *Harmony in Blue* of 1908, he reworked this painting into *Harmony in Red* (1909; Hermitage). Completed at the end of the summer of 1909 in Paris, after Matisse had returned from Cavalière, *Conversation* is one of the artist's most important works, as well as a significant link between *Harmony in Red* and *Family Portrait* (1911; Hermitage).

Conversation is almost the same size as *Harmony in Red*, but is much more monumental in its design. Not all the details are sacrificed to decoration, although an ornamental grill has been purposefully introduced as the central motif. The grill serves as a bridge from the stable, repeated vertical elements of the male half of the picture to the springing arcs and circles of the female half. The landscape seen through the window combines both elements. Their opposition here creates great tension; as Barr (1951) noted, this is the only painting by Matisse where his figures confront one another directly.

Flam (1986) has demonstrated that the iconographic source of *Conversation* could have been the bas-relief in the upper part of the Hammurabi Stele (c. 1760 B.C.; Paris, Musée du Louvre), which Matisse undoubtedly knew. On the other hand, Flam's attempt to see the word "Non" in the grill work as a way to underscore the psychological tension between the two figures seems contrived. In fact, if a word is to be found in the grill, it would appear to be "Nox," rather than "Non." This Latin word refers to nocturnal silence, peace, darkness, which do not relate to this painting. More significantly, Matisse did not normally add words to his paintings, in either a direct or an encoded way. But despite the painting's solemn, iconic presence, its subject—the morning conversation of a couple, he in pajamas and she in a dressing gown, in the living room of their country house—is purely secular. In comparison with the religious art of his contemporaries, Matisse's works are more profoundly archetypal and universal.

In August 1912, the month in which Sergei Shchukin probably bought *Conversation*, he wrote Matisse, "I often think of your blue painting (with two people). It reminds me of a Byzantine enamel, so rich and deep is its color. It is one of the most beautiful paintings in my memory." This affinity to Byzantine art was emphasized by Schneider (1975), who dated the painting to 1911. Nonetheless Barr's dating of the work to 1909 remains the most convincing, if only because both the artist and his wife maintained to Barr that the painting was done before *Dance* (1909–10; Hermitage), an assertion that has also been corroborated by Matisse's son Pierre. Soon after this canvas was completed, a sizeable network of small cracks appeared in different areas of the painting, particularly in the dark blue background. Conservators at the Hermitage believe a reworking after the painting's completion caused the cracks. While Flam thought the reworking occurred in the spring of 1912, just before the painting was exhibited at the Grafton Gallery, London, it happened more probably in 1909, or perhaps in 1911. A. K.

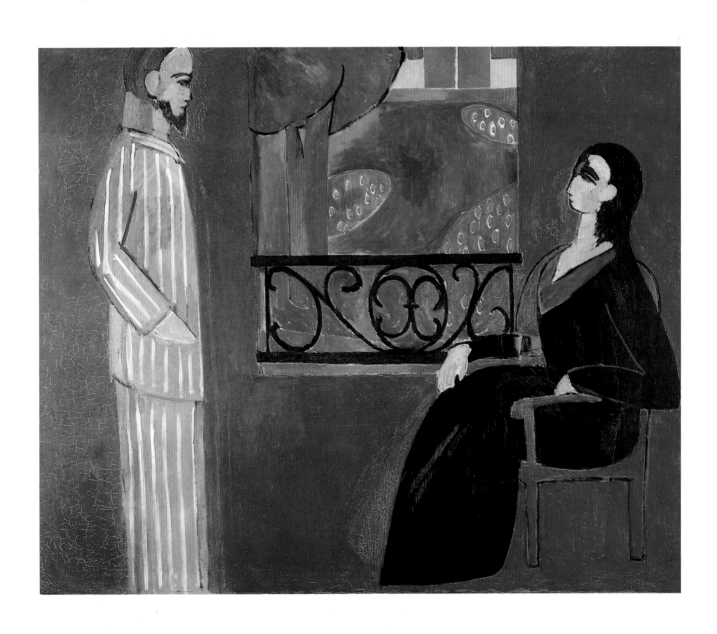

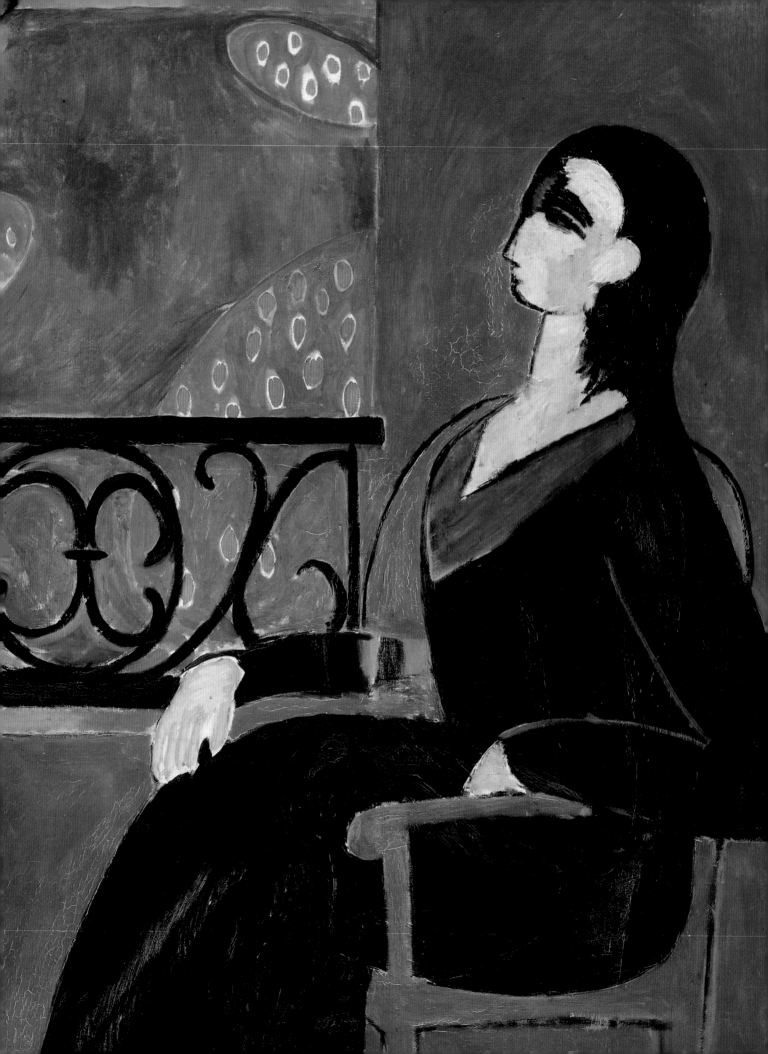

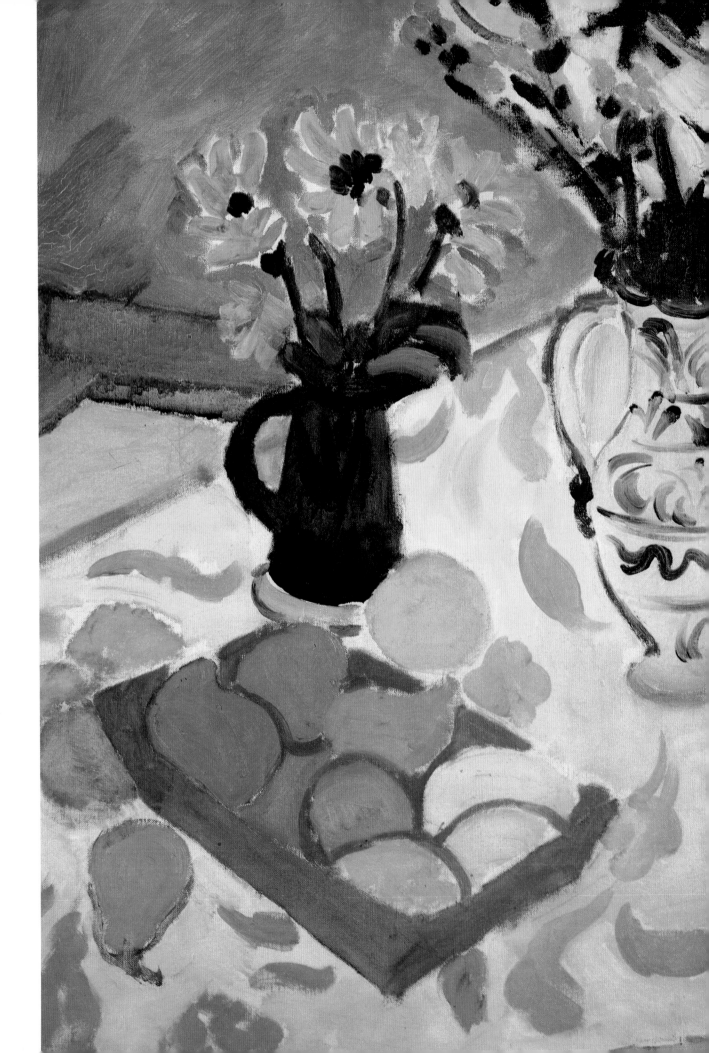

44. *Still Life with "Dance,"* 1909

Oil on canvas, 89 × 116 cm
Signed and dated, lower right: *Henri Matisse/1909*
Leningrad, Hermitage, Inv. no. 9042

TURNING AGAIN TO THE THEME of the studio interior with a still life, which he had undertaken in 1900 in *The Corner of the Studio* (Paris, private collection), Matisse, in *Still Life with "Dance,"* introduced for the first time one of his own works as a subject. He would later pursue this idea in two canvases of 1911: *The Painter's Studio* (Pushkin Museum) and *Red Studio* (New York, The Museum of Modern Art). The painting depicted in this interior with a still life is *Dance I* (1909; New York, The Museum of Modern Art), and not the canvas bought by Sergei Shchukin (1909–10; Hermitage). Despite Flam's (1986) view that the painting seen in the still life is the second variant in its early stages, the Hermitage version has a much more intense palette; thus there is no basis for assuming that, in its first stages, it was identical to the New York painting.

Still Life with "Dance" is usually dated to late 1909, although Matisse had evidently begun working on it considerably before the beginning of that year. In the spring, Shchukin told the artist he was very taken with the composition, which must have been finished or nearly finished. Moreover a photograph by Edward Steichen of Matisse standing in front of this painting, shows *Dance I*, barely begun (the figures' outlines have been delineated), in the background, indicates that Matisse probably worked on both paintings simultaneously. Thus, in all probability, the still life was completed in March or April 1909. This would establish that the studio depicted, both in the Hermitage painting and in the Steichen photograph, was not the one Matisse set up at the end of the summer, when he moved to Issy-les-Moulineaux, which is what both the Hermitage still life and photograph by Steichen have been thought to depict. In fact, in a letter to the artist of March 31, 1909, Shchukin wrote, in response to a visit to Matisse's studio in Paris on the Boulevard des Invalides: "I find your panel *Dance* of such nobility, that I am resolved to brave our bourgeois opinion and hang on my staircase a subject with *nudes*" (Barr [1951], p. 133). Shchukin would have been able to write this way only about a finished work or one that was almost completed. A. K.

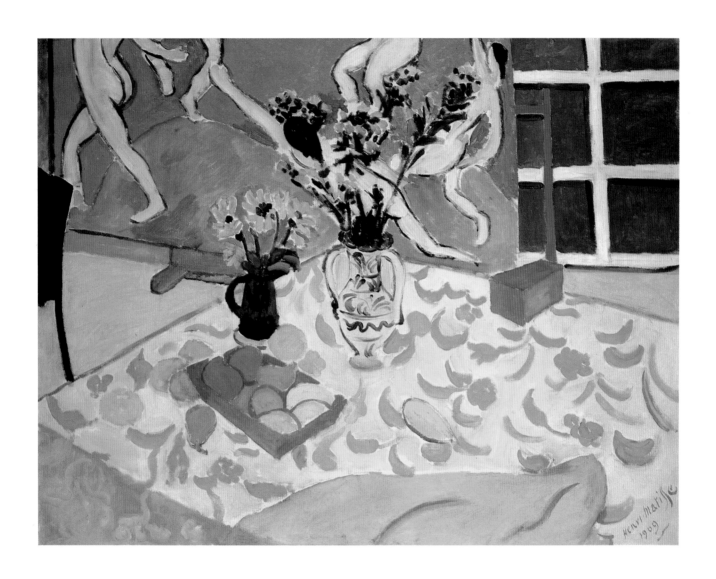

45. *Pink Statuette and Jug on a Red Chest of Drawers*, 1910

Oil on canvas, 90 × 117 cm
Signed and dated, lower right: *Henri Matisse 10*
Leningrad, Hermitage, Inv. no. 6520

THIS PAINTING WAS DONE in Matisse's studio at Issy-les-Moulineaux, as evidenced by the wood-planked wall in the background, which also appears in *Still Life with Geraniums* (1910; Munich, Neue Pinakothek) and *The Painter's Studio* (1911; Pushkin Museum). The dresser appears again in *Red Studio* (1911; New York, The Museum of Modern Art). All three of these paintings are known to depict Matisse's studio at Issy.

The terracotta sculpture of a reclining nude was made by Matisse in 1907 and is known today from several bronze casts. The pose is taken from one of the figures in *Joy of Life* (1905–1906; Merion, Pennsylvania, Barnes Foundation). The sculpture appears in a number of paintings from 1908 to 1912: *Sculpture and Persian Vase* (1908; Oslo, Nasjonalgalleriet), *Goldfish* (1909–10; Copenhagen, Statens Museum for Kunst), *Goldfish and Sculpture* (1911; New York, The Museum of Modern Art), and *Goldfish, An Interior* (1912; Merion, Pennsylvania, Barnes Foundation). The sculpture's undulating contour made it exceedingly interesting for Matisse to juxtapose with flowers and spherical aquariums and vessels. A. K.

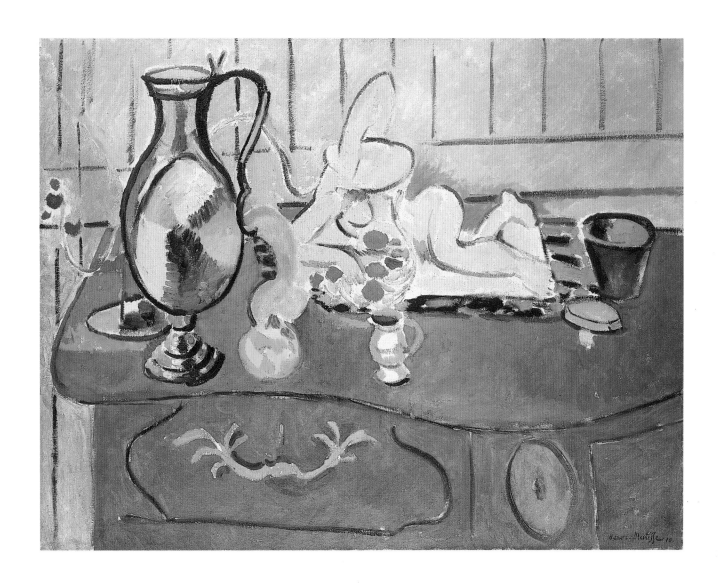

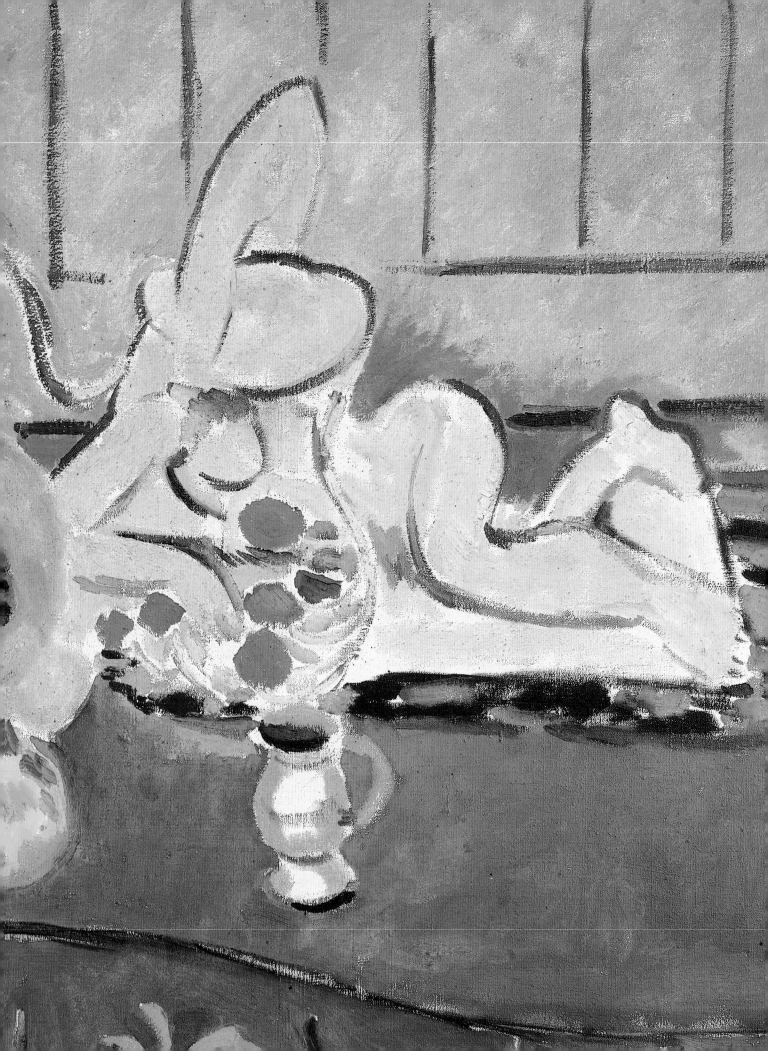

46. *Seville Still Life II*, late 1910 or early 1911

Oil on canvas, 89 × 116 cm
Signed, lower right: *Henri Matisse*
Leningrad, Hermitage, Inv. no. 9043

AFTER MATISSE'S COMPOSITIONS *Dance* and *Music* (1909-10, 1910; both in the Hermitage) were strongly attacked at the Salon d'Automne of 1910, Sergei Shchukin began to have grave doubts about buying the two paintings and Matisse became disheartened. Feeling unable to remain and work in Paris, he left in mid-November for Seville, Spain; by mid-January 1911, he was in Toledo and, by the end of that month, had returned to France. He brought back with him two large compositions, characteristic of his still-life interiors: *Seville Still Life I* (Hermitage) and *Seville Still Life II*, both from 1910 or the first days of 1911.

Although the two works have been considered pendants and have often been confused with one another, they address different problems and do not constitute an ensemble. Understanding this point, Shchukin displayed them separately. In both paintings, Matisse made lavish use of the bold, colorful Spanish shawls that he had collected with the enthusiasm of a tourist. In each work, the shawls are draped over an upholstered sofa in his hotel room, allowing for the play of contrasting textile patterns; each canvas also features a white pot of geraniums. *Seville Still Life II* however seems almost to be a variant close-up of *Seville Still Life I*. Instead of showing the whole room, the artist focused directly on the large, sprawling color spots of the shawls, conveyed in saturated color combinations. In *Seville Still Life I*, the artist purposefully left many areas in the light-colored background unpainted. The dark blue textile at the upper right side of *Seville Still Life II*, with its stylized ocher pomegranates and flowers, was undoubtedly carried back to France by Matisse. It figures prominently in *The Painter's Studio* (1911; Pushkin Museum). A. K.

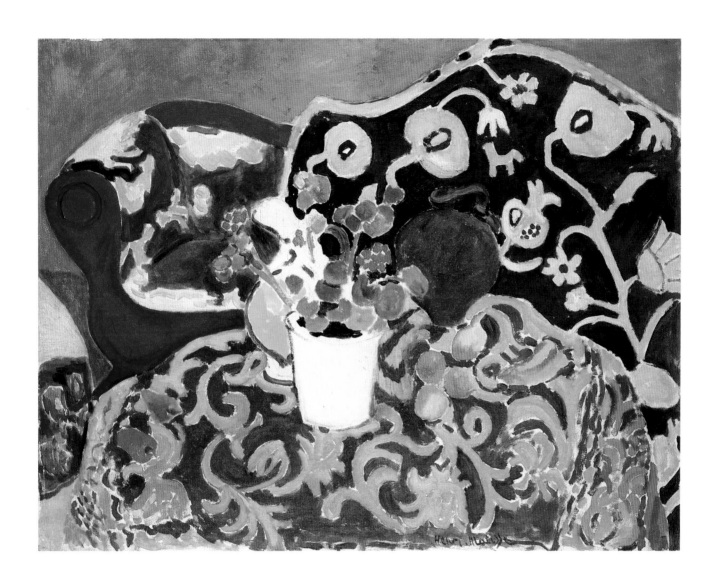

47. *Still Life with a Blue Tablecloth,* 1909

Oil on canvas, 88 × 118 cm
Signed and dated, lower left: *Henri Matisse 09-*
Leningrad, Hermitage, Inv. no. 6569

THIS PAINTING DEMONSTRATES to the fullest Matisse's interest, at this time, in the idea of overall patterning. The bold arabesques of the patterned material that inspired him to undertake *Harmony in Blue* (1908) and subsequently *Harmony in Red* (1909; Hermitage), again dominate *Still Life with a Blue Tablecloth.* The decorative impulse is so strong that the three-dimensional objects maintain their position only with difficulty against the overwhelmingly aggressive cloth, a feat further complicated by their lack of cast shadows. The poet Aragon (1971) said of this painting that the tablecloth had assumed a pose; it had become a model for Matisse.

As usual, in this still life, Matisse approached the problem of color with considerable freedom. Although he respected the actual color of the tablecloth, he gave the chocolate pot which, in the earlier *Crockery on a Table* (1900; Hermitage) retains its metallic hue, a reddish-ocher shade to complement the blue of the cloth.

The painting is thought to have been done early in 1909. Flam (1986) confirmed this date based on a letter from Matisse to his friend the critic Félix Fénéon of February 7, 1909, in which the artist mentioned the painting. A. K.

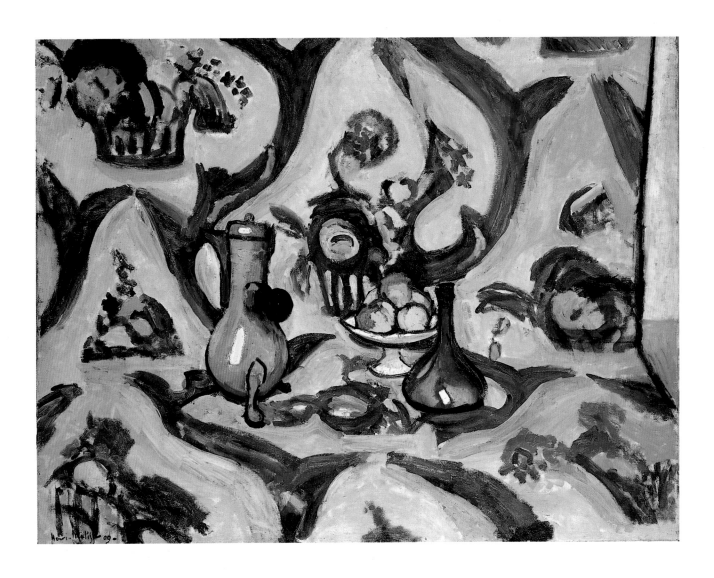

48. *Nasturtiums and "Dance,"* 1912

Oil on canvas, 190.5 × 114.5 cm
Signed, lower right: *Henri Matisse*
Moscow, Pushkin Museum, Inv. no. 3301

IN THIS DRAMATIC INTERIOR SCENE, Matisse incorporated his painting *Dance I* (1909; New York, The Museum of Modern Art). The dynamism of the composition is achieved by the hot and brilliant palette and the bold play of positive and negative space. The figures and still life commingle spatially until the nasturtiums on the stool seem to become the focal point of the dance, as well as of the painting. A variant of this composition, also from 1912, is in The Metropolitan Museum of Art, New York. Much less aggressive in feeling, the Metropolitan painting shows the floor baseboard receding at a much reduced angle; the figures are blurred and the nasturtiums much more distinct from the pictorial backdrop. While the Metropolitan canvas has been thought to be the second variant, it is interesting to speculate that it preceded the version destined for Sergei Shchukin: Knowing his patron's taste, Matisse intensified both the movement and the palette in the second version.

Nasturtiums and "Dance" was painted in Matisse's studio in Issy-les-Moulineaux in 1912 and exhibited that same year in the Salon d'Automne in Paris. The painting, which was done expressly for Shchukin, seems to have formed one side of a decorative triptych purchased by Shchukin. Anxious correspondence from the collector to Matisse indicates that he was impatient to receive *Nasturtiums and "Dance"* (still not delivered by mid-January 1913). Earlier letters from August 1912 make reference to two other big canvases for the Russian's residence. It is quite possible that the other two were *Corner of the Artist's Studio* (no. 49) and the large, rose-colored *Painter's Studio* (1911; Pushkin Museum). These three paintings were hung together as a triptych in Shchukin's house only after the collection was nationalized as the First Museum of Modern Western Painting, in 1918, and then in the Museum of Modern Western Art, after 1923. However, while Shchukin resided in his home, it is evident, from a photograph of his big dining room (fig. p. 25), that the central place in the triptych was occupied by Matisse's *Conversation* (no. 43), a painting that clearly fascinated the collector. Later, after 1948, when the contents of the Museum of Modern Western Art were divided between the Pushkin and Hermitage museums, *Conversation* went to Leningrad while the other three paintings remained in Moscow, thus reinforcing the notion that *The Painter's Studio* was indeed the central panel (see fig. p. 32). Still it is not clear today which arrangement the artist intended or why they were hung in various ways over the years. M. B.

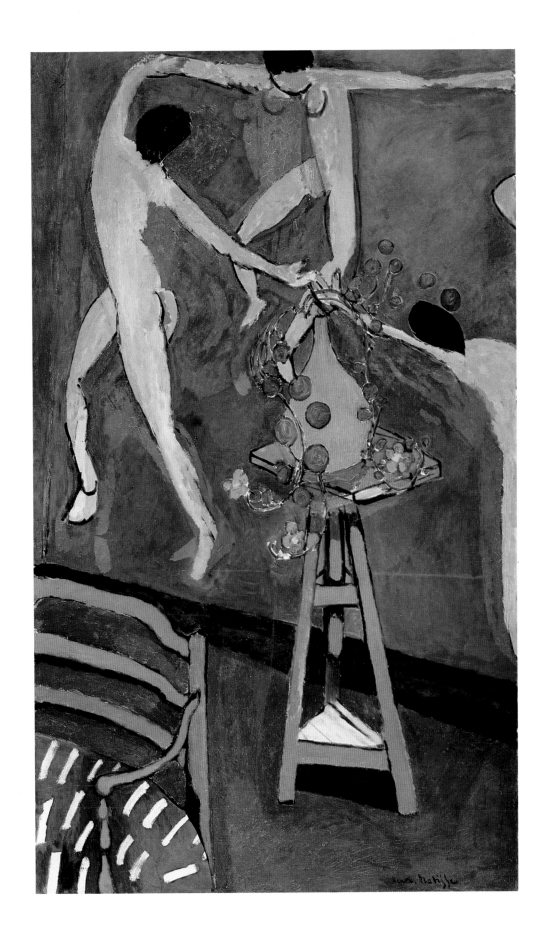

49. *Corner of the Artist's Studio*, 1912

Oil on canvas, 191.5 × 114 cm
Moscow, Pushkin Museum, Inv. no. 3302

IN 1912, IN HIS STUDIO at Issy-les-Moulineaux, Matisse painted both *Corner of the Artist's Studio* and *Nasturtiums and "Dance"* (no. 48) with the intention of using them respectively as the left and right sections of a triptych. The studio corner depicted in the former painting is a part of the larger view executed by the artist in *The Painter's Studio* (1911; Pushkin Museum). All three compositions were acquired by Sergei Shchukin in 1912.

Corner of the Artist's Studio shows a portion of the big screen Matisse kept in his studio; over it, a vividly patterned blue drapery has been casually tossed. Behind the screen is a section of the studio's wood-planked wall, and at the top of the composition appears a part of Matisse's *Le Luxe II* (1907–1908; Copenhagen, Statens Museum for Kunst); both details appear in *The Painter's Studio*. In front of the screen stands a green floor vase, which Matisse brought back from a trip to Morocco in 1912. On top of the vase is perched a red pot from which the long, leafy branches of a plant cascade. Matisse referred to the "green Arab vase" in a letter to the Russian art historian A. Romm in July 1935, in which he requested a photograph of the composition, which was then in the Museum of Modern Western Art, Moscow. At the lower left of the painting, cut off by the corner, is a Mediterranean lounge chair whose angle echoes that of the drapery; it plays a significant role in the composition and invokes, by its very emptiness, the presence of the artist-observer. M. B.

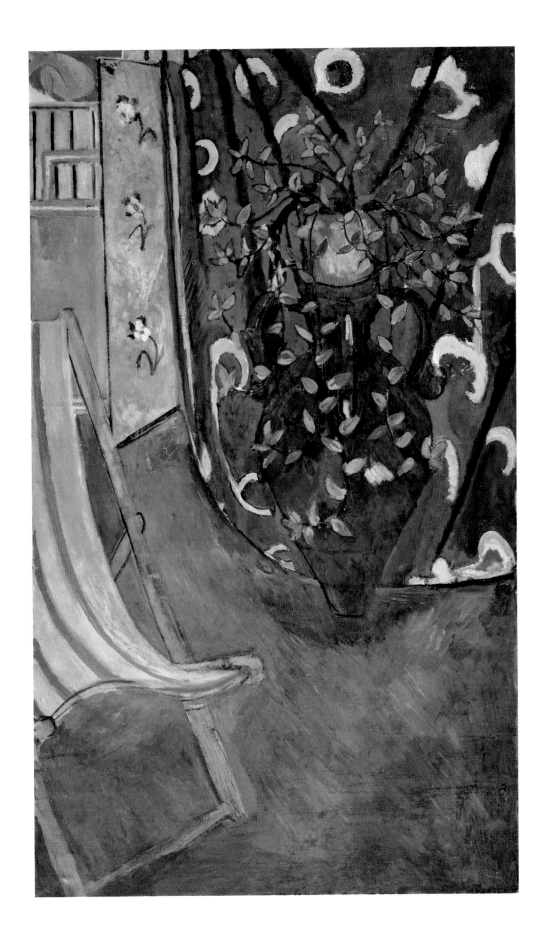

50. *Madame Matisse*, 1913

Oil on canvas, 145 × 97 cm
Signed, lower right: *Henri Matisse*
Leningrad, Hermitage, Inv. no. 9156

THIS DEPICTION OF MATISSE'S WIFE, Amélie, occupied most of the artist's time during the summer of 1913. This is known from a letter Matisse wrote to his friend Charles Camoin on September 15 of that year, in which he said that he had managed to do only this portrait and a bas-relief, and to make progress on his *Bathers* (completed c. 1916–17; The Art Institute of Chicago). The time was well spent: The poet Guillaume Apollinaire called the portrait "the best work in the Salon d'Automne." Still, like much of Matisse's oeuvre, the painting appears at first glance deceptively casual, manifesting a simplicity of drawing and color that in fact were achieved only by considerable labor. As Barr (1951) related, one year after it was painted, the critic Walter Pach observed that the portrait must have been accomplished with relative ease. Matisse responded that, in fact, it had taken over one hundred sittings. These sessions were no doubt devoted to ridding the painting of all unnecessary details in the interest of a simple yet profound harmony.

Madame Matisse's appearance in *The Painter's Family* (1911; Hermitage) is that of a bourgeois housewife. In *Madame Matisse*, she is an elegant Parisian lady. Her clothes—the fashionable feathered hat, the cut of the jacket, the scarf casually thrown around her shoulders—can be seen in fashion magazines of the day and are rendered with precision. Her reserve is part of this elegance. But there is more here than respectability. Matisse told the American journalist Clara T. MacChesney ("A talk with Matisse, leader of the post-impressionists," *New York Times*, Mar. 9, 1913) that he did portraits only rarely, and then approached them from a decorative point of view. Compared to earlier portraits, *Madame Matisse* does present new qualities. The woman's sharp features and the wavering background colors suggest an air of mystery and possible uneasiness. The expressionless face is masklike, recalling masks of other cultures with which Matisse was familiar, such as those used in Greek theater or in African ceremonies (Laude [1968], in fact, suggested a specific Baule influence in this work). This is the last in a string of depictions of the artist's wife which includes *The Guitarist* (1903; New York, Mr. and Mrs. Ralph F. Colin collection), *Red Madras Headdress* (1907–1908; Marion, Pennsylvania, Barnes Foundation), *Spanish Dancer* (1909; Pushkin Museum), and *The Manila Shawl* (1911; Basel, Kunstmuseum). Close in its generalized linearity to *Madame Matisse* is a drawing of the artist's wife of 1915 (Nice-Cimiez, Musée Matisse).

Despite the canvas's monumentality and decorative harmony, Matisse viewed this painting with a critical eye. He wrote to Camoin in November 1913: "As a matter of fact, my picture (the portrait of my wife) enjoys some success in avant-garde circles. But I am not satisfied: it is only the beginning of an agonizing effort." The painting was the last of Matisse's works to be acquired by either Sergei Shchukin or Ivan Morozov. A. K.

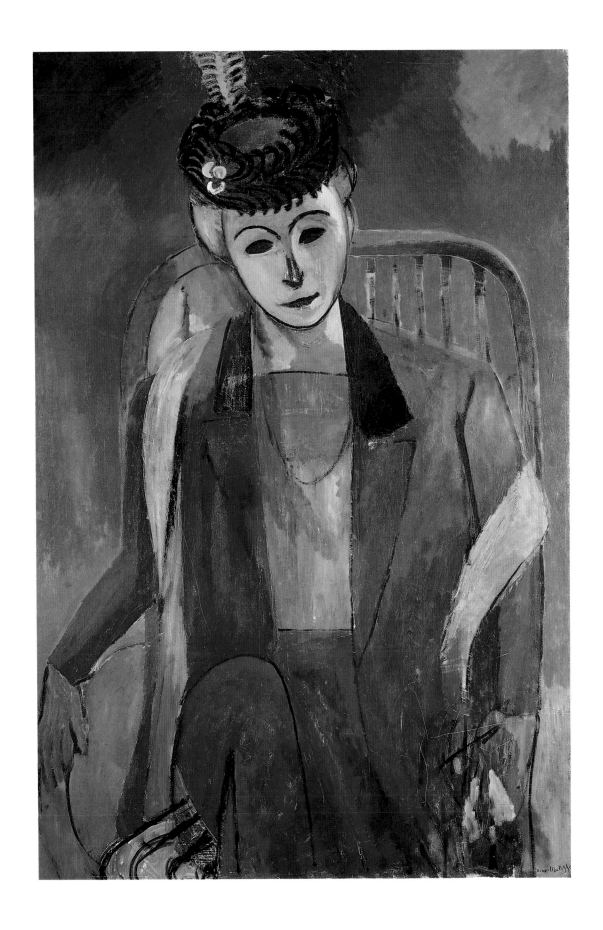

HENRI ROUSSEAU

1844 Laval — Paris 1910

Called "Le Douanier" from the French word "douane," or customs office, for which he worked, Rousseau was a self-taught artist who became one of the most celebrated naive painters of modern times. While he did not retire fully from his job until 1893, from 1886 he exhibited regularly at the Salon des Indépendants, Paris, attracting the attention of such artists as Gauguin, Pissarro, Renoir, Signac, and Toulouse-Lautrec. In 1891, he began a series of landscapes in which animals and figures are removed from their usual contexts and recombined in exotic settings, all precisely rendered in pristine colors. He also painted self-portraits, images of Paris and its suburbs, and patriotic scenes. In the early twentieth century, his work was greatly admired for its primitive directness by such painters as Kandinsky and Picasso and such writers as Cocteau, Apollinaire, and Jarry. Until his death in 1910, Rousseau continued to paint ambitious canvases of a highly imaginative and haunting quality.

51. *Jaguar Attacking a White Horse,* c. 1910

Oil on canvas, 90 × 116 cm
Signed, lower right: *Henri Rousseau*
Moscow, Pushkin Museum, Inv. no. 3351

NOTABLE FOR ITS MASTERFUL EXECUTION and evocative nature, *Jaguar Attacking a White Horse* is very likely the work referred to by Rousseau in a letter of March 5, 1910, to the dealer Ambroise Vollard, in which he wrote: "I am beginning this size 50 canvas, the subject of which will be the battle between a lion and a horse." Although the attacker is a jaguar and not a lion, the size of the canvas and overall theme of two fighting animals suggest that the Moscow canvas is the one mentioned: Rousseau probably changed the lion into a jaguar during the painting's execution. Known for certain however is that the artist sold the Moscow painting to Vollard in March 1910 for 100 francs. The sales receipt and style of the painting both indicate that this is one of the last of Rousseau's tropical landscapes and support Vallier's (1970) dating of the composition to 1910. It is related to *Negro Attacked by a Jaguar* (c. 1909; Basel, Kunstmuseum).

Many of the stylistic peculiarities evident in Rousseau's "tropical battles," such as *Jaguar Attacking a White Horse,* can be explained by the artist's work at Paris's zoo, botanical gardens, and museums, where he observed animals, copied favorite plants and flowers, and studied stuffed wild animals. The lion and antelope in his famous painting *The Hungry Lion* (1905; Switzerland, private collection), for example, were modeled on animals preserved by the Paris taxidermist Canton in 1899; for his jaguar, Rousseau found a stuffed example at the Jardin des Plantes. In preparing his depictions of tropical paradise, he also consulted illustrated atlases, journals, and images on stamps. Hoog (1984–85 Paris, New York) noted, in the Pushkin painting, the "heraldic" interpretation of the horse's head and the feminine form of its front legs. The power of Rousseau's imagination transformed this bizarre combination of elements, investing even such a grim scene as this jaguar attack with poetic grace. M. B.

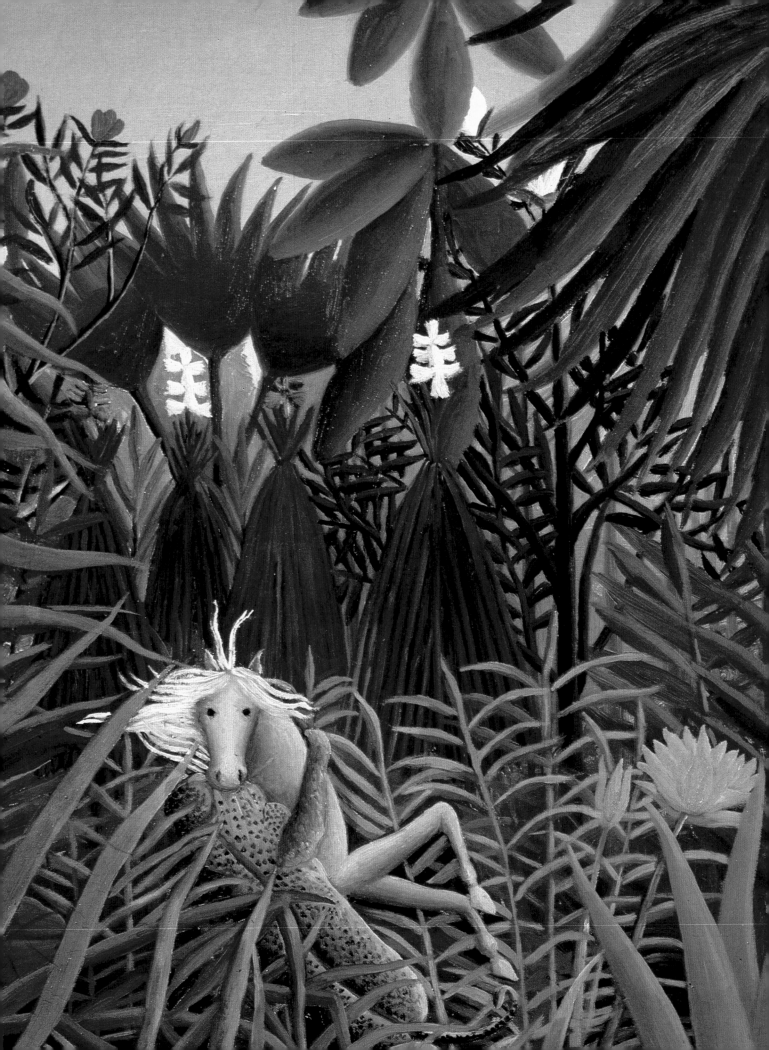

Documentation

Note to Documentation: The city of Leningrad was originally named St. Petersburg. In 1914, after war broke out with Germany, its name was changed to Petrograd. After the death of Lenin in 1924, it was renamed Leningrad. All three names appear in the documentation below, depending on the date of reference. In 1918, both Sergei I. Shchukin's and Ivan A. Morozov's collections were nationalized by decree of the Council of People's Commissars. Shchukin's collection, renamed the First Museum of Modern Western Painting, opened in 1918. Morozov's collection, called the Second Museum of Modern Western Painting, opened the following year. In 1923, both were incorporated into the new State Museum of Modern Western Art. The following documentation contains abbreviated references to collection catalogues, exhibitions, and frequently cited books and journal articles. Full citations can be found under "List of Exhibitions," "List of Collection Catalogues," and "Abbreviated References," beginning on page 163.

NICOLAS POUSSIN

1. *Victory of Joshua over the Amorites*, c. 1625/26

PROVENANCE: By 1685, Duke de Noailles collection. By inheritance to Adrien Moritz (?). July 22, 1770, sale, Dufresne, Amsterdam, nos. 102-103. Between 1763 and 1764, Hermitage, St. Petersburg-Petrograd-Leningrad. In 1927, transferred to Pushkin Museum, Moscow.

EXHIBITIONS: 1955 Moscow, no. 57. 1956a Leningrad, p. 48. 1960 Paris, no. 3. 1978 Düsseldorf, no. 0. 1981 Vienna, pp. 82-85. 1983-84 Paris.

COLLECTION CATALOGUES: Hermitage: 1774, no. 908. 1900, no. 1396, p. 87. Pushkin Museum: 1948, p. 63. 1957, p. 113. 1961, p. 151. 1986, p. 143.

SELECTED REFERENCES: Le Comte 1699-1700, vol. 3, p. 24. Félibien 1725, vol. 4, p. 11. Baldinucci, F., *Notizie de' professori del disegno*, Florence, 1772, vol. 16, p. 99. Friedländer 1914, p. 23. Grautoff 1914, vol. 1, p. 65; vol. 2, no. 5. Magne 1914, no. 139, pp. 73, 205. Volskaya 1946, pp. 28, 31. Sterling 1957, pp. 29-30. Blunt, A., "La Première Période romaine de Poussin," *Actes du colloque internationale Nicolas Poussin*, Paris, 1960, vol. 1, pp. 160, 168-69, 171, 174. Mahon 1960, p. 290. Thuillier, J., "Premiers Compagnons français à Rome," *Actes du colloque internationale Nicolas Poussin*, Paris, 1960, vol. 2, p. 75. Mahon 1962, pp. 5-9, 14, 38, 132. Blunt 1966, no. 30. Blunt 1967, vol. 1, pp. 65-66, 179, 181; vol. 2, pl. 4. Thuillier 1974, no. 12. Georgievskaya and Kuznetsova 1980, no. 2. Wild 1980, vol. 1, p. 34; vol. 2, no. 17, p. 21. Kuznetsova 1982, no. 166. Oberhuber, K., *Poussin, the Early Years in Rome: The Origins of French Classicism*, New York, 1988, no. 2, pp. 38, 40, 41-43, 46, 236, 257.

2. *Victory of Joshua over the Amalekites*, c.1625/26

PROVENANCE: Same as no. 1, except that, in 1927, remained in Hermitage, Leningrad.

EXHIBITIONS: 1956a Leningrad, p. 48. 1960 Paris, no. 2. 1987-88 Belgrade, Ljubljana, Zagreb, no. 13.

COLLECTION CATALOGUES: Hermitage: 1774, no. 875. 1797, no. 1731. 1838, no. 38, p. 175. 1863, 1908, 1916, no. 1395. 1958, vol. 1, p. 326. 1976, p. 222.

SELECTED REFERENCES: Le Comte 1699-1700, vol. 3, p. 24. Bellori, G., *Le vite de' pittori, scultori, ed architetti moderni*, Rome, 1725, p. 265. Félibien 1725, vol. 4, p. 11. Bottari, G., *Dialoghi sopra le tre arti del disegno*, Lucca, 1754, p. 170. Baldinucci, F., *Notizie de' professori del disegno*, Florence, 1772, vol. 16, p. 99. Smith, J., *A Catalogue Raisonné of the Works of the Most Eminent Dutch, Flemish and French Painters . . .*, London, 1837, vol. 8, no. 35. Waagen 1864, p. 282. Friedländer 1914, p. 112. Grautoff 1914, vol. 1, pp. 65-66; vol. 2, no. 4. Magne 1914, no. 138, pp. 73, 205. Friedländer, W., "The Massimi Poussin Drawings at Windsor Castle," *The Burlington Magazine* 54, 312 (Mar. 1929), p. 127. Volskaya 1946, pp. 31-32. Blunt, A., *Art*

and Architecture in France, 1500-1700, London, 1953, p. 166, pl. 125. Sterling 1957, pp. 29-30, pl. 14. Blunt, A., "La Première Période romaine de Poussin," *Actes du colloque internationale Nicolas Poussin*, Paris, 1960, vol. 1, p. 166, fig. 307. Mahon 1960, pp. 290, 296. Thuillier, J., "Tableaux attribués à Poussin dans les galeries italiens," *Actes du colloque internationale Nicolas Poussin*, Paris, 1960, vol. 2, pp. 264-65. Mahon 1962, pp. 5-9, 132, n. 392. Blunt 1966, no. 29. Friedländer 1966, pp. 40-41, 54, 62, 69, 70. Blunt 1967, vol. 1, pp. 65-66, 179, 181; vol. 2, pl. 5. Badt, K., *Die Kunst des Nicolas Poussin*, Cologne, 1969, pp. 93, 99, 293, 376, 467. Thuillier 1974, no. 11. Wild 1980, vol. 1, pp. 34, 39, 80, 185; vol. 2, no. 16, p. 20. Oberhuber, K., *Poussin, the Early Years in Rome: The Origins of French Classicism*, New York, 1988, no. 1, pp. 41, 43-44, 46, 236, 244, 257.

3. *Tancred and Erminia*, c. 1630/31

PROVENANCE: Before 1766, J. A. Aved collection. From 1766, Hermitage, St. Petersburg-Petrograd-Leningrad.

EXHIBITIONS: 1937 Paris, no. 112, p. 59. 1955 Moscow, p. 52. 1956a Leningrad, p. 49. 1960 Paris, no. 42, p. 77. 1965 Bordeaux, no. 11, p. 12. 1965-66 Paris, no. 10, p. 31. 1972 Dresden, no. 36, p. 77. 1975-76 USA, Mexico, Canada, no. 7, pp. 38-40. 1978 Düsseldorf, no. 19a, p. 98. 1981 Vienna, pp. 86-89.

COLLECTION CATALOGUES: Hermitage: 1774, no. 11. 1797, no. 1699. 1838, no. 23, p. 171. 1863, 1908, 1916, no. 1408. 1958, vol. 1, p. 326. 1976, p. 222.

SELECTED REFERENCES: Rémy, P., *Catalogue raisonné des tableaux de différents bons maîtres qui composent le cabinet de feu M. Aved, peintre du roi et de son académie*, Paris, 1766, no. 106. Waagen 1864, p. 284. Grautoff 1914, vol. 1, pp. 108-109; vol. 2, no. 39. Magne 1914, no. 339, p. 219. Wildenstein, G., *Le Peintre Aved, sa vie et son oeuvre 1702-1766*, Paris, 1922, no. 47, pp. 106, 153, 209. Bodkin, T., "A Rediscovered Picture by Nicolas Poussin," *The Burlington Magazine* 74, 435 (May 1939), pt. 1, p. 254. Volskaya 1946, pp. 47-49, n. 36. Sterling 1957, pp. 23, 30, pl. 15. Mahon 1960, p. 299. Mahon 1962, p. 28. Levinson-Lessing, W., *The Hermitage, Leningrad: Baroque and Rococo Masters*, London, 1965, nos. 54-55. Blunt 1966, no. 206, p. 142. Friedländer 1966, pp. 50-51. Wild, D., "Charles Mellin ou Nicolas Poussin," *Gazette des beaux-arts* 69 (Jan. 1967), p. 79, n. 36. Alpatov, M., "Tankred and Herminie," *Studies in Renaissance and Baroque Art Presented to Anthony Blunt on His 60th Birthday*, London, 1967, pp. 130-35. Blunt 1967, vol. 1, pp. 148, 150; vol. 2, pl. 70. Badt, K., *Die Kunst des Nicolas Poussin*, Cologne, 1969, pp. 520-22. Thuillier 1974, no. 68. Zolotov, Y., "Concerning Poussin's Theory of Art," *Art* 1 (1979), pp. 49, 51-52 (in Russian).

4. *The Holy Family with Saints Elizabeth and John the Baptist*, 1655

PROVENANCE: From 1655, Paul Fréart de Chantelou collection. By 1720, Count de Fraula collection, Brussels. Aug. 21, 1738,

sale, de Vos, Brussels, no. 20. Before 1739, acquired in Paris by Sir Robert Walpole, through Lord Waldegrave. Through c. 1779, Walpole collection. From 1779, Hermitage, St. Petersburg-Petrograd-Leningrad.

EXHIBITIONS: 1956a Leningrad, p. 50. 1983-84 Paris, no. 207, p. 168.

COLLECTION CATALOGUES: Hermitage: 1774, no. 2387. 1797, no. 1689. 1838, no. 40, p. 175. 1863, 1908, 1916, no. 1398. 1958, vol. 1, p. 331. 1976, p. 224.

SELECTED REFERENCES: Le Comte 1699-1700, vol. 3, p. 32. Richardson, J., *An Essay on the Theory of Painting*, London, 1715, p. 6. Félibien 1725, vol. 4, p. 64. Smith, J., *A Catalogue Raisonné of the Works of the Most Eminent Dutch, Flemish and French Painters . . .*, London, 1829-49, no. 75. Waagen 1864, no. 286. Grautoff 1914, vol. 1, p. 270; vol. 2, no. 132, p. 256. Friedländer 1914, no. 122. Magne 1914, nos. 242, 249, pp. 152, 213. Friedländer, W., and A. Blunt, *The Drawings of Nicolas Poussin, a Catalogue Raisonné*, London, 1939, vol. 1, no. 59. Blunt, A., *Art and Architecture in France, 1500-1700*, London, 1953, p. 177, pl. 135. Mahon 1962, p. 120. Blunt, "Poussin and His Roman Patrons," *W. Friedlaender zum 90. Geburtstag*, Berlin, 1965, p. 70. Blunt 1966, no. 56. Friedländer 1966, p. 186. Blunt 1967, vol. 1, pp. 214, 301; vol. 2, pl. 219. Thuillier 1974, no. 194. Wild 1980, vol. 1, p. 155; vol. 2, no. 182.

CLAUDE GELLÉE, CALLED CLAUDE LORRAIN

5. *Landscape with Battle on a Bridge*, 1655

PROVENANCE: In 1655, commissioned in Rome by Cardinal Fabio Chigi (later Pope Alexander VII). In 1798, acquired by Prince N. B. Yusupov. Until 1839, Yusupov collection, Moscow. In 1839, transferred to Yusupov Palace, St. Petersburg. From 1918 to 1924, Yusupov Palace Museum, Petrograd. From 1924 to 1927, Hermitage, Petrograd-Leningrad. In 1927, transferred to Pushkin Museum, Moscow.

EXHIBITIONS: 1908 St. Petersburg, no. 295. 1955 Moscow, no. 42. 1956a Leningrad, p. 36.

COLLECTION CATALOGUES: Yusupov: 1839, no. 8. 1920, no. 79. Pushkin Museum: 1948, p. 47. 1957, p. 82. 1961, p. 112. 1986, p. 109.

SELECTED REFERENCES: Pattison, E., *Claude Lorrain, sa vie et son oeuvre*, Paris, 1884, pp. 71-72, 190, 218, 227. Röthlisberger, M., *Claude Lorrain*, New Haven, 1961, vol. 1, pp. 146, 326, 329-30; *Tout l'Oeuvre peint de Claude Lorrain*, Paris, 1977, no. 205. Kitson, M., *Claude Lorrain: Liber Veritatis*, London, 1978, p. 138. Georgievskaya and Kuznetsova 1980, no. 8. Kuznetsova 1982, p. 150. Washington, D.C., National Gallery of Art, *Claude Lorrain 1600-1682*, exh. cat. by D. Russell, 1982, pp. 173-74.

6. *Landscape with the Rape of Europa*, 1655

PROVENANCE: Same as no. 5.

EXHIBITIONS: 1908 St. Petersburg, no. 294. 1955 Moscow, p. 42. 1956a Leningrad, p. 36. 1981 Vienna, p. 64. 1982 Moscow, no. 27.

COLLECTION CATALOGUES: Yusupov: 1839, no. 26. 1920, no. 86. Pushkin Museum: 1948, p. 47. 1957, p. 82. 1961, p. 112. 1986, p. 109.

SELECTED REFERENCES: Pattison, E., *Claude Lorrain, sa vie et son oeuvre*, Paris, 1884, pp. 71, 94, 190-91, 216, 218, 227, 276, 306. Röthlisberger, M., "Les Pendants dans l'oeuvre de Claude Lorrain," *Gazette des beaux-arts* 51 (Apr. 1958), p. 221; *Claude Lorrain*, New Haven, 1961, vol. 1, pp. 24-25, 276, 325-29; *Tout l'Oeuvre peint de Claude Lorrain*, Paris, 1977, no. 204. Kitson, M., *Claude Lorrain: Liber Veritatis*, London, 1978, p. 137. Georgievskaya and Kuznetsova 1980, no. 7. Kuznetsova 1982, pp. 148-49. Washington, D.C., National Gallery of Art, *Claude Lorrain 1600-1682*, exh. cat. by D. Russell, 1982, p. 123.

ANTOINE WATTEAU

7. *The Savoyard*, c. 1716

PROVENANCE: By 1732, Claude Audran collection. From 1734, his younger brother, Jean Audran, and then his son, Benoit Audran II. From 1774, Hermitage, St. Petersburg-Petrograd-Leningrad.

EXHIBITIONS: 1937 Paris, no. 226. 1955 Moscow, p. 24. 1956a Leningrad, p. 12. 1972b Leningrad, no. 3. 1984 Leningrad, no. 7. 1984-85 Paris, no. 32, pp. 319-21. 1987 Leningrad, Moscow, no. 371.

COLLECTION CATALOGUES: Hermitage: 1774, no. 2046. 1838, no. 6, p. 454. 1863, 1908, 1916, no. 1502. 1958, vol. 1, p. 266. 1976, p. 189. 1982, no. 49. 1986, no. 352.

SELECTED REFERENCES: Waagen 1864, p. 304. Goncourt, E. de, *Catalogue raisonné de l'oeuvre peint, dessiné, et gravé d'Antoine Watteau*, Paris, 1875, no. 85. Fréville, M. de, "Estimation des tableaux au XVIIIè siècle," *Nouvelles Archives de l'art français* 4 (1888), pp. 62-64. Josz, V., *Watteau, moeurs du XVIIIè siècle*, Paris, 1903, p. 93. Dacier, E., and A. Vuaflart, *Jean de Jullienne et les graveurs de Watteau au XVIIIè siècle*, Paris, 1922, vol. 3, p. 141. Volskaya, V., *Antoine Watteau*, Moscow, 1933, p. 32 (in Russian). Mathey, J., "A Landscape by Watteau," *The Burlington Magazine* 89, 535 (Oct. 1947), pp. 273-74. Adhémar, H., *Watteau, sa vie, son oeuvre*, Paris, 1950, no. 13, pp. 36, 50, 143-44. Sterling 1957, p. 37. Mathey, J., and K. Parker, *Antoine Watteau: Catalogue complet de son oeuvre dessiné*, Paris, 1957-58, vol. 1, no. 490, pp. 65-67. Mathey, J., *Antoine Watteau: peintures réapparues, inconnues ou négligées par les historiens*, Paris, 1959, pp. 24, 68, 74. Kochina, E., "Antoine Watteau, on the 275th Anniversary of the Artist's Birthday," *Art* 1 (1960), p. 48 (in Russian). Nemilova, I., *Antoine Watteau*, Moscow-Leningrad, 1961, p. 4 (in Russian); *Watteau and His Works in the Hermitage*, Leningrad, 1964, no. 6, pp. 100-110, 124, 157, 286-87, pl. 51 (in Russian with French summary); "Watteau's Painting 'La Marmotte' and the Problem of Dating the Artist's Oeuvre," *Hermitage Studies* 8 (1965), pp. 84-98 (in Russian). Munhall, E., "Savoyards in French Eighteenth-Century Art," *Apollo* 87 (Feb. 1968), p. 90. Ferré, J., *Watteau*, Madrid, 1972, vol. 1, p. 66; vol. 3, pp. 1046-47. Nemilova, I., Y. Zolotov, et al., *Watteau, Album*, Moscow, 1973, pp. 134-36, no. 4 (in Russian). Posner, D., "An Aspect of Watteau, 'peintre de la réalité,'" *Études d'art français offertes à Charles Sterling*, Paris, 1975, pp. 279-86. Guerman, M., *Antoine Watteau*, Leningrad, 1980, pp. 158-60 (in Russian). Roland-Michel, M., *Tout Watteau, la peinture*, Paris, 1982, no. 182. Posner, D., *Antoine Watteau*, London, 1984, pp. 27-31, 111, fig. 1, pl. 19.

FRANÇOIS BOUCHER

8. *Hercules and Omphale*, early 1730s

PROVENANCE: To 1777, Randon de Boisset collection. In 1777, sold, Paris, to Philippe Guillaume Boullogne de Préninville, no. 192. In 1787, sold to the Count de Vaudreuil, no. 75. In 1787, sold to M. Donjeux. On Feb. 7, 1792 (deferred to Feb. 13), sale, Paris, Hôtel de Bullion, no. 37. In the early 1820s, Prince M. Golitsyn collection, Moscow. Before 1827, acquired by Prince N. B. Yusupov. In 1839, transferred to Yusupov Palace, St. Petersburg. From 1918 to 1924, Yusupov Palace Museum, Petrograd. From 1924 to 1930, Hermitage, Petrograd-Leningrad. In 1930, transferred to Pushkin Museum, Moscow.

EXHIBITIONS: 1908 St. Petersburg, no. 285. 1955 Moscow, p. 23. 1956a Leningrad, p. 10. 1986-87 New York, Detroit, Paris, no. 13.

COLLECTION CATALOGUES: Yusupov: 1839, no. 86. Pushkin Museum: 1948, p. 14. 1957, p. 21. 1961, p. 30. 1986, p. 37.

SELECTED REFERENCES: Michel, A., *François Boucher*, Paris, 1906, p. 50, followed by a catalogue raisonné by L. Soullié and C. Masson, no. 167. Nolhac, P. de, *François Boucher*, Paris, 1907, p. 115. MacFall, H., *Boucher*, London, 1908, p. 146. Ananoff, A., *François Boucher*, Lausanne-Paris, 1976, vol. 1, no. 107, pp. 237-38. Georgievskaya and Kuznetsova 1980, no. 45. Kuznetsova 1982, p. 78.

9. *Rest on the Flight into Egypt*, 1757

PROVENANCE: In 1757, commissioned by Madame de Pompadour. From 1757 to 1766, Madame de Pompadour collection. Sometime between 1766 and 1774, acquired in Paris, perhaps from the Madame de Pompadour collection, by Empress Catherine the Great. Between 1838 and 1856, in palace at Gatchina, near St. Petersburg. After 1856, Hermitage, St. Petersburg-Petrograd-Leningrad.

EXHIBITIONS: 1757 Paris (not in catalogue). 1955 Moscow, p. 24. 1956a Leningrad, p. 10. 1970 Leningrad, no. 6. 1982 Tokyo, Kumamoto, no. 52. 1986-87 New York, Detroit, Paris, no. 68.

COLLECTION CATALOGUES: Hermitage: 1774, no. 2059. 1863, 1908, 1916, no. 1486. 1958, vol. 1, p. 263. 1976, p. 187. 1982, no. 18. 1986, no. 13.

SELECTED REFERENCES: *Journal encyclopédique* 7, 1 (Oct. 1757), p. 101. Diderot, D., *Salons*, 1765, vol. 2, p. 76 (reprint: ed. J. Seznac, Oxford, 1979). Georgi, J., *Description of the Russian Imperial Capital City of St. Petersburg and Places of Interest in its Environs*, St. Petersburg, 1794, p. 479 (in Russian). Michel, A., *François Boucher*, Paris, 1906, p. 113, followed by a catalogue raisonné by L. Soullié and C. Masson, no. 716. Nolhac, P. de, *François Boucher*, Paris, 1907, p. 66. Cordey, J., *Inventaire des biens de Madame de Pompadour, rédigé après son décès*, Paris, 1939, p. 90, no. 1234. Ananoff, A., *François Boucher*, Lausanne-Paris, 1976, vol. 2, no. 477. Levey, M., "Paris, Grand Palais, Boucher," *The Burlington Magazine* 129, 1008 (Mar. 1987), pp. 200-201.

JEAN BAPTISTE GREUZE

10. *The Paralytic*, c. 1763

PROVENANCE: In 1766, acquired from Greuze in Paris by Empress Catherine the Great. From 1766, Hermitage, St. Petersburg-Petrograd-Leningrad.

EXHIBITIONS: 1763 Paris, no. 140. 1955 Moscow, p. 28. 1956a Leningrad, p. 18. 1986-87 Paris, no. 318. 1987 Leningrad, Moscow, no. 9. 1987-88 Belgrade, Ljubljana, Zagreb, no. 9. 1988 London, no. 11.

COLLECTION CATALOGUES: Hermitage: 1774, no. 22. 1838, no. 60, p. 180. 1863, 1908, 1916, no. 1520. 1958, vol. 1, p. 281. 1976, p. 197. 1986, no. 59.

SELECTED REFERENCES: Georgi, J., *Description of the Russian Imperial Capital City of St. Petersburg and Places of Interest in its Environs*, St. Petersburg, 1794, p. 479 (in Russian). Diderot, D., *Oeuvres complets*, Paris, 1875-77, vol. 9, p. 143; vol. 10, pp. 207-11, 347. Tourneaux, M., *Diderot et Catherine II*, Paris, 1899, pp. 57-58. Goncourt, E., and J. de, *L'Art du dix-huitième siècle*, Paris, 1914, vol. 2, p. 89. Mauclair, C., J. Martin, and C. Masson, *Jean-Baptiste Greuze, avec catalogue raisonné . . .*, Paris, 1920, no. 186, p. 49. Gerz, V., *The Paralytic*, Leningrad, 1949 (in Russian). Brookner, A., *Greuze: The Rise and Fall of an Eighteenth-Century Phenomenon*, Greenwich, Conn., 1972, pp. 62-63, 86, 103, 106-107, 118. Leningrad, Hermitage, *Jean-Baptiste Greuze, Drawings from the Hermitage Collection*, exh. cat. by I. Novoleskaya, 1977, nos. 57-65, pp. 6-8, 14 (in Russian).

11. *The Spoiled Child*, early 1760s

PROVENANCE: Before 1793, Duke de Choiseul-Praslin collection. 1793, Demarest collection. In 1797, Darnay collection. In

1798, perhaps I. I. Melissino collection. From 1798, Prince A. A. Bezborodko collection, St. Petersburg. From the mid-nineteenth century, Prince F. I. Paskevich collection, St. Petersburg. Before 1923, Princess I. I. Paskevich-Erivanskaya collection, Petrograd. From 1923, Hermitage, Petrograd-Leningrad.

EXHIBITIONS: 1765 Paris, no. 111. 1967-68 Dresden. 1968 Göteborg, no. 26. 1988 London, no. 12.

COLLECTION CATALOGUES: Hermitage: 1958, vol. 1, p. 281. 1976, p. 197. 1982, no. 122. 1986, no. 58.

SELECTED REFERENCES: *Mercure de France* 1 (Oct. 1765), p. 168. Diderot, D., *Oeuvres complets*, Paris, 1875-77, vol. 10, pp. 347-48. Goncourt, E., and J. de, *L'Art du dix-huitième siècle*, Paris, 1914, vol. 2, pp. 77, 87. Mauclair, C., J. Martin, and C. Masson, *Jean-Baptiste Greuze, avec catalogue raisonné . . .*, Paris, 1920, no. 136, p. 89. Miller, M., "French Painting of the XVII and XVIII centuries in the new galleries of the Hermitage," *The City* 1 (1923), p. 71 (in Russian). Dobroklonsky, M., *Dessins des maîtres anciens*, Leningrad, 1926, no. 210, p. 78. Brookner, A., *Greuze: The Rise and Fall of an Eighteenth-Century Phenomenon*, Greenwich, Conn., 1972, pp. 64, 98. Leningrad, Hermitage, *Jean-Baptiste Greuze, Drawings from the Hermitage Collection*, exh. cat. by I. Novoleskaya, 1977, nos. 76-78, p. 14 (in Russian).

JEAN HONORÉ FRAGONARD

12. *The Stolen Kiss*, late 1780s

PROVENANCE: From the end of the eighteenth century, Polish King Stanislaw August Poniatowski collection in Lazienki Palace, Warsaw. From 1895, Hermitage, St. Petersburg-Petrograd-Leningrad.

EXHIBITIONS: 1937 Paris, no. 165. 1955 Moscow, p. 60. 1956a Leningrad, p. 60. 1965 Bordeaux, no. 21. 1965-66 Paris, no. 19. 1969 Budapest, p. 10. 1972 Dresden, no. 15. 1974-75 Paris, Detroit, New York, no. 60. 1975-76 USA, Mexico, Canada, no. 11. 1979-80 Melbourne, Sydney, no. 44. 1980 Tokyo, Kyoto, no. 89. 1987-88 Paris, no. 304. 1988 London, no. 15.

COLLECTION CATALOGUES: Hermitage: 1958, vol. 1, p. 346. 1976, p. 232. 1982, no. 350. 1986, no. 48.

SELECTED REFERENCES: *Journal de Paris* (June 1788), p. 666. *Journal général de France* (1788), p. 274. *Mercure de France* (June 1788), p. 95. Landon, C., *Salon de 1808: Receuil de pièces choisies parmi les ouvrages de peinture et de sculpture exposés au Louvre le 14 octobre 1808*, Paris, 1808, p. 9. Portalis, R., *Honoré Fragonard, sa vie, son oeuvre*, Paris, 1889, pp. 72, 271. Josz, V., *Fragonard*, Paris, 1901, p. 119. Dayot, A., and L. Vaillat, "Fragonard," *L'Art et les artistes* (June-July 1907), no. 27, p. 151. Nolhac, P. de, "Deux Questions sur Fragonard," *Revue de l'art* 22 (July-Dec. 1907), pp. 19-24. Schmidt, J. von, "Le Baiser à la dérobée," *Tableaux célèbres des galeries d'Europe*, Paris, 1909, pp. 52-53. Grappe, G., *La Vie et l'oeuvre de J.-H. Fragonard*, Paris, 1929, vol. 2, pp. 28, 86. Guimbaud, L., *Fragonard*, Paris, 1947, p. 53. Réau, L., *Fragonard, sa vie et son oeuvre*, Brussels, 1956, pp. 52, 70, 108, 157, pl. 59. Sterling 1957, p. 52. Zolotov, Y., *Fragonard*, Moscow, 1959, p. 17 (in Russian). Wildenstein, G., *The Paintings of Fragonard*, London, 1960, no. 523, p. 320, pl. 124. Thuillier, J., *Fragonard*, Geneva, 1967, pp. 12, 54, 72-74. Lifshitz, N., *Jean Honoré Fragonard*, Moscow, 1970, p. 88 (in Russian). Wildenstein, D., *L'Opera completa di Fragonard*, Milan, 1972, no. 546. Compin, I., and P. Rosenberg, "Quatre Nouveaux Fragonards au Louvre," *La Revue du Louvre* 24, 4-5 (1974), pp. 263-76. Gaehtgens, T., "De David à Delacroix: la peinture française de 1774 à 1830," *Kunstchronik* 28 (Feb. 1975), p. 46. Ananoff, A., "Propos sur les peintures de Marguerite Gérard," *Gazette des beaux-arts* 94 (Dec. 1979), pp. 215-16, 218. Wells-Robertson, S., "Marguerite Gérard et les Fragonards," *Bulletin de la Société de l'histoire de l'art français, 1977*, Paris (1979), p. 187.

CLAUDE JOSEPH VERNET

13. *View of the Park of the Villa Ludovisi*, 1749

PROVENANCE: In May-June 1746, commissioned in Rome by the Marquis de Villette. From 1749 to 1765, Marquis de Villette collection. On Apr. 8, 1765, auctioned in Paris. Between 1765 and 1768, acquired by Empress Catherine the Great. In 1768, presented to the Academy of Fine Arts, St. Petersburg. From 1922, Hermitage, Petrograd-Leningrad.

EXHIBITIONS: 1955 Moscow, p. 25. 1956a Leningrad, p. 13. 1988 London, no. 8.

COLLECTION CATALOGUES: St. Petersburg, Academy of Fine Arts: 1874, vol. 2, no. 585. Hermitage: 1958, vol. 1, pp. 271-73. 1976, p. 190. 1982, no. 60. 1986, no. 290.

SELECTED REFERENCES: Lagrange 1864, no. 60, pp. 185, 327. Ingersoll-Smouse 1926, vol. 1, no. 213, p. 53, fig. 52. Nemilova, I., "Contemporary French Art in Eighteenth-Century Russia," *Apollo* 101 (June 1975), p. 440. Deryabina, E., "Paintings of Joseph Vernet in the Hermitage," in *Western European Art of the 18th Century*, Leningrad, 1987, pp. 48-49 (in Russian).

14. *View of the Park of the Villa Pamphili*, 1749

PROVENANCE: Same as no. 13, except, in 1930, transferred to Pushkin Museum, Moscow.

EXHIBITIONS: 1955 Moscow, p. 25. 1956a Leningrad, p. 13. 1965 Bordeaux, no. 37. 1965-66 Paris, no. 36. 1976-77 Paris, no. 219. 1988 London, no. 9.

COLLECTION CATALOGUES: St. Petersburg, Academy of Fine Arts: 1874, vol. 2, no. 586. Pushkin Museum: 1948, p. 18. 1957, p. 26. 1961, p. 36. 1986, p. 44.

SELECTED REFERENCES: Lagrange 1864, p. 327. Ingersoll-Smouse 1926, vol. 1, no. 212, p. 55, fig. 51. Georgievskaya and Kuznetsova 1980, no. 61. Kuznetsova 1982, p. 95.

15. *The Death of Virginie*, 1789

PROVENANCE: Girardot de Marigny collection. Before 1801, Czar Paul I collection. From 1801, Hermitage, St. Petersburg-Petrograd-Leningrad.

EXHIBITIONS: 1789 Paris, no. 26. 1976-77 Paris, no. 61. 1986-87 Paris, no. 328.

COLLECTION CATALOGUES: Hermitage: 1908, 1916, no. 1554. 1958, vol. 1, p. 274. 1976, p. 191. 1982, no. 78. 1986, no. 308.

SELECTED REFERENCES: Lagrange 1864, pp. 292-94, 458-59. Ingersoll-Smouse 1926, vol. 1, p. 32; vol. 2, no. 1186, p. 44, fig. 279. Khai, O., "Some Paintings in the Hermitage Collection on Subjects Derived from Thomas Cornell, Bernardin de Saint-Pierre, and La Fontaine," *Literary Heritage* 33-34 (1939), pp. 981-82 (in Russian). Nemilova, I., "Contemporary French Art in Eighteenth-Century Russia," *Apollo* 101 (June 1975), p. 440.

HUBERT ROBERT

16. *Flight*, c. 1780

PROVENANCE: D. I. Shchukin collection, Paris and Moscow. Museum of Fine Arts, Moscow, later renamed Pushkin Museum, Moscow. From 1933, Hermitage, Leningrad.

EXHIBITIONS: 1955 Moscow, p. 54. 1956a Leningrad, p. 52. 1965 Bordeaux, no. 33. 1965-66 Paris, no. 33. 1985 Leningrad, no. 18.

COLLECTION CATALOGUES: Hermitage: 1958, vol. 1, p. 336. 1976, p. 225. 1982, no. 277. 1986, no. 201.

SELECTED REFERENCES: Kamenskaya, T., *Hubert Robert*, Leningrad, 1939, pp. 22-23 (in Russian). Nemilova, I., "Paintings of Hubert Robert on Literary Subjects," *Hermitage Studies* 1

(1956), pp. 211-14 (in Russian). Beau, M., *La Collection des dessins d'Hubert Robert au Musée de Valence*, Lyon, 1968, no. 78. Geneva, Galerie Cayeux, *Un Album de croquis d'Hubert Robert*, exh. cat. by J. de Cayeux, 1979, no. 124. Nemilova, I., "More on the Subjects of H. Robert," *Hermitage Studies* 22 (1982), pp. 69-72 (in Russian). Valence, Musée, *Les Hubert Robert de la collection Veyrenc au Musée de Valence*, exh. cat. by J. de Cayeux, 1985, p. 298.

17. *Landscape with a Hermit*, c. 1780

PROVENANCE: From 1948, Hermitage, Leningrad.

EXHIBITION: 1985 Leningrad, no. 55.

COLLECTION CATALOGUES: Hermitage: 1958, vol. 1, p. 338. 1976, p. 227. 1982, no. 314. 1986, no. 238.

SELECTED REFERENCES: Nemilova, I., "Paintings of Hubert Robert on Literary Subjects," *Hermitage Studies* 1 (1956), pp. 207-11 (in Russian). Valence, Musée, *Les Hubert Robert de la collection Veyrenc au Musée de Valence*, exh. cat. by J. de Cayeux, 1985, p. 186.

ELISABETH LOUISE VIGÉE LE BRUN

18. *Count Grigori Chernyshov*, 1793

PROVENANCE: In 1793, commissioned in Vienna by Count G. Chernyshov. Chernyshov family collection, at their estate, Yaropoletz, Moscow province. Chernyshova-Kruglikova family collection, St. Petersburg-Petrograd. From 1923, Hermitage, Petrograd-Leningrad.

EXHIBITION: 1905 St. Petersburg, no. 208.

COLLECTION CATALOGUES: Hermitage: 1958, vol. 1, p. 275. 1976, p. 193. 1982, no. 83. 1986, no. 316.

SELECTED REFERENCES: Vigée Le Brun, E., *Souvenirs de Madame Louise-Elisabeth Vigée le Brun . . .*, Paris, 1835, vol. 2, p. 371. Wrangel, N., "Foreigners in Russia," *The Old Years* (July-Sept. 1911), pp. 22, 76, n. 10 (in Russian). Nikolenko, L., "The Russian Portraits of Madame Vigée-Lebrun," *Gazette des beaux-arts* 70 (July-Aug. 1967), nos. 54, 54a, pp. 95, 115-16.

FRANÇOIS GÉRARD

19. *Josephine*, 1801

PROVENANCE: In 1801, commissioned by Josephine for Malmaison. From 1801 to 1814, Josephine's collection, Malmaison. After 1814, Eugène Beauharnais, Duke of Leuchtenberg, collection. Dukes of Leuchtenberg, Munich, St. Petersburg-Petrograd. From 1919, Hermitage, Petrograd-Leningrad.

EXHIBITIONS: 1861 St. Petersburg, no. 696. 1889 St. Petersburg, no. 179. 1923 Petrograd, Hall 1. 1938 Leningrad, no. 295. 1955 Moscow, p. 35. 1956a Leningrad, p. 26. 1972a Leningrad, no. 338.

COLLECTION CATALOGUES: Hermitage: 1958, vol. 1, p. 390. 1976, p. 262. 1983, no. 190.

SELECTED REFERENCES: Brun-Neergaard, T., *Sur la Situation des beaux-arts en France, ou lettres d'un danois à son ami*, Paris, 1801, pp. 118-19. *Oeuvres du baron François Gérard*, Paris, 1852-53, pt. 1, p. 8. Blanc, C., *Histoire des peintres de toutes les écoles. Ecole française*, Paris, 1863, vol. 3, chap. on François Gérard, p. 11. Izerghina, A., *French Painting in the Hermitage: First Half and Middle of the Nineteenth Century*, Leningrad, 1969, pp. 16-17, 19, ill. (in Russian). Berezina, V., *The State Hermitage. French Painting in the Nineteenth Century: From David to Fantin-Latour*, Leningrad, 1972, pp. 39-41, ill. (in Russian). Berezina 1987, no. 23. Kostenevich 1987, no. 12.

LOUIS LÉOPOLD BOILLY

20. *Young Artist*, 1800

PROVENANCE: In the early nineteenth century, acquired in Paris by Prince N. B. Yusupov. After 1811, Yusupov collection, Moscow. In 1839, transferred to Yusupov Palace, St. Petersburg. From 1918 to 1924, Yusupov Palace Museum, Petrograd. From 1924 to 1927, Hermitage, Petrograd-Leningrad. In 1927, transferred to Pushkin Museum, Moscow.

EXHIBITIONS: 1908 St. Petersburg, no. 65. 1912 St. Petersburg, no. 57. 1955 Moscow, p. 22. 1956a Leningrad, p. 8. 1974-75 Paris, Detroit, New York, no. 7.

COLLECTION CATALOGUES: Yusupov: 1839, no. 229. Pushkin Museum: 1948, p. 13. 1957, p. 19. 1961, p. 27. 1986, p. 35.

SELECTED REFERENCES: Hautecoeur, L., "L'Exposition centennale de peinture française à Saint-Petersburg," *Les Arts* 11 (Sept. 1912), no. 129, p. 24. Marmottan, P., *Le Peintre Louis Boilly (1761-1845)*, Paris, 1913, p. 245. Mabille de Poncheville, A., *Boilly*, Paris, 1931, p. 172. Hallam, J., *Genre Works of Louis Boilly*, Ann Arbor, 1979, pp. 58-60. Georgievskaya and Kuznetsova 1980, no. 79. Kuznetsova 1982, p. 74. Eliel, C., *Form and Content in the Genre Works of Louis-Léopold Boilly*, Ann Arbor, 1985, p. 151, fig. 176.

21. *The Billiard Party*, 1807

PROVENANCE: By 1810, acquired in Paris by Prince N. B. Yusupov. After 1811, Yusupov collection, Moscow. In 1839, transferred to Yusupov Palace, St. Petersburg. From 1918 to 1924, Yusupov Palace Museum, Petrograd. From 1925, Hermitage, Leningrad.

EXHIBITIONS: 1908 St. Petersburg, no. 94. 1912 St. Petersburg, no. 58. 1955 Moscow, p. 22. 1956a Leningrad, p. 8. 1965 Bordeaux, no. 47. 1965-66 Paris, no. 46. 1969 Budapest, no. 1.

COLLECTION CATALOGUES: Yusupov: 1839, no. 450. 1920, no. 71. Hermitage: 1958, vol. 1, p. 363. 1976, p. 241. 1983, no. 35.

SELECTED REFERENCES: Harrise, H., *L. L. Boilly*, Paris, 1898, no. 95. Marmottan, P., *Le Peintre Louis Boilly (1761-1845)*, Paris, 1913, p. 245. Berezina, V., *Louis Léopold Boilly: The Game of Billards*, Leningrad, 1949 (in Russian). Izerghina, A. *French Painting in the Hermitage: First Half and Middle of the Nineteenth Century*, Leningrad, 1969, p. 22 (in Russian). Berezina, V., *The State Hermitage. French Painting in the Nineteenth Century: From David to Fantin-Latour*, Leningrad, 1972, pp. 56-57, ill. (in Russian). Hallam, J., *Genre Works of Louis Boilly*, Ann Arbor, 1979, pp. 97-98, n. 196, fig. 105. Berezina 1987, nos. 36-38. Kostenevich 1987, no. 13.

JACQUES LOUIS DAVID

22. *Sappho, Phaon, and Cupid*, 1809

PROVENANCE: In 1808, commissioned in Paris by Prince N. B. Yusupov. After 1811, Yusupov collection, Moscow. In 1839, transferred to Yusupov Palace, St. Petersburg. From 1918 to 1924, Yusupov Palace Museum, Petrograd. From 1925, Hermitage, Leningrad.

EXHIBITION: 1956a Leningrad, p. 20.

COLLECTION CATALOGUES: Yusupov: 1839, no. 217. 1920, no. 120, p. 163, ill. Hermitage: 1958, vol. 1, p. 375. 1976, p. 251. 1983, no. 100. 1986, no. 251.

SELECTED REFERENCES: *Notice sur la vie et les ouvrages de M. J.-L. David*, Paris, 1824, p. 44. Thomé, A., *La Vie de David, premier peintre de Napoléon*, Paris, 1826, pp. 152-53, 236. Coupin, P., *Essai sur J.-L. David, peintre d'histoire, ancien membre de l'Institut, officier de la Légion d'Honneur*, Paris, 1827, p. 55. Villars, Miette de, *Mémoires de David, peintre et député à la Convention*, Paris, 1850, p. 156. David, J., *Le Peintre Louis David 1748-1825, souvenirs et documents inédits*, Paris, 1880, pp. 390, 579, 646. Cantinelli, R., *Jacques-Louis David, 1748-1825*, Paris-Brussels, 1930,

no. 110, pp. 93, 112. Humbert, A., *Louis David, peintre et conventionel. Essai de critique marxiste*, Paris, 1936, pp. 144-45, 173. Holma, K., *David, son évolution et son style*, Paris, 1940, no. 126, pp. 86, 128. Friedländer, W., *David to Delacroix*, Cambridge, Mass., 1952, pp. 31-32. Hautecoeur, L., *Louis David*, Paris, 1954, p. 226. Sterling 1957, pp. 68-69. Berezina, V., *Jacques Louis David*, Leningrad, 1963, pp. 53-54 (in Russian). Kuznetsova, I., *David*, Moscow, 1965, pp. 190, 223 (in Russian). Haskell, F., *An Italian Patron of French Neo-Classic Art: Sommariva* (The 1972 Zaharoff Lecture), Oxford, 1972, pp. 21-22, ill. Honour, H., "Canova and David," *Apollo* 96 (Oct. 1972), p. 316. Verbraecken, R., *Jacques Louis David jugé par ses contemporains et par la postérité*, Paris, 1973, p. 189, n. 273. Wildenstein, D., and G., *Documents complémentaires au catalogue de l'oeuvre de Louis David*, Paris, 1973, nos. 1563, 1632, 1810, 1938, pp. 182, 189, 208-209, 226. Schnapper, A., in 1974-75 Paris, Detroit, New York, no. 36. Honour, H., "Y eut-il une Peinture 'néo-classique' en France?" *Revue de l'art* 34 (1976), p. 86. Adams, B., "Painter to Patron: David's Letters to Youssoupoff about the 'Sappho, Phaon, and Cupid,'" *Marsyas, Studies in the History of Art* 19 (1977-78), pp. 29-36, pl. 16. Brookner, A., *Jacques-Louis David*, London, 1980, p. 163, fig. 94. Schnapper, A., *David, témoin de son temps*, Fribourg, 1980, pp. 268-70. Berezina 1987, nos. 10-11. Kostenevich 1987, nos. 9-10.

JEAN AUGUSTE DOMINIQUE INGRES

23. *Count Nikolai Guryev*, 1821

PROVENANCE: In 1821, commissioned in Florence by Count N. D. Guryev. From 1821 to 1849, Guryev collection. From 1849 to 1871, M. D. Guryeva (née Naryshkina) collection, St. Petersburg. From 1871 to 1889, E. D. Naryshkina collection, St. Petersburg. From 1889 to 1922, A. N. Naryshkina collection, St. Petersburg-Petrograd. From 1922, Hermitage, Petrograd-Leningrad.

EXHIBITIONS: 1889 St. Petersburg, no. 77. 1923 Petrograd, Hall 1. 1938 Leningrad, no. 332. 1955 Moscow, p. 62. 1956a Leningrad, p. 62. 1965 Bordeaux, no. 53. 1967-68 Paris, no. 120, pp. 172-73. 1972a Leningrad, no. 402. 1974-75 Paris, Detroit, New York, no. 109. 1988 London, no. 18.

COLLECTION CATALOGUES: Hermitage: 1958, vol. 1, p. 458. 1976, p. 303. 1983, no. 241.

SELECTED REFERENCES: Delaborde, H., *Ingres, sa vie, ses travaux, sa doctrine, d'après les notes manuscrites et les lettres du maître*, Paris, 1870, no. 123, p. 249. Lapauze, H., *J. A. D. Ingres, les cahiers de Montauban*, Montauban, 1898, p. 214; *Les Dessins de J. A. D. Ingres du musée de Montauban*, Paris, 1901, albums 9-10. *Portraits of Russians who Lived in the Eighteenth and Nineteenth Centuries*, St. Petersburg, 1907, vol. 3, no. 4, pl. 201 (in Russian). Boyer d'Ageu, A., *Ingres, d'après une correspondance inédite*, Paris, 1909, p. 69. Lapauze, H., *Ingres, sa vie et son oeuvre (1780-1867), d'après des documents inédits*, Paris, 1911, p. 214; "Sur un Portrait inédit d'Ingres," *Renaissance de l'art français moderne* (1923), p. 446. Wildenstein, G., *The Paintings of J. A. D. Ingres*, London, 1954, no. 148, p. 193, pl. 55. Sterling 1957, p. 74, pl. 55. Kamenskaya, T., "Les Oeuvres d'Ingres au Musée de l'Ermitage," *Bulletin du Musée Ingres* 6 (1959). Berezina, V., *Ingres, Portrait of N. D. Guryev*, Leningrad, 1960 (in Russian); *Jean Auguste Dominique Ingres, Album*, Leningrad, 1967, p. 10 (in Russian). Rosenblum, R., *Jean-Auguste-Dominique Ingres*, New York, 1967, pp. 120-21, pl. 30. Ternois, D., and E. Camesasca, *Tout l'Oeuvre peint d'Ingres*, Paris, 1971, no. 106. Berezina, V., *Jean Auguste Dominique Ingres*, Moscow, 1977, nos. 61-62, pp. 114-18 (in Russian). Whiteley, J., *Ingres*, London, 1977, p. 62. Berezina 1987, no. 68. Kostenevich 1987, nos. 32-33.

24. *Virgin with Chalice*, 1841

PROVENANCE: In 1841, commissioned in Rome by Grand Duke Aleksandr Nikolaevich, the future Czar Alexander II. In 1845,

presented to the Museum of the Academy of Fine Arts, St. Petersburg. From 1922 to 1930, Hermitage, Petrograd-Leningrad. In 1930, transferred to Pushkin Museum, Moscow.

EXHIBITIONS: 1842 St. Petersburg. 1861 St. Petersburg, no. 297. 1955 Moscow, p. 62. 1956a Leningrad, p. 62. 1979 Dresden, no. 34. 1988 London, no. 19.

COLLECTION CATALOGUES: St. Petersburg, Academy of Fine Arts: 1874, no. 639. Pushkin Museum: 1948, p. 87. 1957, p. 149. 1961, p. 157. 1986, p. 191.

BIBLIOGRAPHY: Lenormant, C., "La Vièrge adorant l'eucharistie, tableau de M. Ingres," *L'Artiste* (1841), p. 194. Vernier, L., "De la Madonne executée pour le Grand Duc héritier de toutes les russies par M. Ingres," *L'Artiste* (1841), p. 1. Delaborde, H., *Ingres, sa vie, ses travaux, sa doctrine, d'après les notes manuscrites et les lettres du maitre,* Paris, 1870, no. 11, p. 181. Lapauze, H., *Ingres, sa vie et son oeuvre (1780-1867), d'après des documents inédits,* Paris, 1911, p. 214. Wildenstein, G., *The Paintings of J. A. D. Ingres,* London, 1956, no. 234, p. 212. Sterling 1957, p. 74. Ternois, D., and E. Camesasca, *Tout l'Oeuvre peint d'Ingres,* Paris, 1971, no. 132. Berezina, V., *Jean Auguste Dominique Ingres,* Moscow, 1977, p. 174 (in Russian). Georgievskaya and Kuznetsova 1980, no. 100. Kuznetsova 1982, pp. 283-84.

EDOUARD MANET

25. *The Bar,* c. 1878

PROVENANCE: Until Mar. 6, 1900, A. Tavernier collection, Paris. On Mar. 6, 1900, sold by Galerie Georges Petit, Paris, no. 54, to S. I. Shchukin for 4,800 francs. From 1900 to 1903, Shchukin collection, Moscow. In 1903, acquired by M. A. Morozov; after his death, to his wife, M. Morozova. In 1910, given by M. Morozova to the Tretyakov Gallery, Moscow. On Feb. 21, 1925, transferred to Museum of Modern Western Art, Moscow, where it remained until 1948. From 1948, Pushkin Museum, Moscow.

EXHIBITIONS: 1955 Moscow, no. 43. 1960 Moscow, p. 26. 1966-67 Tokyo, Kyoto, no. 49. 1974 Leningrad, no. 17. 1974-75 Moscow, no. 7.

COLLECTION CATALOGUES: Museum of Modern Western Art: 1928, no. 282. Pushkin Museum: 1957, p. 84. 1961, p. 115. 1986, pp. 111, 156, ill.

SELECTED REFERENCES: Duret, T., *Histoire d'Edouard Manet et de son oeuvre par Théodore Duret, avec un catalogue des peintures et des pastels,* Paris, 1902, no. 226. Ternovetz 1925, p. 457. Moreau-Nélaton, E., *Manet raconté par lui-même,* Paris, 1926, vol. 2, no. 242. Réau 1929, no. 900. Jamot, P., and G. Wildenstein, *Manet,* Paris, 1932, no. 292. Tabarant, A., *Manet et ses oeuvres,* Paris, 1947, no. 302, pp. 330-31. Sterling 1958, pp. 84, 86, pl. 65. Barskaya, A., *Edouard Manet, Album,* Moscow, 1961, p. 9, pl. 22 (in Russian). Rouart, D., and G. Wildenstein, *Edouard Manet, catalogue raisonné,* Lausanne-Paris, 1975, vol. 1, no. 275. Georgievskaya and Kuznetsova 1980, no. 147. Bessonova and Barskaya 1985, no. 7, p. 332. Chegodaev, A., *Edouard Manet,* Moscow, 1985 (in Russian). Bessonova and Williams 1986, p. 46.

PIERRE AUGUSTE RENOIR

26. *Under the Trees, Moulin de la Galette,* 1875

PROVENANCE: By 1896, Eugène Murer collection, Paris and Auvers. In 1896, purchased from Murer by Georges Viau, Paris. His collection until Mar. 4, 1907, when sold to Galerie Durand-Ruel, Paris, no. 53. On Mar. 4, 1907, purchased for 28,500 francs by I. A. Morozov. From 1907 to 1918, Morozov collection, Moscow. From 1918/19 to 1923, Second Museum of Modern Western Painting, Moscow. From 1923 to 1948, Museum of Modern Western Art, Moscow. From 1948, Pushkin Museum, Moscow.

EXHIBITIONS: 1903 Vienna, no. 49. 1904 Paris (Salle Renoir), no. 1. 1955 Moscow, p. 53. 1960 Moscow, p. 31. 1965 Bordeaux, no. 69. 1965-66 Paris, no. 68. 1966-67 Tokyo, Kyoto, no. 53. 1972 Otterlo, no. 49. 1972 Prague, no. 31. 1973 Washington, D.C., New York, et al., no. 36. 1974 Leningrad, no. 36. 1974-75 Moscow, no. 33. 1978b Paris, no. 19. 1985 Venice, Rome, no. 21. 1987 Lugano, no. 9.

COLLECTION CATALOGUES: Museum of Modern Western Art: 1928, no. 503. Pushkin Museum: 1957, p. 118. 1961, p. 157. 1986, p. 149.

SELECTED REFERENCES: Heilbut, E., "Die Impressionisiten Ausstellung der Wiener Secession," *Kunst und Künstler* (1903), p. 184, ill. Makovsky 1912, pp. 9, 23. Meier-Graefe, J., *Auguste Renoir,* Paris, 1912, p. 60. Vollard, A., *Tableaux, pastels et dessins de Pierre-Auguste Renoir,* Paris, 1918, vol. 1, no. 379, p. 95, ill; *La Vie et l'oeuvre de Pierre-Auguste Renoir,* Paris, 1919, p. 48, ill. Bürger, W., "Renoir," *Die Kunst für Alle* 35 (1919-20), p. 174, ill. Réau 1929, no. 503. Drucker, M., *Renoir,* Paris, 1955, pl. 36. Sterling 1958, pp. 102-103, pl. 82. Daulte, F., *Auguste Renoir, catalogue raisonné de l'oeuvre peint,* Lausanne, 1971, vol. 1, no. 197. Fezzi, E., *L'Opera completa de Renoir nel periodo impressionista, 1869-1883,* Milan, 1972, no. 240, p. 99. Georgievskaya and Kuznetsova 1980, no. 165. Bessonova and Barskaya 1985, nos. 47-48, p. 342. Bessonova and Williams 1986, p. 110.

27. *Girls in Black,* c. 1880/82

PROVENANCE: From 1908 to 1918, S. I. Shchukin collection, Moscow. From 1918 to 1923, First Museum of Modern Western Painting, Moscow. From 1923 to 1948, Museum of Modern Western Art, Moscow. From 1948, Pushkin Museum, Moscow.

EXHIBITIONS: 1955 Moscow, p. 54. 1956a Leningrad, p. 51. 1960 Moscow, p. 32. 1974 Leningrad, no. 42. 1974-75 Moscow, no. 40. 1988 London, no. 21.

COLLECTION CATALOGUES: Shchukin: 1913, no. 193. Museum of Modern Western Art: 1928, no. 501. Pushkin Museum: 1957, p. 118. 1961, p. 157. 1986, p. 160, pl. 162.

SELECTED REFERENCES: Réau 1929, no. 1071. Sterling 1958, p. 102, pl. 81. Fosca, F., *Renoir: His Life and Work,* London, 1961, p. 84. Feist, P., *Auguste Renoir,* Leipzig, 1961, no. 36, p. 64. Daulte, F., *Auguste Renoir, catalogue raisonné de l'oeuvre peint,* Lausanne, 1971, vol. 1, no. 375. Fezzi, E., *L'Opera completa de Renoir nel periodo impressionista, 1869-1883,* Milan, 1972, no. 454, pp. 108-109. Georgievskaya and Kuznetsova 1980, no. 168. Bessonova and Barskaya 1985, nos. 56-57, p. 344. Bessonova and Williams 1986, p. 121.

PAUL CÉZANNE

28. *The Smoker,* c. 1890/92

PROVENANCE: Galerie Vollard, Paris. From 1910 to 1918, I. A. Morozov collection, Moscow. From 1918/19 to 1923, Second Museum of Modern Western Painting, Moscow. From 1923 to 1931, Museum of Modern Western Art, Moscow. In 1931, transferred to Hermitage, Leningrad.

EXHIBITIONS: 1904 Paris, no. 1. 1956a Leningrad, p. 56. 1956b Leningrad, no. 18. 1971 Tokyo, Kyoto, no. 53. 1972 Otterlo, no. 2. 1973 Washington, D.C., New York, et al., no. 4. 1974 Leningrad, no. 53. 1978 Le Havre. 1979 Kyoto, Tokyo, Kamakura, no. 7. 1985 Venice, Rome, no. 8. 1986 Tokyo, Kobe, Nagoya, no. 33.

COLLECTION CATALOGUES: Museum of Modern Western Art: 1928, no. 566. Hermitage Museum: 1958, vol. 1, p. 444. 1976, p. 292.

SELECTED REFERENCES: Meier-Graefe, J., *Paul Cézanne,* Munich, 1910, p. 53. Makovsky 1912, p. 23. Vollard, A., *Paul Cézanne,* Paris, 1914, p. 33. Meier-Graefe, J., *Cézanne und sein Kreis,* Munich, 1920, p. 197. Réau 1929, no. 728. Venturi 1936, no. 686. Sterling 1958, pp. 122-23, 237, n. 95, pl. 97. Izerghina

and Barskaya 1975, no. 41. Barskaya and Georgievskaya 1975, no. 19. Reff 1977, p. 19. Cooper, D., "Lugano, French Paintings from Russia," *The Burlington Magazine* 125, 966 (Sept. 1983), p. 576. Kostenevich 1987, no. 96; 1989, no. 57.

29. *The Smoker*, c. 1890/92

PROVENANCE: Galerie Vollard, Paris. From 1913 to 1918, S. I. Shchukin collection, Moscow. From 1918 to 1923, First Museum of Modern Western Painting, Moscow. From 1923 to 1948, Museum of Modern Western Art, Moscow. From 1948, Pushkin Museum, Moscow.

EXHIBITIONS: 1926a Moscow, no. 17. 1955 Moscow, p. 57. 1956a Leningrad, p. 56. 1956b Leningrad, no. 19. 1965 Bordeaux, no. 56. 1965-66 Paris, no. 48. 1976 Dresden, no. 13. 1976 Prague, no. 2. 1978a Paris, no. 5. 1984 Tokyo, Nara, no. 3. 1988 London, no. 28.

COLLECTION CATALOGUES: Shchukin: 1913, no. 205. Museum of Modern Western Art: 1928, no. 551. Pushkin Museum: 1961, p. 169. 1986, p. 162.

SELECTED REFERENCES: Tugendhold 1914, pp. 38-39. Ternovetz 1925, p. 470, ill. Réau 1929, no. 733. Venturi 1936, no. 688. Dorival, B., *Cézanne*, Paris, 1948, p. 61. Feist, P., *Paul Cézanne*, Leipzig, 1963, pl. 63. Gatto and Orienti 1970, no. 602, p. 113. Barskaya and Georgievskaya 1975, no. 18. Reff 1977, pp. 18-19. Georgievskaya and Kuznetsova 1980, no. 181. Bessonova and Barskaya 1985, no. 99, p. 354. Bessonova and Williams 1986, p. 179.

30. *Still Life with Peaches and Pears*, c. 1890/94

PROVENANCE: By 1912, Galerie Vollard, Paris. From 1912 to 1918, I. A. Morozov collection, Moscow. From 1918/19 to 1923, Second Museum of Modern Western Painting, Moscow. From 1923 to 1948, Museum of Modern Western Art, Moscow. From 1948, Pushkin Museum, Moscow.

EXHIBITIONS: 1926a Moscow, no. 19. 1936 Paris, no. 68. 1937 Paris. 1955 Moscow, p. 57. 1956a Leningrad, p. 55. 1956b Leningrad, no. 15.

COLLECTION CATALOGUES: Museum of Modern Western Art: 1928, no. 562. Pushkin Museum: 1957, p. 128, ill. 1961, p. 169. 1986, p. 162, ill.

SELECTED REFERENCES: Ternovetz 1925, p. 465. Réau 1929, no. 744. Venturi 1936, no. 619. Loran, E., *Cézanne's Composition, Analysis of His Form with Diagrams and Photographs of His Motifs*, Berkeley-Los Angeles, 1959, p. 92, pl. 20. Elgar, F., *Cézanne*, Paris, 1968, p. 125, pl. 71. Gatto and Orienti 1970, no. 771, p. 121. Barskaya and Georgievskaya 1975, no. 16. Reff 1977, p. 29. Georgievskaya and Kuznetsova 1980, no. 180. Bessonova and Barskaya 1985, no. 87, p. 351. Bessonova and Williams 1986, p. 166.

31. *Still Life with Curtain*, c. 1894/95

PROVENANCE: Galerie Vollard, Paris. From 1907 to 1918, I. A. Morozov collection, Moscow. From 1918/19 to 1923, Second Museum of Modern Western Painting, Moscow. From 1923 to 1930, Museum of Modern Western Art, Moscow. From 1930, Hermitage, Leningrad.

EXHIBITIONS: 1926a Moscow, no. 14. 1956a Leningrad, p. 56. 1956b Leningrad, no. 22. 1971 Tokyo, Kyoto, no. 54. 1972 Otterlo, no. 4. 1974 Leningrad, no. 54. 1975-76 USA, Mexico, Canada, no. 25. 1977 New York, Houston, no. 27. 1978a Paris, no. 23. 1983 Dresden, no. 27. 1983 Lugano, no. 6. 1984 Leningrad, Moscow, no. 91. 1985 Venice, Rome, no. 9. 1988 London, no. 29.

COLLECTION CATALOGUES: Museum of Modern Western Art: 1928, no. 561. Hermitage: 1958, vol. 1, p. 444. 1976, p. 293.

SELECTED REFERENCES: Makovsky 1912, p. 23. Vollard, A., *Paul Cézanne*, Paris, 1914, pl. 48. Bernard, E., *Souvenirs sur Paul Cézanne*, Paris, 1925, facing p. 92. Réau 1929, no. 743. Venturi

1936, no. 731. Gowing, L., in Edinburgh, Royal Scottish Academy, and the Arts Council of Great Britain, *An Exhibition of Paintings by Cézanne*, London, 1954, no. 58. Sterling 1958, pp. 116, 216, pl. 32. Barskaya and Georgievskaya 1975, no. 20. Izerghina and Barskaya 1975, no. 43. Cooper, D., "Lugano: French Paintings from Russia," *The Burlington Magazine* 125, 966 (Sept. 1983), pp. 575-76. Kostenevich 1987, no. 95; 1989, no. 59.

32. *Mont Sainte-Victoire*, c. 1882/85

PROVENANCE: From 1904 to 1907, Galerie Vollard, Paris. From 1907 to 1918, I. A. Morozov collection, Moscow. From 1918/19 to 1923, Second Museum of Modern Western Painting, Moscow. From 1923 to 1948, Museum of Modern Western Art, Moscow. From 1948, Pushkin Museum, Moscow.

EXHIBITIONS: 1904 Paris, no. 7. 1926a Moscow, no. 8. 1956b Leningrad, no. 8. 1972 Prague, no. 5.

COLLECTION CATALOGUES: Museum of Modern Western Art: 1928, no. 557. Pushkin Museum: 1961, p. 168. 1986, p. 161.

SELECTED REFERENCES: Meier-Graefe, J., *Impressionisten: Guys, Manet, Van Gogh, Pissarro, Cézanne, mit einer Einleitung über den Wert der französischen Kunst*, Munich, 1907, p. 191, ill. Makovsky 1912, pp. 23, 28-29. Meier-Graefe, J., *Paul Cézanne*, Munich, 1913, p. 67, ill.; *Cézanne und sein Kreis*, Munich, 1922, p. 152, ill. Ternovetz 1925, p. 465. Pfister, K., *Cézanne. Gestalt, Werk, Mythos*, Potsdam, 1927, pl. 48. Réau 1929, no. 739. Venturi 1936, no. 423. Elgar, F., *Cézanne*, Paris, 1968, p. 209, pl. 122. Gatto and Orienti 1970, no. 430. Barskaya and Georgievskaya 1975, no. 8. Georgievskaya and Kuznetsova 1980, no. 184. Bessonova and Barskaya 1985, no. 81, p. 350. Bessonova and Williams 1986, p. 161.

33. *Mont Sainte-Victoire*, c. 1906

PROVENANCE: By 1906, acquired from Cézanne by Ambroise Vollard, Paris. From 1906 to 1911, Galerie Vollard, Paris. From 1911 to 1918, S. I. Shchukin collection, Moscow. From 1918 to 1923, First Museum of Modern Western Painting, Moscow. From 1923 to 1948, Museum of Modern Western Art, Moscow. From 1948, Pushkin Museum, Moscow.

EXHIBITIONS: (?) 1905 Paris, no. 318. 1926a Moscow, no. 25. 1956b Leningrad, no. 25. 1965 Bordeaux, no. 58. 1965-66 Paris, no. 50. 1972 Otterlo, no. 7. 1978a Paris, no. 91. 1983 Lugano, no. 8. 1986 Washington, D.C., Los Angeles, New York, no. 8. 1988 London, no. 31.

COLLECTION CATALOGUES: Shchukin: 1913, no. 210. Museum of Modern Western Art: 1928, no. 552. Pushkin Museum: 1961, p. 169. 1986, p. 163.

PAUL GAUGUIN

34. *Self-Portrait*, c. 1888/89, 1891/93, or after

PROVENANCE: In Apr. 1903, Gauguin sent to France a self-portrait (possibly this work) for sale to Gustave Fayet; it remained with Fayet until 1906. In 1906, S. I. Shchukin acquired a self-portrait by Gauguin from Fayet. From 1906 to 1918, S. I. Shchukin collection, Moscow. From 1918 to 1923, First Museum of Modern Western Painting, Moscow. From 1923 to 1948, Museum of Modern Western Art, Moscow. From 1948, Pushkin Museum, Moscow.

EXHIBITIONS: 1906 Paris, possibly no. 1, 2, or 3. 1926b Moscow, no. 2. 1966-67 Tokyo, Kyoto, no. 61. 1983 Lugano, no. 15. 1985 Venice, Rome, no. 22. 1986 Washington, D.C., Los Angeles, New York, no. 15. 1988 London, no. 23. 1989 Moscow, Leningrad, no. 32.

COLLECTION CATALOGUES: Shchukin: 1913, no. 18. Museum of Modern Western Art: 1928, no. 88. Pushkin Museum: 1961, p. 54. 1986, p. 56.

SELECTED REFERENCES: Tugendhold 1914, p. 38. Piertsov, P., *The Shchukin Collection of French Painting*, Moscow, 1921, pp. 77, 108 (in Russian). Ternovetz 1925, p. 472. Réau 1929, no. 830. Rewald, J., *Gauguin*, Paris, 1938, pl. 40. Van Dovski, L. [Herbert Lewandowski], *Paul Gauguin oder die Flucht von der Zivilisation*, Bern, 1950, no. 206. Sterling 1958, pp. 126, 128, pl. 102. Wildenstein 1964, no. 297. Mittelstädt, K., *Die Selbstbildnisse Paul Gauguins*, Berlin, 1966, no. 19, pp. 18, 70. Cachin, F., *Gauguin*, Paris, 1968, p. 364. Sugana, G., *L'Opera completa di Gauguin*, Milan, no. 132, pp. 94-95. Georgievskaya and Kuznetsova 1980, no. 192. Cooper, D., "Lugano: French Paintings from Russia," *The Burlington Magazine* 125, 966 (Sept. 1983), p. 575. Bessonova and Barskaya 1985, no. 121, pp. 360-61. Bessonova and Williams 1986, p. 207. Cachin, F., "Gauguin Portrayed by Himself and by Others," in 1988-89 Washington, D.C., Chicago, Paris, pp. xviii-xix, ill.

35. *Woman Holding Fruit*, 1893

PROVENANCE: Until 1908, Galerie Vollard, Paris. In 1908, purchased by I. A. Morozov for 8,000 francs. From 1908 to 1918, Morozov collection, Moscow. From 1918/19 to 1923, Second Museum of Modern Western Painting, Moscow. From 1923 to 1948, Museum of Modern Western Art, Moscow. From 1948, Hermitage, Leningrad.

EXHIBITIONS: 1926b Moscow, no. 11. 1956a Leningrad, p. 16. 1969 Budapest, no. 19. 1970 Osaka, no. 246. 1974 Leningrad, no. 7. 1975-76 USA, Mexico, Canada, no. 26. 1978b Paris, no. 14. 1982 Tokyo, no. 10. 1983 Lugano, no. 20. 1985 Venice, Rome, no. 25. 1987 Tokyo, Nagoya, no. 70.

COLLECTION CATALOGUES: Museum of Modern Western Art: 1928, no. 109. Hermitage: 1958, vol. 1, p. 371. 1976, p. 247.

SELECTED REFERENCES: Makovsky 1912, p. 20. Réau 1929, no. 842. Van Dovski, L. [Herbert Lewandowski], *Paul Gauguin oder die Flucht von der Zivilisation*, Bern, 1950, no. 265. Sterling 1958, p. 130, pl. 104. Wildenstein 1964, no. 501. Kantor-Gukovskaya, A., *Paul Gauguin*, Leningrad, 1965, p. 116 (in Russian). Danielsson, B., "Gauguin's Tahitian Titles," *The Burlington Magazine* 109, 760 (Apr. 1967), p. 230. Cachin, F., *Gauguin*, Paris, 1968, p. 363. Izerghina and Barskaya 1975, no. 56. Kostenevich 1987, nos. 107-108; 1989, nos. 77-78.

36. *Sunflowers*, 1901

PROVENANCE: From 1908 to 1918, S. I. Shchukin collection, Moscow. From 1918 to 1923, First Museum of Modern Western Painting, Moscow. From 1923 to 1931, Museum of Modern Western Art, Moscow. In 1931, transferred to Hermitage, Leningrad.

EXHIBITIONS: 1926b Moscow, no. 12. 1965 Bordeaux, no. 62. 1965-66 Paris, no. 59. 1966-67 Tokyo, Kyoto, no. 62. 1972 Otterlo, no. 19. 1973 Washington, D.C., New York, et al., no. 15. 1978 Le Havre. 1987 Tokyo, Nagoya, no. 141. 1988-89 Washington, D.C., Chicago, Paris, no. 253.

COLLECTION CATALOGUES: Shchukin: 1913, no. 22. Museum of Modern Western Art: 1928, no. 101. Hermitage: 1958, vol. 1, p. 373. 1976, p. 248.

SELECTED REFERENCES: Tugendhold 1914, p. 38; 1923, p. 48. Réau 1929, no. 843. Sterling 1958, pp. 135, 238, n. 115, pl. III. Wildenstein 1964, no. 603. Kantor-Gukovskaya, A., *Paul Gauguin*, Leningrad, 1965, pp. 169-70 (in Russian). Izerghina and Barskaya 1975, no. 67. Kostenevich 1987, no. 109; 1989, no. 90.

PIERRE BONNARD

37. *Mirror over Washstand*, 1908

PROVENANCE: On Sept. 8, 1908, acquired from Bonnard by Galerie Bernheim-Jeune, Paris. On Oct. 3, 1908, sold to I. A. Morozov. From 1908 to 1918, Morozov collection, Moscow. From 1918/19 to 1923, Second Museum of Modern Western Painting, Moscow. From 1923 to 1948, Museum of Modern Western Art, Moscow. From 1948, Pushkin Museum, Moscow.

EXHIBITIONS: 1908 Paris, no. 184. 1965 Bordeaux, no. 75. 1965-66 Paris, no. 73. 1983 Dresden, no. 19. 1988 London, no. 32.

COLLECTION CATALOGUES: Museum of Modern Western Art: 1928, no. 21. Pushkin Museum: 1961, p. 21. 1986, pp. 29-30.

SELECTED REFERENCES: Makovsky 1912, p. 19. Réau 1929, no. 705. Denis, M., *Journal*, Paris, 1957, vol. 2, p. 101. Dauberville 1968, no. 488. Georgievskaya and Kuznetsova 1980, no. 215. Bessonova and Barskaya 1985, no. 210, p. 382. Bessonova and Williams 1986, p. 275.

38. *The Beginning of Spring, Small Fauns*, c. 1909

PROVENANCE: In 1909, acquired from Bonnard by Galerie Bernheim-Jeune, Paris. On June 28, 1909, sold to Henry Bernstein, Paris; his collection until June 8, 1911. On June 8, 1911, sold, Hôtel Drouot, Paris, no. 4, to Galerie Bernheim-Jeune, Paris. In 1912, sold to I. A. Morozov for 5,000 francs. From 1912 to 1918, Morozov collection, Moscow. From 1918/19 to 1923, Second Museum of Modern Western Painting, Moscow. From 1923 to 1948, Museum of Modern Western Art, Moscow. From 1948, Hermitage, Leningrad.

EXHIBITIONS: 1956a Leningrad, p. 8. 1978 Le Havre. 1979 Kyoto, Tokyo, Kamakura, no. 25. 1982 Moscow, no. 87. 1984 Tokyo, Nara, no. 19. 1984-85 Zurich, Frankfurt, no. 60. 1988-89 Tokyo, Kyoto, Nagoya, no. 35.

COLLECTION CATALOGUES: Museum of Modern Western Art: 1928, no. 20. Hermitage: 1958, vol. 1, p. 360. 1976, p. 239.

SELECTED REFERENCES: Makovsky 1912, p. 19. Coquiot, G., *Bonnard*, Paris, 1922, p. 56. Terrasse, C., *Bonnard*, Paris, 1927, p. 94. Réau 1929, p. 704. Sterling, C., "Notice biographique de Bonnard," *L'Amour de l'art* 14 (Apr. 1933), p. 89. Dauberville 1968, no. 540. Izerghina and Barskaya 1975, no. 98. Kostenevich 1987, no. 122; 1989, no. 128.

39. *Summer in Normandy*, c. 1912

PROVENANCE: In 1913, acquired from Bonnard by Galerie Bernheim-Jeune, Paris. In 1913, sold by Bernheim-Jeune to Denis Cochin, Paris. In 1913, sold by Galerie E. Druet, Paris, to I. A. Morozov for 6,000 francs. From 1913 to 1918, Morozov collection, Moscow. From 1918/19 to 1923, Second Museum of Western Painting, Moscow. From 1923 to 1948, Museum of Modern Western Art, Moscow. From 1948, Pushkin Museum, Moscow.

EXHIBITIONS: 1913a Paris, no. 2. 1939 Moscow, p. 52. 1971 Tokyo, Kyoto, no. 60. 1972 Prague, no. 2. 1984-85 Zurich, Frankfurt, no. 71. 1987 Lugano, no. 28.

COLLECTION CATALOGUES: Museum of Modern Western Art: 1928, no. 22. Pushkin Museum: 1961, p. 21. 1986, p. 30.

SELECTED REFERENCES: Terrasse, C., *Bonnard*, Paris, 1927, pp. 126-27, ill. Réau 1929, no. 706. Terrasse, A., *Pierre Bonnard*, Paris, 1967, p. 97. Dauberville 1968, no. 695. Georgievskaya and Kuznetsova 1980, no. 217. Bessonova and Barskaya 1985, no. 227, p. 385. Bessonova and Williams 1986, p. 281.

40. *Summer, The Dance*, c. 1912

PROVENANCE: In 1912, acquired from Bonnard by Galerie Bernheim-Jeune, Paris. In 1913, sold to I. A. Morozov. From 1913 to 1918, Morozov collection, Moscow. From 1918/19 to 1923, Second Museum of Modern Western Painting, Moscow. From 1923 to 1948, Museum of Modern Western Art, Moscow. From 1948, Pushkin Museum, Moscow.

EXHIBITION: 1912a Paris, no. 2.

COLLECTION CATALOGUES: Museum of Modern Western Art: 1928, no. 24. Pushkin Museum: 1986, p. 30.

SELECTED REFERENCES: Réau 1929, no. 709. Dauberville 1968, no. 720. Georgievskaya and Kuznetsova 1980, no. 26, pp. 336,

367, ill. Bessonova and Barskaya 1985, no. 223, p. 384. Bessonova and Williams 1986, p. 280.

HENRI MATISSE

41. *Game of Bowls*, 1908

PROVENANCE: By 1908, Galerie Bernheim-Jeune, Paris. From 1908 to 1918, S. I. Shchukin collection, Moscow. From 1918 to 1923, First Museum of Modern Western Painting, Moscow. From 1923 to 1948, Museum of Modern Western Art, Moscow. In 1948, transferred to Hermitage, Leningrad.

EXHIBITIONS: 1969 Moscow, Leningrad, no. 20. 1969-70 Prague, no. 6. 1972 Otterlo, no. 31. 1973 Washington, D.C., New York, et al., no. 22. 1986 Lille, no. 8. 1988-89 Barcelona, Madrid, no. 7.

COLLECTION CATALOGUES: Shchukin: 1913, no. 109. Museum of Modern Western Art: 1928, no. 318. Hermitage: 1958, vol. 1, p. 409. 1976, p. 278.

SELECTED REFERENCES: Mercereau, A., "Henri Matisse and Modern Painting," *Golden Fleece* 6 (1909), p. 7, ill. (in Russian). Réau 1929, no. 929. Barr 1951, pp. 25, 106, 132. Diehl 1954, p. 32. Sterling 1958, pp. 171-72. Lassaigne 1959, p. 49. Izerghina and Barskaya 1975, no. 157. Izerghina et al. 1978, no. 21. Flam 1986, pp. 226-27. Kostenevich 1989, no. 193.

42. *Nymph and Satyr*, 1909

PROVENANCE: In Nov. 1908 (before completion), reserved by Galerie Bernheim-Jeune, Paris, for 2,500 francs. In Feb. 1909, Matisse arranged with Bernheim-Jeune for painting to be shipped to S. I. Shchukin. From 1909 to 1918, Shchukin collection, Moscow. From 1918 to 1923, First Museum of Modern Western Painting, Moscow. From 1923 to 1948, Museum of Modern Western Art, Moscow. From 1948, Hermitage, Leningrad.

EXHIBITIONS: 1965 Bordeaux, no. 88. 1965-66 Paris, no. 87. 1968 London, no. 42. 1969 Moscow, Leningrad, no. 21. 1969-70 Prague, no. 7. 1972 Otterlo, no. 33. 1973 Washington, D.C., New York, et al., no. 23. 1981 Tokyo, Kyoto, no. 27. 1985 Venice, Rome, no. 34. 1988 Sydney, Melbourne, no. 28.

COLLECTION CATALOGUES: Shchukin: 1913, no. 112. Museum of Modern Western Art: 1928, no. 320. Hermitage: 1958, vol. 1, p. 409. 1976, p. 278.

SELECTED REFERENCES: Mercereau, A., "Henri Matisse and Modern Painting," *Golden Fleece* 6 (1909), p. 14, ill. (in Russian). Tugendhold 1914, p. 42. Réau 1929, no. 935. Barr 1951, pp. 25, 106, 132, 358. Diehl 1954, p. 37. Sterling 1958, pp. 171-72. Aragon, L., *Henri Matisse, Roman*, Paris, 1971, vol. 1, pp. 301, 315. Neff, J., "An Early Ceramic Triptych by Henri Matisse," *The Burlington Magazine* 114, 837 (Dec. 1972), pp. 852-53. Izerghina and Barskaya 1975, no. 158. Izerghina et al. 1978, no. 22. Flam 1986, pp. 246-50. Kostenevich 1989, no. 194.

43. *Conversation*, 1909

PROVENANCE: Probably in Aug. 1912, acquired from Matisse by S. I. Shchukin. From 1912 to 1918, Shchukin collection, Moscow. From 1918 to 1923, First Museum of Modern Western Painting, Moscow. From 1923 to 1930, Museum of Modern Western Art, Moscow. In 1930, transferred to Hermitage, Leningrad.

EXHIBITIONS: 1912 London, no. 28. 1969 Moscow, Leningrad, no. 27. 1986 Québec, no. 27. 1986 Washington, D.C., Los Angeles, New York, no. 27.

COLLECTION CATALOGUES: Shchukin: 1913, no. 122. Museum of Modern Western Art: 1928, no. 341. Hermitage: 1958, vol. 1, p. 409. 1976, p. 278.

SELECTED REFERENCES: Réau 1929, no. 955. Barr 1951, pp. 104, 106, 123, 126, 149, 152, 555. Izerghina and Barskaya 1975, no. 156. Schneider, P., "The Striped Pajama Icon," *Art in America* 4 (July-Aug. 1975), pp. 76-82. Flam 1986, pp. 248-52, 279, 494. Kostenevich 1987, no. 149; 1989, no. 197.

44. *Still Life with "Dance,"* 1909

PROVENANCE: Early in 1910, purchased from Matisse by I. A. Morozov for 5,000 francs. From 1910 to 1918, Morozov collection, Moscow. From 1918/19 to 1923, Second Museum of Modern Western Painting, Moscow. From 1923 to 1948, Museum of Modern Western Art, Moscow. From 1948, Hermitage, Leningrad.

EXHIBITIONS: 1910 Paris, no. 64. 1969 Moscow, Leningrad, no. 26. 1970 Paris, no. 98. 1975-76 USA, Mexico, Canada, no. 27. 1979 Kyoto, Tokyo, Kamakura, no. 30. 1982-83 Zurich, Düsseldorf, no. 27. 1986 Lille, no. 12. 1988-89 Barcelona, Madrid, no. 10.

COLLECTION CATALOGUES: Museum of Modern Western Art: 1928, no. 351. Hermitage: 1958, vol. 1, p. 414. 1976, p. 278.

SELECTED REFERENCES: Makovsky 1912, p. 22. Réau 1929, no. 963. Barr 1951, p. 127. Diehl 1954, p. 6. Charbonnier, G., "Entretiens avec Henri Matisse," *Les Monologues du peintre*, Paris, 1960, vol. 2, pp. 7-16. Izerghina and Barskaya 1975, no. 159. Neff, J., "Matisse and Decoration: The Shchukin Panels," *Art in America* 4 (July-Aug. 1975), p. 48. Izerghina et al. 1978, no. 27. Schneider 1984, pp. 35-36, 345. Flam 1986, pp. 271-73, 495-96. Kostenevich 1989, no. 198.

45. *Pink Statuette and Jug on a Red Chest of Drawers*, 1910

PROVENANCE: By 1913 to 1918, S. I. Shchukin collection, Moscow. From 1918 to 1923, First Museum of Modern Western Painting, Moscow. From 1923 to 1930, Museum of Modern Western Art, Moscow. In 1930, transferred to Hermitage, Leningrad.

EXHIBITIONS: 1969 Moscow, Leningrad, no. 31. 1970 Paris, no. 100.

COLLECTION CATALOGUES: Shchukin: 1913, no. 105. Museum of Modern Western Art: 1928, no. 326. Hermitage: 1958, vol. 1, p. 414. 1976, p. 273.

SELECTED REFERENCES: Tugendhold 1914, p. 42. Réau 1929, no. 940. Barr 1951, pp. 106, 127-28. Izerghina and Barskaya 1975, no. 161. Izerghina et al. 1978, no. 32. Kostenevich 1989, no. 201.

46. *Seville Still Life II*, late 1910 or early 1911

PROVENANCE: Early in 1911, acquired from Matisse by S. I. Shchukin. From 1911 to 1918, Shchukin collection, Moscow. From 1918 to 1923, First Museum of Modern Western Painting, Moscow. From 1923 to 1948, Museum of Modern Western Art, Moscow. From 1948, Hermitage, Leningrad.

EXHIBITIONS: 1965 East Berlin, p. 51. 1966-67 Tokyo, Kyoto, no. 71. 1969 Moscow, Leningrad, no. 34. 1970 Paris, no. 104. 1982-83 Zurich, Düsseldorf, no. 32. 1986 Lille, no. 13.

COLLECTION CATALOGUES: Shchukin: 1913, no. 116. Museum of Modern Western Art: 1928, no. 329. Hermitage: 1958, vol. 1, p. 414. 1976, p. 278.

SELECTED REFERENCES: Tugendhold 1914, p. 42. Réau 1929, no. 943. Barr 1951, pp. 25, 134, 143, 151. Diehl 1954, p. 68. Sterling 1958, pp. 176-77, pl. 146. Izerghina and Barskaya 1975, no. 167. Izerghina et al. 1978, no. 35. Kostenevich 1989, no. 206.

47. *Still Life with a Blue Tablecloth*, 1909

PROVENANCE: In Feb. 1909, Matisse arranged with Galerie Bernheim-Jeune, Paris, for a still life (probably this work) to be shipped to S. I. Shchukin. From 1909 to 1918, Shchukin collection, Moscow. From 1918 to 1923, First Museum of Modern Western Painting, Moscow. From 1923 to 1931, Museum of

Modern Western Art, Moscow. In 1931, transferred to Hermitage, Leningrad.

EXHIBITIONS: 1956a Leningrad, p. 38. 1969 Moscow, Leningrad, no. 25. 1970 Paris, no. 93. 1972 Otterlo, no. 32. 1973 Washington, D.C., New York, et al., no. 24. 1981 Tokyo, Kyoto, no. 32. 1983 Dresden, no. 107. 1984 Leningrad, Moscow, no. 54. 1986 Lille, no. 11. 1988-89 Barcelona, Madrid, no. 9.

COLLECTION CATALOGUES: Shchukin: 1913, no. 114. Museum of Modern Western Art: 1928, no. 321. Hermitage: 1958, vol. 1, p. 409. 1976, p. 278.

SELECTED REFERENCES: Tugendhold 1914, p. 42; 1923, p. 73. Réau 1929, no. 934. Barr 1951, p. 126. Lassaigne 1959, p. 56. Aragon, L., *Henri Matisse, roman*, Paris, 1971, vol. 1, pp. 90-91. Izerghina and Barskaya 1975, no. 155. Izerghina et al. 1978, no. 26. Schneider 1984, pp. 143, 388. Flam 1986, pp. 252, 494. Kostenevich 1989, nos. 195-96.

48. *Nasturtiums and "Dance,"* 1912

PROVENANCE: In the summer of 1912, acquired from Matisse by S. I. Shchukin. Sometime after mid-Jan. 1913 to 1918, Shchukin collection, Moscow. From 1918 until 1923, First Museum of Modern Western Painting, Moscow. From 1923 until 1948, Museum of Modern Western Art, Moscow. From 1948, Pushkin Museum, Moscow.

EXHIBITIONS: 1912b Paris, no. 769. 1958 Brussels, no. 210. 1965 Bordeaux, no. 90. 1965-66 Paris, no. 90. 1967 Montreal, no. 138. 1969 Moscow, Leningrad, no. 41. 1969-70 Prague, no. 12. 1972 Otterlo, no. 34. 1973 Washington, D.C., New York, et al., no. 25. 1981 Tokyo, Kyoto, no. 33. 1983 Lugano, no. 31. 1985 Venice, Rome, no. 37. 1986 Washington, D.C., Los Angeles, New York, no. 31. 1988 London, no. 37. 1988-89 Barcelona, Madrid, no. 18.

COLLECTION CATALOGUES: Shchukin: 1913, no. 121. Museum of Modern Western Art: 1928, no. 331. Pushkin Museum: 1961, p. 121. 1986, p. 116.

SELECTED REFERENCES: Tugendhold 1914, p. 42; 1923, p. 143. Réau 1929, no. 945. Becker, J., "The Museum of Modern Western Painting in Moscow," *Creative Art* (Apr. 1932), p. 283. Barr 1951, pp. 127, 144-45, 148, 156-57, 537, 555. Diehl 1954, no. 57, pp. 68, 138-48, 154. Sterling 1958, p. 180. Lassaigne 1959, p. 66. Luzi, M., and M. Carra, *L'Opera di Matisse dalla rivolta "fauve" all'intimismo, 1904-1928*, Milan, 1971, no. 147, p. 92, ill. Orienti, S., *Henri Matisse*, London-New York, 1972, p. 32. Izerghina et al. 1978, no. 42. Georgievskaya and Kuznetsova 1980, no. 231. Schneider 1984, p. 265, ill. Flam 1986, pp. 344-48, 500, nn. 41-42.

49. *Corner of the Artist's Studio,* 1912

PROVENANCE: In the summer of 1912, acquired from Matisse by S. I. Shchukin. From 1912 to 1918, Shchukin collection, Moscow. From 1918 to 1923, First Museum of Modern Western Painting, Moscow. From 1923 to 1948, Museum of Modern Western Art, Moscow. From 1948, Pushkin Museum, Moscow.

EXHIBITIONS: 1912b Paris, perhaps no. 770. 1969 Moscow, Leningrad, no. 42. 1972 Prague, no. 25. 1979 Kyoto, Tokyo, Kamakura, no. 32. 1986 Lille, no. 14. 1987 Lugano, no. 32. 1988-89 Barcelona, Madrid, no 19.

COLLECTION CATALOGUES: Shchukin: 1913, no. 123. Museum of Modern Western Art: 1928, no. 332. Pushkin Museum: 1961, p. 121. 1986, p. 116.

SELECTED REFERENCES: Tugendhold 1914, p. 42; 1923, p. 143. Réau 1929, no. 946. Barr 1951, p. 157. Izerghina et al. 1978, no 43. Georgievskaya and Kuznetsova 1980, no. 229. Flam 1986, pp. 345, 347, 500, n. 41, pl. 348.

50. *Madame Matisse,* 1913

PROVENANCE: In Apr. 1913, purchased from Matisse by S. I.

Shchukin for 10,000 francs. From 1913 to 1918, Shchukin collection, Moscow. From 1918 to 1923, First Museum of Modern Western Painting, Moscow. From 1923 to 1948, Museum of Modern Western Art, Moscow. From 1948, Hermitage, Leningrad.

EXHIBITIONS: 1913b Paris, no. 1469. 1958 Brussels, no. 209. 1968 London, no. 50. 1969 Moscow, Leningrad, no. 50. 1970 Paris, no. 112. 1971 Tokyo, Kyoto, no. 58. 1972a Leningrad, no. 358. 1972 Otterlo, no. 55. 1973 Washington, D.C., New York, et al., no. 26. 1986 Lille, no. 19. 1988-89 Barcelona, Madrid, no. 24.

COLLECTION CATALOGUES: Museum of Modern Western Art: 1928, no. 342. Hermitage: 1958, vol, 1, p. 415. 1976, p. 279.

SELECTED REFERENCES: Apollinaire, G., "M. Bérard inaugure le Salon d'Automne," *L'Intransigéant* (Nov. 14, 1913); "Le Vernissage du Salon d'Automne," *L'Intransigéant* (Nov. 16, 1913). Sillart, "Salon d'Automne 1913," *Apollon* (1914), p. 51 (in Russian). Tugendhold 1914, p. 42. Coquiot, G., *Cubistes, futuristes, passéistes*, Paris, 1914, pp. 104-105. Sembat, M., *Henri Matisse*, Paris, 1920, p. 53. Réau 1929, no. 956. Barr 1951, p. 183. Matisse, H., *Portraits*, Monte Carlo, 1954, p. 22. Sterling 1958, pp. 180-82, pl. 148. Lassaigne 1959, p. 86. Laude, J., *La Peinture française et l'art nègre*, Paris, 1968, p. 233. Russell, J., *The World of Matisse*, New York, 1969, p. 87. Aragon, L., *Henri Matisse, roman*, Paris, 1971, vol. 1, pp. 22-23, 302. Giraudy, D., "Correspondance Henri Matisse–Charles Camoin," *Revue de l'art* 12 (1971), pp. 15-16. Matisse, H., *Ecrits et propos sur l'art*, Paris, 1972, p. 117. Izerghina and Barskaya 1975, no. 173. Izerghina et al. 1978, no. 51. Flam 1986, pp. 370-72. Kostenevich 1987, nos. 152-53; 1989, no. 215.

HENRI ROUSSEAU

51. *Jaguar Attacking a White Horse,* c. 1910

PROVENANCE: In Mar. 1910, purchased from Rousseau by Ambroise Vollard, Paris, for 100 francs; his collection until 1913. In 1913, sold by Vollard to S. I. Shchukin. From 1913 to 1918, Shchukin collection, Moscow. From 1918 to 1923, First Museum of Modern Western Painting, Moscow. From 1923 to 1948, Museum of Modern Western Art, Moscow. From 1948, Pushkin Museum, Moscow.

EXHIBITIONS: 1913 New York, Chicago, Boston, no. 382 (except in Boston, no. 192). 1964 Rotterdam, no. 111. 1972 Otterlo, no. 52. 1973 Washington, D.C., New York, et al., no. 39. 1979 Kyoto, Tokyo, Kamakura. 1984-85 Paris, New York, no. 64.

COLLECTION CATALOGUES: Shchukin: 1913, no. 231. Museum of Modern Western Art: 1928, no. 538. Pushkin Museum: 1982, no. 538. 1986, p. 157.

SELECTED REFERENCES: Tugendhold 1914, p. 45. Ternovetz 1925, p. 484, ill. Réau 1929, no. 1094. Uhde, W., *Henri Rousseau*, Berlin-Dresden, 1923, p. 191, pl. 239. Vallier, D., *Henri Rousseau*, Paris, 1961, no. 169. Bouret, J., *Le Douanier Rousseau*, Neuchâtel, 1961, no. 223, p. 262. Vallier, D., *Tout l'Oeuvre peint de Henri Rousseau*, Paris, 1970, no. 250, pp. 114-15. Behalji-Merin, L. and O., *Leben und Werk des Malers Henri Rousseau*, Dresden, 1971, no. 55, p. 84. Georgievskaya and Kuznetsova 1980, no. 222. Le Pichon, Y., *Le Monde du douanier Rousseau*, Paris, 1981, p. 149, ill. Stabenow, C., *La Jungle de Henri Rousseau*, Paris, 1984, no. 20, pp. 7-9, 12. Bessonova and Barskaya 1985, no. 153, pp. 371-72. Bessonova and Williams 1986, p. 245.

List of Exhibitions

1757, 1763, 1765, 1789 Paris
Salons. See *Collection des livrets anciennes expositions depuis 1673 jusqu'en 1800*. Paris, 1869–71.

1842 St. Petersburg
Academy of Fine Arts.

1861 St. Petersburg
"Index of Collections of Paintings and Rare Works of Art Owned by Members of the Imperial Family and by Private Individuals in St. Petersburg" (in Russian).

1889 St. Petersburg
"Old Master and Modern Paintings from Private Collections"(in Russian).

1903 Vienna
"Entwicklung des Impressionismus in Malerie u. Plastik." XVI. Ausstellung der Vereinigung Bildender Künstler Österreichs Secession Wien.

1904, 1905 Paris
"Salon d'Automne." Grand Palais.

1905 St. Petersburg
"Exhibition of Historical Russian Portraits." Tauride Palace (in Russian).

1906 Paris
"Oeuvres de Gauguin" in "Salon d'Automne." Grand Palais.

1908 Paris
"Salon d'Automne." Grand Palais.

1908 St. Petersburg
"The Old Years" (*Starye Gody*). Exhibition of paintings (in Russian).

1910 Paris
"Henri Matisse." Galerie Bernheim-Jeune.

1912 London
"Second Post-Impressionist Exhibition." Grafton Galleries.

1912a Paris
"Bonnard: oeuvres récentes." Galerie Bernheim-Jeune.

1912b Paris
"Salon d'Automne." Grand Palais.

1912 St. Petersburg
"A Century of French Painting, 1812–1912" (in Russian).

1913 New York, Chicago, Boston
"International Exhibition of Modern Art, Association of American Painters and Sculptors." New York, Armory of the Sixty-Ninth Infantry; The Art Institute of Chicago; and Boston, Copley Hall.

1913a Paris
"Bonnard: oeuvres récentes." Galerie Bernheim-Jeune.

1913b Paris
"Salon d'Automne." Grand Palais.

1923 Petrograd
"Nineteenth-Century Painting." Cat. by F. F. Nothaft. Hermitage (in Russian).

1926a Moscow
"Paul Cézanne, Vincent van Gogh." Museum of Modern Western Art (in Russian).

1926b Moscow
"Paul Gauguin." Museum of Modern Western Art (in Russian).

1936 Paris
"Cézanne." Orangerie des Tuileries.

1937 Paris
"Chefs d'oeuvre de l'art français." Exposition universelle. Palais national des arts.

1938 Leningrad
"Portraiture from the Eighteenth to the Twentieth Century." Hermitage (in Russian).

1939 Moscow
"French Landscapes of the Nineteenth and Twentieth Centuries." Museum of Modern Western Art (in Russian).

1955 Moscow
"French Art of the Fifteenth through the Twentieth Century." Pushkin Museum (in Russian).

1956a Leningrad
"French Art of the Twelfth through the Twentieth Century." Hermitage (in Russian).

1956b Leningrad
"Paul Cézanne (1839–1906), The Fiftieth Anniversary of His Death." Hermitage (in Russian).

1958 Brussels
"Cinquante Ans d'art moderne." Exposition universelle. Palais international des beaux-arts.

1960 Moscow
"French Art of the Second Half of the Nineteenth Century from the National Museums of the U.S.S.R." Pushkin Museum (in Russian).

1960 Paris
"Nicolas Poussin." Musée du Louvre.

1964 Rotterdam
"De Lusthof der Naïeven." Museum Boymans.

1965 East Berlin
"Von Delacroix bis Picasso, ein Jahrhundert französischer Malerei Ausstellung." Nationalgalerie.

1965 Bordeaux
"Chefs d'oeuvre de la peinture française dans les musées de l'Ermitage et de Moscou." Cat. by G. Martin-Méry. Musée des beaux-arts.

1965–66 Paris
"Chefs d'oeuvre de la peinture française dans les musées de Léningrad et de Moscou." Musée du Louvre.

1966–67 Tokyo, Kyoto
"Masterpieces of Modern Painting from the U.S.S.R.: The Hermitage, Pushkin, Russian, and Tretyakov Museums in Leningrad and Moscow." Tokyo, National Museum of Western Art; and Kyoto City Art Museum (in Japanese).

1967 Montreal
"Man and His World"/"Terre des hommes." Expo-67, International Fine Arts Exhibition. Org. by National Gallery of Canada.

1967–68 Dresden
"Meisterwerke der Ermitage, Leningrad. Französische Maler des 17 und 18 Jahrhunderts." Staatliche Kunstsammlungen.

1967–68 Paris
"Ingres." Petit Palais.

1968 Göteborg
"Ermitaget i Leningrad. 100 malningar och teckningar från

renässans till 1700-tal. Ulställing." Konstmuseum.

1968 London
"Henri Matisse: A Retrospective Exhibition." Hayward Gallery.

1969 Budapest
"Francia mesterek a Leningrádi Ermitázsbol." Szépmüvészeti Múzeum.

1969 Moscow, Leningrad
"Henri Matisse: Painting, Sculpture, Graphic Arts and Letters: An Exhibition in Honor of the Centenary of the Artist's Birth." Pushkin and Hermitage museums (in Russian).

1969–70 Prague
"Henri Matisse (1869–1954): Díla ze sovétskych muzei." Národní Galerie.

1970 Leningrad
"François Boucher (1703–1770): Painting, Graphics, and Applied Art." Hermitage (in Russian).

1970 Osaka
Expo-70. International Fine Arts Exhibition.

1970 Paris
"Henri Matisse, Exposition du centenaire." Grand Palais.

1971 Tokyo, Kyoto
"One Hundred Masterpieces from the U.S.S.R." Tokyo, National Museum; and Kyoto, National Museum (in Japanese).

1972 Dresden
"Meisterwerke aus der Ermitage, Leningrad, und aus dem Puschkin-Museum, Moskau." Gemäldegalerie.

1972a Leningrad
"The Art of the Portrait: Ancient Egypt, Classical Antiquity, the Orient, Western Europe." Hermitage (in Russian).

1972b Leningrad
"Watteau and His Times: Painting, Graphics, Sculpture, and Applied Art." Cat. intro. by I. Nemilova and N. Biryukova. Hermitage (in Russian).

1972 Otterlo
"Van Gogh tot Picasso" (from the Pushkin Museum, Moscow, and the Hermitage, Leningrad). Rijksmuseum Kröller-Müller.

1972 Prague
"Od Poussina K Picassovi, Mistrovská díla Muzea A. S. Puškin á Moskva." Národní Galerie.

1973 Washington, D.C., New York, et al.
"Impressionist and Post-Impressionist Paintings from the U.S.S.R., Lent by the Hermitage Museum, Leningrad, and the Pushkin Museum, Moscow." Washington, D.C., National Gallery of Art; New York, M. Knoedler and Co., Inc.; Los Angeles County Museum of Art; The Art Institute of Chicago; Fort Worth, Kimbell Art Museum; and The Detroit Institute of Arts.

1974 Leningrad
"Impressionist Painting: Centenary of the First Exhibition of 1874." Hermitage (in Russian).

1974–75 Moscow
"Impressionist Painting. Centenary of the First Exhibition of Impressionist Painters." Pushkin Museum (in Russian).

1974–75 Paris, Detroit, New York
"De David à Delacroix: la peinture française de 1774 à 1830." Paris, Grand Palais; The Detroit Institute of Arts; and New York, The Metropolitan Museum of Art (as "French Painting 1774–1830: The Age of Revolution").

1975–76 USA, Mexico, Canada
"Master Paintings from the Hermitage and the State Russian Museum, Leningrad." Washington, D.C., National Gallery of Art; New York, M. Knoedler and Co., Inc.; The Detroit Institute of Arts; Los Angeles County Museum of Art; Houston, Museum of Fine Arts; Mexico City, Museo de Arte Moderno (as "Pinturas maestras de los museos estales del Ermitage y Ruso, Leningrado"); Winnipeg Art Gallery; and Montreal Museum of Fine Arts.

1976 Dresden
"Meisterwerke aus der Puschkin-Museum Moskau und aus der Ermitage Leningrad." Gemäldegalerie Neue Meister, Albertinum.

1976 Prague
See 1976 Dresden above. Národní Galerie.

1976–77 Paris
"Joseph Vernet 1714–1789." Musée de la Marine, Palais de Chaillot.

1977 New York, Houston
"Cézanne, The Late Work." New York, The Museum of Modern Art; and Houston, Museum of Fine Arts.

1978 Düsseldorf
"Nicolas Poussin 1594–1665." Städtische Kunsthalle.

1978 Le Havre
"La Peinture impressionniste et post-impressionniste du Musée de l'Ermitage." Musée des beaux-arts.

1978a Paris
"Cézanne: les années dernières (1895–1906)." Grand Palais.

1978b Paris
"De Renoir à Matisse: vingt-deux chefs-d'oeuvre des musées soviétiques et français." Grand Palais.

1979 Dresden
"Gottfried Semper zum 100. Todestag: Ausstellung." Staatliche Kunstsammlungen.

1979 Kyoto, Tokyo, Kamakura
"Exhibition of Works by French Artists from the End of the Nineteenth to the Beginning of the Twentieth Century, from the Collections of the Hermitage and Pushkin Museums." Kyoto, National Museum of Modern Art; Tokyo, Civic Museum of Figurative Arts; and Kamakura, Kanagawa Prefectural Museum of Modern Art (in Japanese).

1979–80 Melbourne, Sydney
"Old Master Painting from the U.S.S.R." Melbourne, National Gallery of Victoria; and Sydney, Art Gallery of New South Wales.

1980 Tokyo, Kyoto
"Jean Honoré Fragonard." Tokyo, National Museum of Western Art; and Kyoto City Art Museum (in Japanese).

1981 Tokyo, Kyoto
"Henri Matisse." Tokyo, National Museum of Western Art; and Kyoto, National Museum of Modern Art (in Japanese).

1981 Vienna
"Gemälde aus der Ermitage und dem Puschkin-Museum: Ausstellung von Meisterwerken des 17. Jahrhunderts aus den Staatlichen Museen von Leningrad und Moskau." Kunsthistorisches Museum.

1982 Moscow
"Antiquity in European Painting from the Fifteenth to the Beginning of the Twentieth Century." Pushkin Museum (in Russian).

1982 Tokyo
"Women in Art." National Museum of Western Art (in Japanese).

1982 Tokyo, Kumamoto
"François Boucher (1703–1770)." Cat. by D. Sutton. Tokyo Metropolitan Art Museum; and Kumamoto Prefectural Museum of Art.

1982–83 Zurich, Düsseldorf
"Henri Matisse." Zurich, Kunsthaus; and Düsseldorf, Städtische Kunsthalle.

1983 Dresden
"Das Stilleben und sein Gegenstand: Eine Gemeinschaftsausstellung von Museen aus der UdSSR, der CSSR und der DDR." Gemäldegalerie Neue Meister, Albertinum.

1983 Lugano
"Capolavori impressionisti e post-impressionisti dai musei sovietici." Collezione Thyssen-Bornemisza, Villa Favorita.

1984 Leningrad
"Antoine Watteau, The Three-Hundredth Anniversary of His Birth." Hermitage (in Russian).

1984 Leningrad, Moscow
"European Still-Life Painting from the Sixteenth to the Early Twentieth Century, Paintings from the U.S.S.R. and the D.D.R." Hermitage and Pushkin museums (in Russian).

1984 Tokyo, Nara
"French Artists of the Late Nineteenth and Early Twentieth Centuries from the Collections of the Hermitage and Pushkin museums." Tokyo Metropolitan Art Museum; and Nara Prefectural Museum of Art (in Japanese).

1984–85 Paris
"Watteau 1684–1721." Cat. by M. Grasselli and P. Rosenberg. Grand Palais (also in English: Washington, D.C., National Gallery of Art, 1984).

1984–85 Paris, New York
"Henri Rousseau." Paris, Grand Palais; and New York, The Museum of Modern Art.

1984–85 Zurich, Frankfurt
"Pierre Bonnard." Zurich, Kunsthaus; and Frankfurt, Städelsches Kunstinstitut und Städtische Galerie.

1985 Leningrad
"Hubert Robert and the Architectural Landscape of the Second Half of the Eighteenth Century." Cat. intro. by I. Novoleskaya. Hermitage (in Russian).

1985 Venice, Rome
"Cézanne, Monet, Renoir, Gauguin, Van Gogh, Matisse, Picasso: 42 capolavori dai musei sovietici." Venice, Museo Correr; and Rome, Museo Capitolino.

1986 Lille
"Matisse: peintures et dessins du Musée Pouchkine et du Musée de l'Ermitage." Musée des beaux-arts.

1986 Québec
"Tableaux des maîtres français impressionistes et post-impressionistes de l'Union Soviétique." Musée du Québec.

1986 Tokyo, Kobe, Nagoya
"Cézanne." Tokyo, Isetan Museum of Art; Kobe, Hyogo Prefectural Museum of Modern Art; and Nagoya, Aichi Art Gallery (in Japanese).

1986 Washington, D.C., Los Angeles, New York
"Impressionist to Early Modern Paintings from the U.S.S.R.: Works from the Hermitage, Leningrad, and the Pushkin Museum, Moscow." Washington, D.C., National Gallery of Art; Los Angeles County Museum of Art; and New York, The Metropolitan Museum of Art.

1986–87 New York, Detroit, Paris
"François Boucher." New York, The Metropolitan Museum of Art; The Detroit Institute of Arts; and Paris, Grand Palais.

1986–87 Paris
"La France et la Russie au siècle des lumières: relations culturelles et artistiques de la France et de la Russie au 18ème siècle." Grand Palais.

1987 Leningrad, Moscow
"Russia-France: The Age of Englightenment: Russo-French Cultural Links in the Eighteenth Century." Hermitage (in Russian).

1987 Lugano
"Capolavori impressionisti e post-impressionisti dai musei sovietici, II." Collezione Thyssen-Bornemisza, Villa Favorita.

1987 Tokyo, Nagoya
"Paul Gauguin." Tokyo, National Museum of Modern Art; and Nagoya, Aichi Art Gallery (in Japanese).

1987–88 Belgrade, Ljubljana,Zagreb
"Svetski majstori iz riznica Ermitaza od 15–18 veka." Belgrade, Narodni muzej; Ljubljana, Narodna galerija; and Zagreb, Muzejski Prostor.

1987–88 Paris
"Fragonard." Cat. by P. Rosenberg. Grand Palais (also in English: New York, The Metropolitan Museum of Art, 1988).

1988 London
"French Paintings from the U.S.S.R.: Watteau to Matisse." National Gallery.

1988 Sydney, Melbourne
"Masterpieces from the Hermitage, Leningrad: Western European Art of the Fifteenth through the Twentieth Century." Sydney, Art Gallery of New South Wales; and Melbourne, National Gallery of Victoria.

1988–89 Barcelona, Madrid
"Henri Matisse: pinturas y dibujos de los Museos Pushkin de Moscu y el Ermitage de Leningrado." Barcelona, Museu Picasso; and Madrid, Centro de Arte Reina Sofia.

1988–89 Tokyo, Kyoto, Nagoya
"Barbizon School, Impressionist, Early Modern Paintings from the Hermitage." Tokyo, Jasuda Kasai Museum of Art; Kyoto City Art Museum; and Nagoya, City Museum (in Japanese).

1988–89 Washington, D.C., Chicago, Paris
"The Art of Paul Gauguin." Washington, D.C., National Gallery of Art; The Art Institute of Chicago; and Paris, Grand Palais.

List of Collection Catalogues

HERMITAGE, LENINGRAD

1774
Catalogue des tableaux qui se trouvent dans les galeries et dans les cabinets du palais impérial de Saint Petersbourg. St. Petersburg. Cat. by E. Munich.

1797
Catalogue of Paintings in the Imperial Gallery of the Hermitage. . . . St. Petersburg (in Russian)

1838
Livret de la galerie impérial de l'Ermitage de Saint-Petersbourg. St. Petersburg. Cat. by F. Labensky.

1863
Ermitage impérial, catalogue de la galerie de tableaux. St. Petersburg. Cat. by B. von Köhne.

1900
The Imperial Hermitage, Catalogue of the Painting Gallery. St. Petersburg. Cat. by A. Somov (in Russian).

1908
The Imperial Hermitage, Catalogue of the Painting Gallery. St. Petersburg. Cat. by A. Somov (in Russian).

1916
The Imperial Hermitage, Concise Catalogue of the Painting Gallery. Petrograd. Cat. by A. Somov (in Russian).

1958
The Hermitage, The Department of Western European Art: Catalogue of Paintings. Leningrad-Moscow (in Russian).

1976
The Hermitage, Catalogue of Western European Painting. Italy, Spain, France, Switzerland. Leningrad (in Russian).

1982
French Eighteenth-Century Painting in the Hermitage. Leningrad. Cat. by I. Nemilova (in Russian).

1983
The Hermitage, Catalogue of Western European Painting: French Painting, Early and Mid-Nineteenth-Century. Moscow-Florence. Cat. by V. Berezina.

1986
The Hermitage, Catalogue of Western European Painting: French Painting, Eighteenth Century. Leningrad-Florence. Cat. by I. Nemilova.

MUSEUM OF MODERN WESTERN ART

1928
State Museum of Modern Western Art, Illustrated Catalogue. Moscow (in Russian).

PUSHKIN MUSEUM, MOSCOW

1948
The Pushkin Museum of Fine Arts, Catalogue of the Painting Gallery. Moscow (in Russian).

1957
The Pushkin Museum of Fine Arts, Catalogue of the Painting Gallery. Moscow (in Russian).

1961
The Pushkin Museum of Fine Arts, Catalogue of the Painting Gallery. Moscow (in Russian).

1982
Masterpieces from the Pushkin Museum of Fine Arts, Moscow. Cat. by I. Antonova. Moscow.

1986
Masterpieces from the Pushkin Museum of Fine Arts, Moscow. Cat. by I. Antonova. Moscow (in Russian).

ST. PETERSBURG, ACADEMY OF FINE ARTS

1874
The Painting Gallery of the Imperial Academy of Fine Arts. Part 2: Catalogue of Foreign Paintings. St. Petersburg. Cat. by A. Somov (in Russian).

SHCHUKIN COLLECTION

Shchukin 1913
Catalogue of Paintings of the S. I. Shchukin Collection. Moscow (in Russian).

YUSUPOV COLLECTION

Yusupov 1839
Musée du prince Youssoupoff contenant les tableaux, marbres, ivoires et porcelaines qui se trouvent dans son hôtel à Saint-Petersbourg. St. Petersburg.

Yusupov 1920
The State Museum Reserve. Catalogue of Works of Art from the Former Yusupov Gallery. Petrograd (in Russian).